GRATIA DEI

A JOURNEY THROUGH THE MIDDLE AGES

AIM TRIMARK

As presenting sponsor of *Gratia Dei, A Journey Through the Middle Ages*, AIM Trimark Investments is proud to help the Musée de la civilisation explore our societal roots. These roots had their beginnings with the arrival of Christopher Columbus on North American shores in 1492. The evolution of Canadian institutions and ideas that followed is heavily based on medieval influences, which had their roots in Europe between the 4th and 15th centuries. Our universities, banks, trade associations, community groups and corporations are just a few examples of the legacy the Middle Ages has bestowed.

This unique exhibition is the result of the collaboration of numerous medieval scholars at institutions across Europe and Canada. Their intellectual curiosity has made it possible for us to savour this often-misunderstood period through themes of space and time, the countryside and peasantry, the city and the merchants, the authorities, knowledge and communications.

AIM Trimark encourages alternative thinking and the sharing of new vision. That vision may come from questioning accepted views of the world, past and present. However removed these views may seem from our day-to-day lives, their careful exploration makes our lives richer. That is why we feel that the arts and culture play a vital role in the betterment of society, from the local to the national level. As part of a global company, with roots stretching back to the nineteenth century, we are committed to consistently supporting culture in the communities in which we do business.

Philip Taylor
President and CEO
AIM Trimark Investments

This book was produced within the framework of an exhibition entitled *Gratia Dei: les chemins du Moyen Âge*, shown at the Musée de la civilisation in the city of Québec from May 21, 2003 to March 28, 2004. Thanks to its travelling exhibitions program and the latter's acting coordinator Yvan Chouinard, the Musée de la civilisation is organizing the exhibition's presentation in several places, including: the Public Museum of Grand Rapids, Grand Rapids, MI, USA, from May 22 to August 15, 2004; the Westfälisches Landesmuseum für Kunst und Kulturgeschichte Münster, Germany, from October 16, 2004 to January 4, 2005; the Church of Saint-Antoine, Liège, Belgium (Musée de la Vie Wallonne), from February 12 to May 1, 2005; the Musée d'Aquitaine, Bordeaux, France, from October 6, 2005 to January 16, 2006.

EXHIBITION
MUSÉE DE LA CIVILISATION PERSONNEL AND ASSOCIATES
Project manager: Hélène Daneau. Scientific advisor: Didier Méhu. Curator: Nicole Grenier.
Production assistants: Annie Beauregard and Katherine Tremblay. Secretary: Caroline Dumas.
The exhibition is the result of close cooperation between the Musée de la civilisation and five main partners:
Westfälisches Landesmuseum für Kunst und Kulturgeschichte (Münster), Hermann Arnhold. Musée d'Aquitaine de Bordeaux, Annick Bergeon. Museo Archeológico Nacional de Madrid, Angela Franco Mata. Trésor de la cathédrale de Liège, Philippe George. Museum Catharijne Convent of Utrecht, Helen C. Wüstefeld.

PUBLICATION
Author: Didier Méhu, Université Laval, Québec. Coordinator: Marie-Charlotte De Koninck, Musée de la civilisation. Contributors: Jean-Pierre Reverseau, Chief Curator, Musée de l'Armée, Paris. Eduard Frunzeanu, PhD candidate, medieval studies, Université de Montréal. Photographs of the artefacts of the Musée de la civilisation : Jacques Lessard.

PUBLISHER: ÉDITIONS FIDES
Translator: Geneviève Roquet. Translation Reviser: Sheila Fischman. Managing Editor: Guylaine Girard. Managing Producer: Carole Ouimet.
Art Director: Gianni Caccia. Computer graphics Designer: Bruno Lamoureux. Digitization of the illustrations: PhotoSynthèse.

National Library of Canada cataloguing in publication

Méhu, Didier

Gratia Dei: A Journey Through the Middle Ages

Translation of: Gratia Dei.
Includes bibliographical references.

ISBN 1-897092-00-8

1. Civilization, Medieval – Exhibitions. 2. Middle Ages – Exhibitions. 3. Social history – Medieval, 500-1500 – Exhibitions. 4. Art, Medieval – Exhibitions. I. Title.
CB351.M4613 2004 940.1'074'714471 C2004-940429-6

Legal deposit: 2nd quarter 2004
National Library of Québec
National Library of Canada
© Éditions Fides, 2004

The Musée de la civilisation is a government corporation subsidized by the Ministère de la culture et des communications du Québec. The publisher wishes to thank the Canada Council for Arts, the Department of Canadian Heritage, and the Société de développement des entreprises culturelles du Québec (SODEC) for their generous support of its publishing programs. The publisher is funded by the Government of Quebec tax credit program for publishing, a program managed by the SODEC.

Printed in Canada, May 2004

Gratia Dei

A Journey Through the Middle Ages

DIDIER MÉHU

Translation
by
Geneviève Roquet

MUSÉE DE LA
CIVILISATION
Québec

FIDES

FOREWORD

Has any period of Western history been as extensively reshaped by the romantic spirit and the taste for the picturesque as the Middle Ages? While we may not all live in the shadow of this era's most visible legacy – its cathedrals, towers and city walls – who among us has not been introduced to its history through a novel or film, whether Sir Walter Scott's *Ivanhoe*, which gave expression to the chivalrous ideal, the *Tristan and Isolde* romances, which established the motifs of hopeless love and the love triangle, or a Walt Disney production such as *Robin Hood?* This film, in particular, mythicized Robin Hood as the protector of paupers, widows and orphans and, by the same token, transformed Richard the Lion-Hearted, knight and king, into the ultimate Crusader, willing to sacrifice his life and castle to recapture Jerusalem from the infidels. Such themes, however, belong to the epic world of the popular Middle Ages. With its grandiose scenery, fortified castles, its princesses and knights in armour, no imaginative universe has been more romanticized than that of the Middle Ages.

Medieval culture, according to the historian Jacques LeGoff, was not simply a culture that made great use of imagery, but was a culture actually based on imagery. And it is on medieval society's pictorial self-representation that this book is centred. The reader should not be surprised, therefore, that so many of the works shown here reflect the Christian faith and come within the realm of the sacred. Medieval society celebrated the sacred before celebrating the profane; indeed, for centuries, it transposed the profane into the sacred on an everyday basis. The peasant ploughing his field, represented on a low relief or capital, is in symbiosis with nature and the universe, and thereby partakes of the work of God.

In these few lines, we have already touched on the most popular elements of the medieval bequest: its champions, its ideals, its decor, its peasantry, its great religious faith, its poetry. It seems that there is no end to the fascination that medieval society holds over our contemporary world. Hollywood and European cinema draw constantly on its history and rich imagery. The Middle Ages have even found their way into Internet games that attract scores of players.

And museums? Conscious of the popularity of medieval culture and its appeal to modern audiences, aware that Westerners on both sides of the Atlantic are in many respects heirs to medieval institutions, we ventured to devise and produce a comprehensive exhibition about a society whose

influence has reached as far as North America. Thanks to a largely cross-Atlantic partnership, we can finally celebrate the opening of our exhibition. I would like to emphasize that this partnership, which so greatly benefits the Musée de la civilisation and its visitors, is not only institutional, but also scientific. We would not have been able to explore medieval culture in such depth without the important contributions of our partners, in particular the Westfälisches Landesmuseum für Kunst und Kulturgeschichte (Münster), the Musée d'Aquitaine de Bordeaux, the Museo Arqueólogico Nacional of Madrid, the Trésor de la cathédrale de Liège and the Catharijne Convent of Utrecht. I would like to express my profound gratitude to their representatives for their loans of artifacts and works of art, and for the knowledge that they were willing to share with us. Furthermore, I stress the fact that the exhibition and publication could not have been presented without the generosity of 41 institutions that were kind enough to lend us their invaluable objects.

The team that organized this exhibition is greatly indebted to Didier Méhu, professor of medieval history at the Université Laval, for having inspired, informed, guided and supported it throughout the course of the project. It is only fitting that the Musée de la civilisation should honour him, as much for his knowledge as for his constant availability. And to convince you of this medievalist's expertise, we invite you to go through this book, which he wrote for us. Thanks to the author's lively style and remarkable talents as a popularizer, it offers a refreshingly clear outlook on medieval culture. It will not make you forget or give up your picturesque and, who knows, possibly fantastic view of the Middle Ages; chances are, however, that you will come to a new understanding of medieval civilization. No less could be expected of an exhibition devoted to that period of history called conventionally – and with unwitting condescension – the "Middle" Ages, an era that nonetheless shaped the evolution of humanity and revealed to the highest degree our fundamental aspirations, whether spiritual, romantic, civic or simply material.

CLAIRE SIMARD
Executive Director
Musée de la civilisation

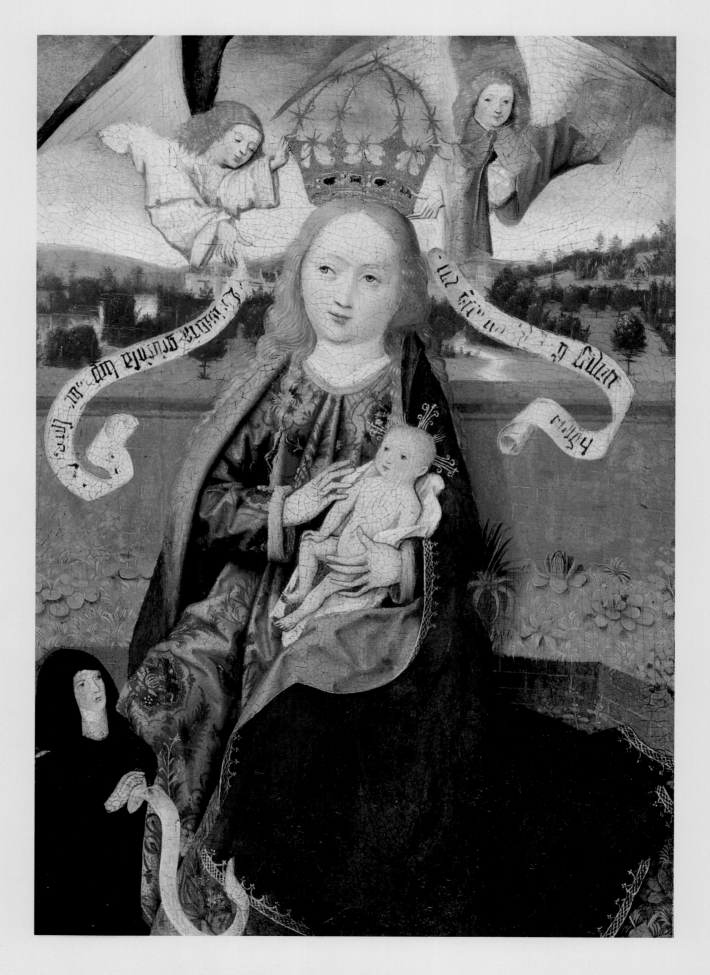

THE MIDDLE AGES HAVE BECOME something of a fashion: pseudo-medieval boutiques, fetes and re-enactments are all the rage. Medieval cuisine, films, novels and interactive games appeal to inquiring minds and palates. Romanesque churches attract throngs of visitors, and many still travel the old pilgrimage routes to Santiago de Compostela, some seeking a form of spirituality lost to the modern world, others merely trying to relieve the stress of the year by walking through magnificent landscapes. Exhibitions devoted to the Middle Ages have even been organized in such unexpected regions as Quebec.

But what do we really know about the Middle Ages? Was it a period, as some would have it, that shaped much of modern Western civilization? Was it the sinister era others allude to when they condemn ideas or practices as hailing from the "Dark Ages," or was it an age of harmony that may still have something to teach us?

What Middle Ages?

The term usually evokes a definite period of history, bracketed by the fifth and fifteenth centuries of the Christian era. Let us begin by setting the record straight.

The Middle Ages were not so much a historical period as a civilization that spread across Western Europe, and Western Europe only, a civilization that stretched from Hungary to the shores of the Atlantic, from Portugal to Southern Scandinavia. Attributing Middle Ages to other geographical areas amounts to extending the pattern of European evolution to the whole world. It would be as nonsensical to speak of the Middle Ages in Africa or China as it would be absurd to speak of the Ming era in Spain or of the third century of the Hegira in Canada.

The conceptualization of history is above all the conceptualization of diversity, an exercise that requires some basic conceptual precautions.

*M*iddle Ages or Renaissance?
According to art historians,
15th-century Flemish painting spans
both periods. The artistic Renaissance
began as early as the 14th century
in Italy and as late as the 16th in France.
Studying only forms, however,
would exclude the study of society.

FACING PAGE

Virgin and Child
Master of Liesborn, workshop, ca. 1470,
(Painting on oak panel, 41.5 × 26.3 cm;
© Westfälisches Landesmuseum für Kunst
und Kulturgeschichte, Münster, 626 LM;
photo: Sabine Ahlbrand-Dornseif
and Rudolf Wakonigg)

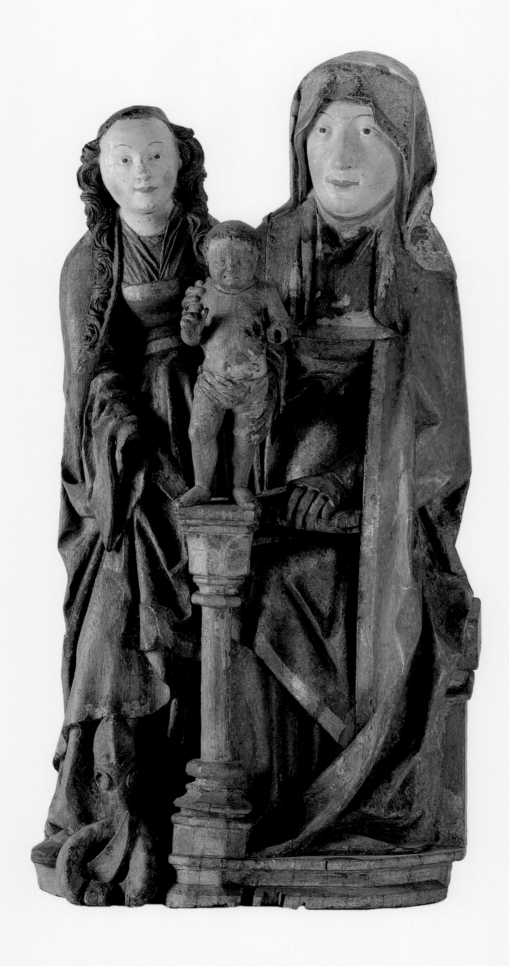

A "Middling Age" Between Antiquity and the Renaissance

In many respects, the very definition of the Middle Ages rests on a misconception. This "misunderstanding" was introduced at the end of the fifteenth century by some intellectuals known as humanists, who adopted a deeply negative attitude towards their historical predecessors. Fascinated by Greek and Latin Antiquity, they measured past European history against the standards of these civilizations, which they were rediscovering and promoting as models of contemporary taste. To them, the end of the Roman Empire marked the tragic decline of a brilliant civilization, followed by endless years of inhumanity, obscurantism and contempt for beauty. To their eyes, caught between two brilliant ages – splendid Antiquity and its Renaissance – was a middle, and above all a middling civilization. The "middling age" was considered so lacklustre that its greatest architectural achievements were termed "Gothic," an allusion to the Goths who had reigned terror on fourth- and fifth-century Europe.

The "Middle" Ages could have been more kindly introduced, and if the issue had been given any serious thought, their very name would have been long since replaced by a more favourable designation. But it seems that it is too late.

To rediscover the distinctive traits of this original civilization, we must follow its paths, even though such an approach is uncertain – impossible, some would say – because our patterns of thought are conditioned, indeed constrained, by the words and concepts forged by the society we live in. But this, after all, is the very challenge of history.

The Structures of Medieval Civilization

If we are to understand a civilization, we must first admit that it was governed by its own particular rules. This calls for a certain degree of humility. We cannot profess to understand the men and women of the Middle Ages simply because they were our ancestors, lived in the same areas as we do and left us a wealth of buildings, archives and words. At first glance, the rules that structured their society seem strange, if not foreign, to us.

Consider, for instance, that in the year 1000 monks used to lay statues of saints on the ground to make it rain or to call down curses upon knights who had stolen their lands. Think of those witches who were absolutely convinced that they flew away on their brooms at night to meet the devil and couple with him. Think of the merchants who kept nothing but silver pennies in their purses, but who did their bookkeeping in shillings and pounds – currencies that were not actually in circulation.

The men and women of the eleventh century were neither more nor less intelligent than their Neolithic ancestors or their twenty-first century descendants. Simply, they did not have the same intellectual tools, the same representation of the world, the same expectations

The Holy Family, with St. Anne, the Virgin and Jesus. The image is typical of medieval civilization, which attached more value to spiritual relations – perfectly embodied by the Virgin and her mother – than to bonds of the flesh. Little can be gleaned from this representation, however, without a basic understanding of the structures of medieval society.

concerning their daily life, the same beds or clothes, or the same life expectancy as modern man. These are not trivial matters, but crucial factors in the distinctive structuring of a society.

Society as *Ecclesia*

One feature truly defined the Middle Ages: the complete interweaving of the concepts of "Church" and "society." Medieval society saw itself as an *Ecclesia* – a Church, in Latin – a Christian society centred on the ideal of salvation. Modern conceptions of religion or faith are inappropriate to describe this kind of society. Today, faith involves a choice, which was not the case in medieval society. That the ultimate purpose of all men was to reach heaven – or, failing that, to burn in hell – was not a matter of debate in the Middle Ages; it was a given, an unquestionable truth. Man had been created by God and to God he would return for all eternity if he behaved honourably.

The first clear theorization of this social system was Saint Augustine's *City of God*, written in the early decades of the fifth century. In this model, the "earthly city" instituted by men was a transient realm that had no other purpose than to prepare for the "heavenly city." Social relations within the earthly city were guided by the basic principles of *caritas*, charity, *fides*, faith and *pax*, peace. Through baptism, people were admitted into the Christian community and thus into society itself. The same sacrament brought them *fides*, a spiritual link with God, and *caritas*, the particular bond through which they became brothers and equals despite differences in social status, the bond that encouraged them to exchange goods, vows and services. *Pax* was the ideal harmony that united and upheld Christian society.

These conceptions may seem quite abstract; in fact, one might rightly wonder how many members of the illiterate peasantry actually embraced them. No doubt very few, at least on a conscious level. But the fact remains that social relations as a whole were structured on the model of *caritas*.

Medieval Dynamics

A description of the social structures of the Middle Ages – a period that stretched from the fifth to the fifteenth century – may create an impression of stagnation. Was there so little social evolution over such a long period? Let there be no mistake on this point: the fact that a society's structure remains stable does not mean that it has settled into an invariable form, nor can such stability prevent the development of social contradictions heralding change.

The observation of a society's dynamics should not preclude a broader historical perspective. There are major breaks that upset the balance of a social system, and there are events that transform the internal organization of a society without bringing about its upheaval.

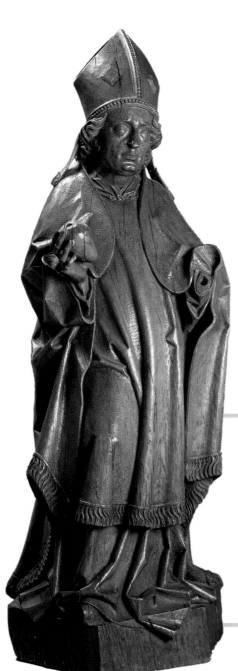

*S*t. Augustine (354–430) was the greatest Father of the Church. His writings, in particular The City of God and the Confessions, had a profound influence on the evolution of the Church throughout the Middle Ages.

St. Augustine
Cleves/Gueldre, Germany/the Netherlands,
Arnt van Zwolle, 1460–1492,
(Oak, 102 × 36 × 26.5 cm;
© Museum Catharijneconvent, Utrecht,
ABM bh272; photo: Ruben de Heer)

Accordingly, during the Middle Ages, a form of international trade that some have called pre-capitalistic emerged from a society governed by the Church – an ecclesiastical society in which *caritas* not only took precedence over profit, but also shaped its very definition. This is not to deny that merchants sowed the seeds of a schism that would eventually shatter medieval civilization, or that many such forms of disruption would come forth from towns or villages, instigated by kings or knights, by scholars steeped in Greek and Latin culture or by the peasantry.

The Middle Ages: High or Low?

Throughout its reign, medieval civilization was driven by powerful dynamics, which were particularly intense between the ninth and thirteenth centuries. To characterize these dynamics, historians have traditionally divided the Middle Ages into sub-periods. Thus they speak of the Early or Late Middle Ages, of the first Middle Ages or of the pre-Renaissance. These terms must be defined more precisely.

English scholars divide the medieval era into three periods. The Early Middle Ages comprise the years between the fifth and tenth centuries. The High Middle Ages, ushered in by the victory of William the Conqueror in 1066, are usually defined as the most brilliant period of medieval civilization, between the eleventh and thirteenth centuries. The fourteenth and fifteenth centuries form the Late Middle Ages.

The terms used in German literature are quite similar to the English designations. The early medieval era is called Frühmittelalter, the intermediate epoch Hochmittelalter, the final period Spätmittelalter. But the boundaries between these periods differ, notably because the imperial coronation of Otto I the Great in 962 is used to mark the beginning of the High Middle Ages (Hochmittelalter).

In French, different names are given to these sub-periods, and there are some variances with regard to their chronology. The High Middle Ages (haut Moyen Âge) are understood to be the first centuries of the medieval era, while its decline is referred to not as "Late" but, pejoratively, as "Low": the "bas Moyen Âge." The intermediary epoch is predictably called "central" (Moyen Âge central). Moreover, this era begins some two centuries before its English equivalent, lasting from the ninth to the thirteenth century, and sometimes only to the twelfth century, according to those historians who like to portray the "splendid" thirteenth century as the "zenith of the Middle Ages."

To each his history, to each his terminology. Every culture interprets the Middle Ages according to its own history. How can such differences be transcended? Above all, by favouring the comprehensive, long-term approach pioneered by such historians as Fernand Braudel and Jacques Le Goff. And by focussing research on social structures while grounding it in comparative history, which leaves little room for theoretical divides inspired by nationalism. In that respect, the distance provided by a North American perspective may prove to be highly useful.

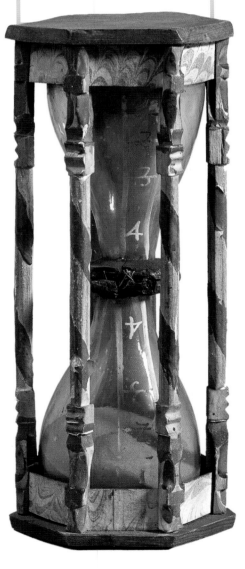

The development of trade was one of the most striking aspects of medieval dynamics. Merchants broke through the fetters of feudal society, pushed back the limits of the unknown world and transformed the conception of space and time. The hourglass, one of their inventions, was notably used to determine the length of auctions.

Hourglass
14th century. (17 × 7 × 7 cm;
© Museum der Stadt Regensburg,
AB 471; photo: Peter Ferstl)

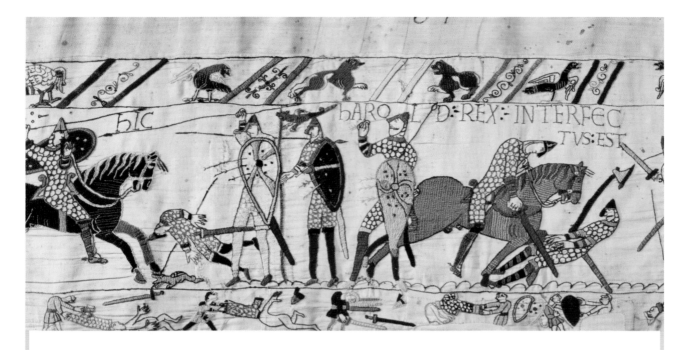

The Battle of Hastings
Bayeux Embroidery, late 11th century.
(© Ville de Bayeux)

*T*he Bayeux Embroidery, woven and embroidered during the 1070s, depicts the Norman invasion of England led by Duke William I, also known as the Conqueror. The final parts of the embroidery focus on William's victory at the Battle of Hastings in 1066. Most historians agree that the Norman conquest led to the establishment of a feudal monarchy in England, and characterize it as the turning point between the Early and High Middle Ages.

The Thread of History

The following pages chart a non-chronological course through the Middle Ages. The evolution of medieval civilization is outlined in separate sections, which, taken as a whole, offer a comprehensive description of the period's dynamics. Nonetheless, to avoid losing the thread, some points of reference are needed.

For instance, which date should be accepted as marking the birth of medieval civilization? In fact, it might be wiser to mention several. The beginning of the fourth century was a critical period. In 312, the Roman Emperor Constantine converted to Christianity and put an end to the persecution that the followers of Christ had suffered for a century and a half. Christian dogma gradually took form. The Councils of Nicaea (325) and Constantinople (381) defined the Creed. Some decades later, Saint Augustine wrote *The City of God* and Saint Jerome translated the Bible into Latin. Bishoprics were established in almost every Roman city, and religious rigorists founded the first monasteries around the Mediterranean Sea. While this hardly brought the Roman Empire to its knees, the network of the Christian Church gradually became more effective than that of Roman consuls and procurators, which it would soon be ready to replace.

Moreover, in the cities of the Empire as on its roads, various Eastern peoples mingled with Roman citizens and did business with them. In the

fourth and fifth centuries, Huns, Goths, Saxons, Vandals, Franks and Lombards left the steppes of Asia or Central Europe to roam the Empire, eventually settling from England to Spain. Since their native lands lay beyond imperial borders, they were called "barbarians." The Ostrogoths ended their migration in Italy, and joined the imperial civil service in such great numbers that, by 450, they held the emperors at their mercy. In 476, Odoacer, the leader of an Ostrogothic faction, deposed the child emperor Romulus Augustulus without claiming the imperial throne, which was henceforth left vacant in the West.

From 312 to 476, Roman institutions rapidly lost their effectiveness, thus setting the stage for the rise of medieval civilization. The following centuries witnessed an increasing intermingling of Church and society. This was less a linear evolution – there is no such thing in history – than a pronounced pattern, whose most salient features can only be sketched out here.

Between the end of the fifth century and the seventh century, most "barbarian" kings converted to Christianity, and by so doing brought into the Christian fold the most influential members of their people. Their actions were guided by strategic interests, and not by the hand of God. These new sovereigns realized they could only benefit from winning the support of a network that had acquired "international" dimensions. The alliance between the Army and the Church – one of the leitmotifs of anticlerical complaints in days of old – was born in the Middle Ages, and it would define the entire era.

This alliance was formally sealed at the end of the eighth century. At the time, the kingdom of the Franks was the most powerful realm in Western Europe. Two of its kings, Pepin the Short and his son Charles, allied themselves with the papacy by promising that the chief concern of their governments would be to preserve Christian *pax* and *unitas*. Charles brought several bordering nations under Frankish rule and was hence known by the names of *magnus*, Charles the Great or Charlemagne. While his descendants, the Carolingians, carried on the program of their two illustrious ancestors with varying degrees of success, their mode of government became firmly established.

But the play of medieval dynamics involved forces from all parts of society. From the country, where peasants, lords and clerics would together restructure the whole of society. From towns, which, after a period of darkness, reclaimed their prominence in the eleventh century. From such nouveaux riches as merchants, from such new civil servants as knights.

Ahead lies a medieval odyssey whose course, first plotted by the Carolingians, becomes increasingly labyrinthine after the turn of the millennium.

A journey such as might have been undertaken by the men and women of the Middle Ages on their way to salvation. A journey that explores various aspects of medieval civilization and outlines its evolution. A journey from Spain to England, from the Danube to the Atlantic, from the North Sea to Sicily.

A journey made *gratia Dei*, "by the grace of God," not so much to praise him as to understand his role in the structuring of social relations.✛

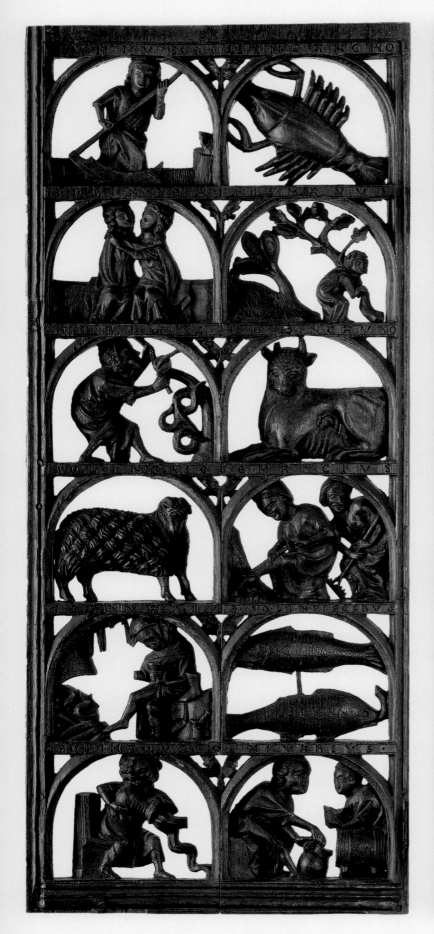
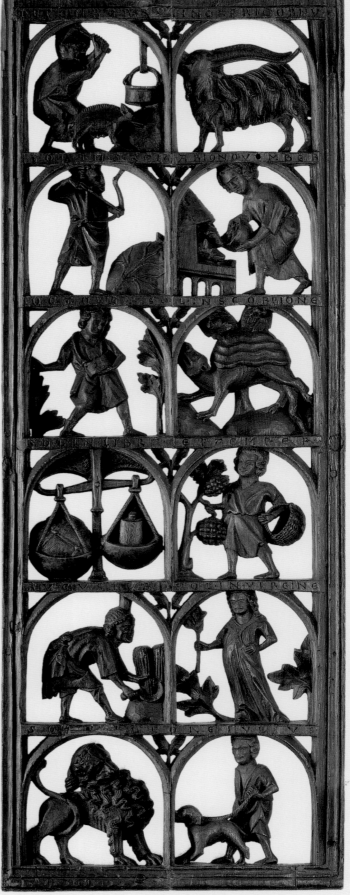

Space and Time

SPACE, TIME, life, death, hell, heaven, the earth, the sky, the forest, even water and roads: in the Middle Ages, everything was redefined according to criteria radically different from those of Antiquity.

The Time of God

Time belonged to God, and had a beginning and an end. Originating at Creation, it would come to a close on Judgement Day.

Since the Lord created the world in six days, it followed naturally that men must go about their business for six days and rest on the seventh. Yet it would take centuries to persuade all of them to remain idle on Sundays. Bishops laboured the point in sermons as early as the fourth century but, up to the turn of the millennium, many peasants preferred to tend their herd on Sundays rather than follow the flock to church.

The medieval year was punctuated by religious feasts. The most important ones commemorated the life of Christ, while others were held in memory of particularly exemplary saints; together, they shaped the entire fabric of social relations. The greatest feasts of all, Christmas and Easter, were ushered in by two forty-day periods of purification, Advent and Lent. Preparation for the holy days was marked by fasting and sexual abstinence. The feast day itself was a time of general reconciliation: the faithful made peace with their souls and with their fellow men, with priests and with overlords. Fairs and judicial sessions were held on such occasions. All fighting was suspended, and bonds of solidarity were strengthened through communal meals.

The year was also governed by the rhythm of the seasons, which were of vital importance to a population that depended almost entirely on

FACING PAGE
Fretwork with representations of the seasons and the zodiac
Former collegiate church of St. Boniface, Freckenhorst, Westphalia, Germany, ca. 1350, (Oak, 122 × 45 cm; © Westfälisches Landesmuseum für Kunst und Kulturgeschichte Münster, E-91 a, b LM; photo: Sabine Ahlbrand-Dornseif and Rudolf Wakonigg)

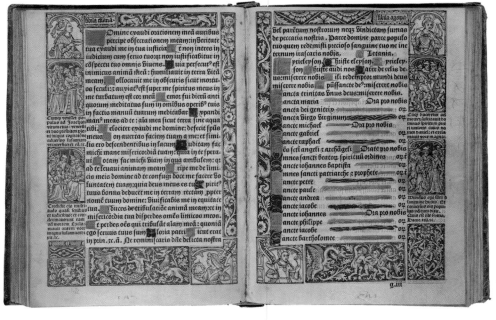

Livre d'heures à l'usage de Rome
[Book of Hours for the use of Rome]
Paris, Philippe Pigouchet for Simon Vostre, printer, ca. 1500, (Paper, 13.5 × 19 × 4.5 cm; Musée de la civilisation, dépôt du Séminaire de Québec)

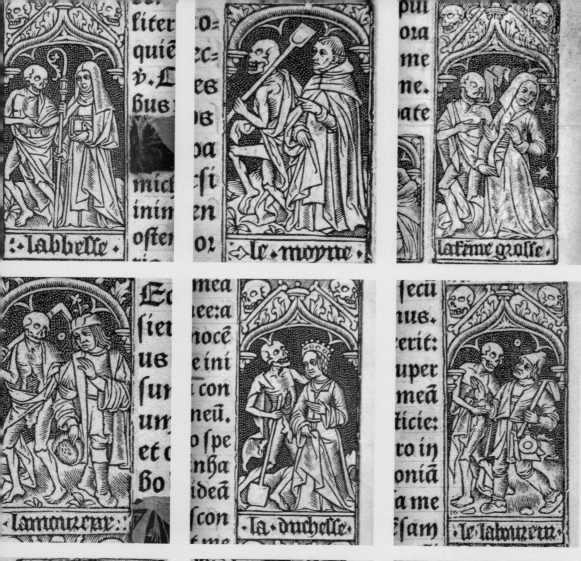

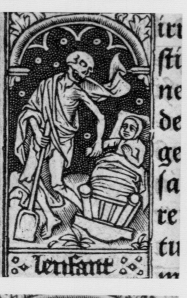

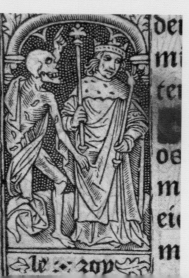

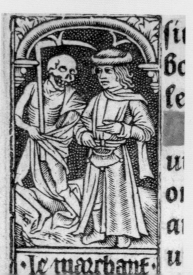

Left to right: *the abbess, the monk, the pregnant woman, the lover, the duchess, the ploughman, the old woman, the child, the burgher, the archbishop, the king, the merchant.*

*I*n the late Middle Ages, a new theme appeared in literature and painting: the danse macabre, *a democratic version of the Dance of Death. In its pictorial representations, men and women of all ages and social levels were swept up in a dance towards death by their skeletal doubles. This imagery denoted a new relationship to the body and to time that reflected more closely the human condition.*

Danse Macabre (The dance of death)
Livres d'heures à l'usage de Rome
[Book of Hours for the use of Rome],
Philippe Pigouchet for Simon Vostre,
printer, Paris, ca. 1500.
(Musée de la civilisation, dépôt
du Séminaire de Québec)

Bell
Church of Mehr, Cleves, Germany, ca. 1400.
(Bronze, 62 × 50 cm; © Westfälisches
Landesmuseum für Kunst und
Kulturgeschichte Münster / Permanent
loan from the Bishopric of Münster,
BM 431; photo: Rudolf Wakonigg)

agriculture for its livelihood. It was often repre-
sented in pictorial form, with twelve illustrations
standing for the twelve months. To each month
was associated a specific rural activity as well as a
sign of the zodiac, which served as a reminder
that earthly time was conditioned by the cycli-
cal unfolding of celestial time.

To measure time, the Church used canon-
ical hours, which divided the day into eight
hours, each marking a period of prayer of
the divine office: matins, lauds, prime, terce,
sext, nones, vespers and compline. When
bells were introduced in the seventh cen-
tury, they were used to strike these hours,
structuring the day. The twelfth century her-
alded further investigation into the meas-
urement of time. Scholars and merchants, the medieval calculation special-
ists, both tried to devise systems by which the day could be divided into equal
parts. Their research led to the thirteenth-century invention of the me-
chanical clock. From then on, the mastery of time became the focus of a
heated dispute. Which bells would set the tempo of social life: those of the
Church, which struck the eight canonical hours, or those of the town,
which chimed 24 hours?

Fasciculus temporum [Historical chronicle]
Werner Rolevinck (1425–1502), Strasbourg, France,
Johannes Prüss, printer, ca. 1490. (Paper, 28 × 21 cm;
Musée de la civilisation, dépôt du Séminaire de Québec,
Inc. 1)

Knowing How to Die

Men knew that they were allowed only a temporary, usually a brief stay on
earth. Very few lived longer than 40 years, and countless died before even
learning how to walk. The plague disappeared from Europe in the sixth cen-
tury, but when it reappeared in 1348, it wiped out more than a third of the
continent's population. Prayers to Saint Roch or to Saint Sebastian were of no
avail. The scourge of God resurfaced and spread regularly until the eighteenth
century; each outbreak left in its wake a trail of corpses thrown into mass
graves; each pestilence cut down the living regardless of their age or social po-
sition, as in a *danse macabre* – a democratized version of the Dance of Death.

*Where everlasting life was concerned, some eminently practical issues had
to be settled, lest the faithful stray from the path. While people were quite
willing to believe that the dead would be risen on Judgement
Day, they were also curious to know what state the bodies
would be in. It was disheartening to imagine decayed
remains or crumbling bones being brought back to life.
Gradually, then, men came to believe that the body would be
resurrected in its "best state," as it had been when the deceased
had reached his physical prime. Kings, Popes and lords contributed
to this belief by commissioning works in which they were depicted lying on their
tombs in ceremonial regalia. These works, known as recumbent figures, showed
the dead in full glory, wearing the attire and insignia that symbolized their might.*

**Recumbent figure: the knight of Curton armed
with a lance and a shield bearing his coat of arms**
Dépôt Henri d'Armaillé, 13th century.
(Limestone, 35 × 50 × 217 cm; Musée d'Aquitaine,
Bordeaux, D.2000.2.1; © DEC; photo: B. Fontanel)

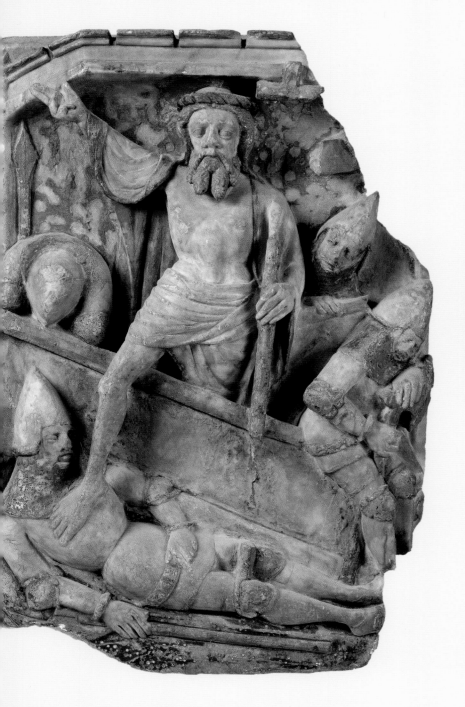

The Resurrection of Christ
Retable (detail), Nottingham or York,
ca. 1470. (Alabaster relief, 40 × 27 × 6 cm;
(Donated by Charles Sauvageot, Paris,
Musée national du Moyen Âge – Thermes
de Cluny, Inv. Cl. 19327;
© Photo RMN-Gérard Blot)

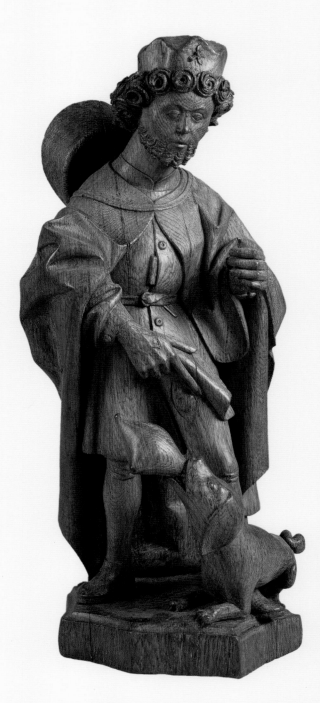

St. Roch
Cleves/Gueldre, Germany/the Netherlands,
early 16th century. (Oak, 56 × 25 × 25 cm;
© Museum Catharijneconvent, Utrecht,
ABM bh293; photo: Ruben de Heer)

Not surprisingly, one of the fundamental duties of a good Christian was to prepare well for his death. The practice of making wills, abandoned since the seventh century, made a triumphant return in the twelfth century, first to Mediterranean lands and then to the rest of Europe. The first forms of medieval wills, oral contracts, were eventually superseded by testaments recorded by a notary in the presence of several witnesses. The Church always found a way to have one of its representatives on the premises to ensure that such documents were inspired by piety. After all, legacies to the Church did offer the best guarantee against hardship for souls en route to the Eternal.

Restructuring the Next World

While heaven and hell were not constructs of the Middle Ages, the medieval Church brought considerable clarification to their geography and mores. Its dogma was based on specific conceptions of the body and of time. Human beings were composed of a body and of a soul, which, united until death, would thereafter be parted. The body would eventually decay in cemetery earth, but the soul would be judged. In recognition of acts of charity or as sanction for sin, it would either join the ranks of the Elect or be punished in hell. Such verdicts were provisional, though, and would be reviewed on Judgement Day. At that time, all those who had lived since the days of Adam and Eve would be resurrected, and both the dead and the living would undergo a final trial binding them for all eternity.

In hell, each sin earned its specific punishment. The miser would be hanged with his purse fastened around his neck. The glutton would be force-fed or bound to a table richly laden with foods just out of his reach. Lecherous lovers would be put in chains. Heaven became slowly associated with specific imagery. In the early motif of Abraham's bosom, the souls of the just, portrayed as naked men and women, were wrapped in a cloth that the patriarch, father of all the faithful, held on his knees. At the end of the Middle Ages, this theme gave way to that of the celestial court, in which the Elect were gathered around the Virgin and God in an order that reflected their merit. What did they do? They contemplated God. Throughout eternity.

In the twelfth century, the Church invented purgatory, an intermediate place in which certain souls must remain to atone for their sins. Anyone could now achieve salvation, if only after hundreds or thousands of years of purgation. Souls suffered the same agonies in purgatory as in hell, though these were inflicted in a milder manner and would not last forever. Artfully crafted ghost stories, which preachers delivered in town squares, lent credence to these new notions. It was said that the souls of the dead came back to haunt the living – in particular, their cemeteries – to testify to the

Hell
Origin unknown, 13th century. (Stained glass, 70.5 × 43 cm; © Collections de l'Université Laval, L.BAV.2)

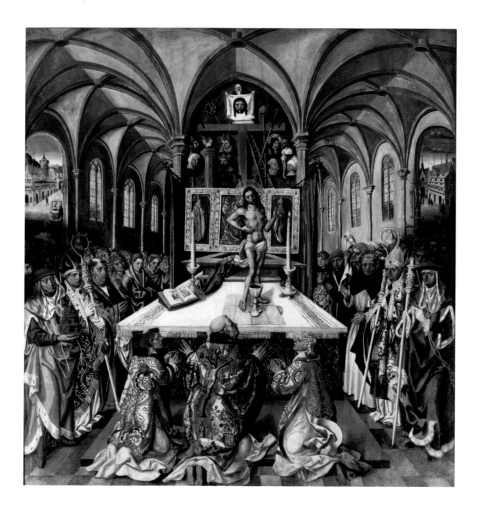

It was said that while celebrating mass, Gregory the Great, Pope from 590 to 604, had a vision of Christ rising from the tomb. The event was rarely given pictorial form during the ensuing centuries. However, as the concept of purgatory gained currency in the 13th century, the image of the risen Christ on the altar, symbolising eternal life, became a common motif in medieval art. Moreover, popular belief had it that the more masses said, the more often the miracle might be repeated, this time for the salvation of all souls. The theme of the Mass of St. Gregory thus provided the Church with a powerful means of encouraging the faithful to have masses said for souls in purgatory and of promoting demand for indulgences. In this painting, the founding sacrifice of Christ is represented by the Instruments of the Passion, which are given particular emphasis. The artist used a contemporary setting, depicting in the background the German city of Braunschweig in the late 15th century.

The Mass of St. Gregory
German school, late 15th century.
(Oil on wood, 190 × 172 cm;
© Trésor de la cathédrale de Liège, Inv. 7)

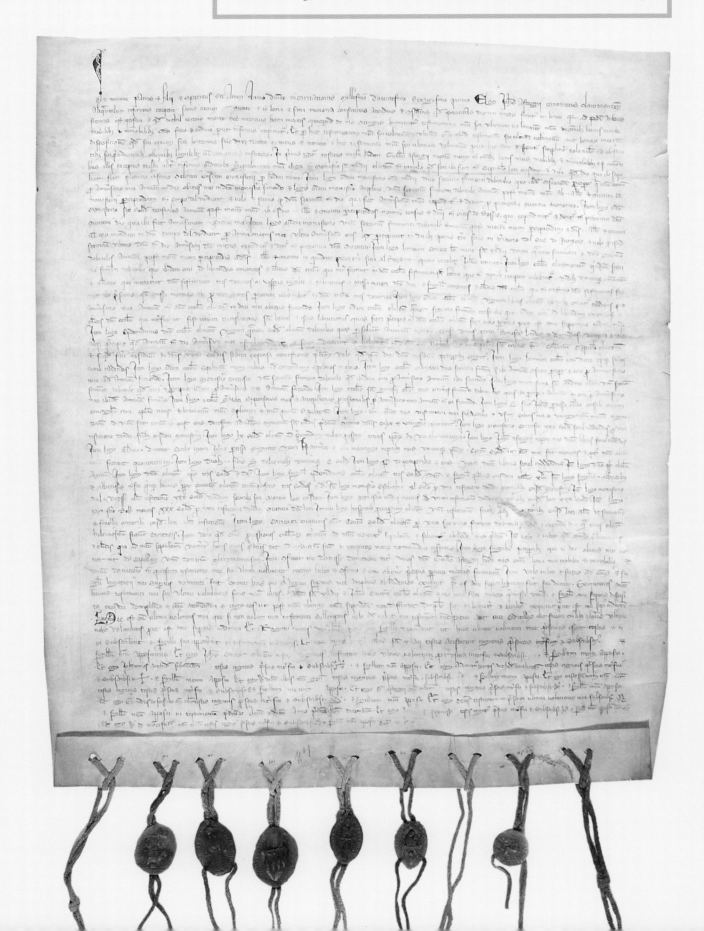

Testament of Jean Astorg, canon of the Cathedral Chapter of Clermont (France), 1261. (Parchment, 55 × 44 cm; © Archives départementales du Puy-de-Dôme, 3 G PS 17; photo: Serge Seguin)

*S*ealed with six seals: seal of Adhémar de Cros, archdeacon of Aurillac; seal of Guillaume Dalmas, abbot of the collegiate church of Saint-Genès de Clermont; seal of Casto de Saint-Nectaire, canon of Clermont and abbot of the collegiate church of Saint-Vosy du Puy; seal of Géraud Astorg, canon of Clermont; and two unidentified seals. Three seals are missing.

torments they endured in purgatory. As a way to end their suffering, these lost souls advocated profuse memorial services and generous donations to religious communities.

The Medieval Universe: Contrast and Hierarchy

Just as God had created the earth and the heavenly bodies, the whole of Creation was structured by fundamental oppositions. All things were either high or low, central or peripheral, spiritual or carnal, male or female. The highest realm was that of God and of eternity, the lowest, that of mankind and of transience. Central areas were havens, but peripheral ones harboured the unknown, if not evil itself.

On a world-wide scale, central territories were in effect Christian ones; in the eleventh century, they could be equated roughly with Western Europe. On their periphery lay the dangerous lands of heathens, home to monsters or fabulous beings faithfully depicted on *mappamundi* (maps of the world).

The contrast between centre and periphery could be applied to any number of settings. In the countryside, all social activity centred on villages, which were invested with positive value. Beyond lay the wilderness: forests, moors and swamps. In villages, houses clustered around the church, which was also the focus of social life – yet another centre. In urban areas, misfits and polluting industries were relegated to the town's outskirts. A hellish array of monstrous gargoyles and obscene modillions stood guard over the outer walls of churches. And in illuminated manuscripts, the Virgin, seated in majesty at the centre of the page, was surrounded by rutting animals and lewd monks.

Though outlying lands were in principle hostile to man, he might still venture there on occasion. Churches were sometimes erected at the boundaries of populated areas or in the forest. Knights held their tournaments on deserted heaths or at the outskirts of villages; lords laid claim to the forest to assert their rule over nature, and therefore over men.

FACING PAGE

Abraham's bosom (above) and hell (below)
Psautier de Blanche de Castille et de Saint Louis, [Psalter of Blanche de Castille and Saint Louis], probably Paris, between 1220 and 1230. (Bibliothèque de l'Arsenal, Ms 1186, fol. 171 v°, © Bibliothèque nationale de France, Paris)

BELOW

God as architect of the universe
Bible moralisée [Moralized Bible], probably Rheims, France, mid-13th century. (© Österreichische Nationalbibliothek, Vienna, Ms codex 2554, fol. 1v°)

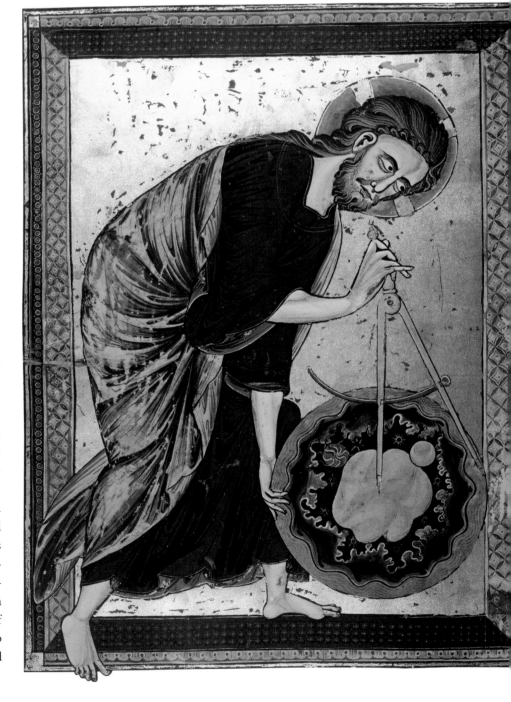

Pilgrimages

Pilgrimage routes led people out of their usual world. Local pilgrimages often involved praying to a saint considered to have healing powers; their destination would be the saint's chapel, often built beyond the village limits, in a glade or near a spring.

While some pilgrimage centres owed their fame to nothing more than effective marketing, others acquired particular significance because they had been the site of a miracle or because they gave shelter to renowned relics. Thus the faithful came from afar to venerate the veil of the Virgin in Chartres or to pray to her image in Rocamadour. Pilgrims flocked to Lucca to contemplate an effigy of Christ that, according to legend, had been sculpted in part by otherworldly hands. Others sought out the Magi in Cologne, Saint Vincent in Saragossa, Saint Boniface at Fulda or the archangel Michael on the mount that bears the saint's name and challenges the seas. Whatever their earthly destination, pilgrims were in truth making their way to God, and were accordingly given due respect and protection. They were exempted, for example, from paying tolls on bridges. Since it was a Christian's duty to offer them alms and shelter, almonries and hospices sprang up along the routes they took. And pilgrims could scarcely be mistaken for common travellers: they wore distinctive garments and insignia, and toted a particular staff known as a *bourdon*, on which they hooked a gourd containing their daily ration of water. They carried over their shoulders a *besace* – a beggar's bag with two pouches; when they got home, they would pin to it the small badges they had bought or had been given at pilgrimage centres.

Three pilgrimages were recommended above all others: to Rome, to Jerusalem and to Santiago de Compostela. At the centre of Christendom was Rome, the city that sheltered the tombs of the two founding apostles: Peter, the cornerstone of the Church, and Paul, the first great evangelist. Jerusalem was the symbolic centre of the world, and was so portrayed on maps, even though everyone knew that it lay beyond the confines of Christendom. Compostela too was on the fringes of the Christian universe. At the northwestern extremity of Castile, it was caught between the hostile sea and surrounding Saracen troops. In the tenth century, the tomb of the apostle James the Greater was "found," as legend would have it, in Compostela. The discovery offered a heaven-sent opportunity to launch new attacks against the Muslim invader in Castile.

In the eleventh century, the Church promoted the three great pilgrimages by promising indulgences to those who went on them. Through the granting of indulgences, the faithful were pardoned for their sins and guaranteed a shorter stay in purgatory. But it was with the Crusades that this systematized zeal truly reached its peak: nothing was deemed more righteous than setting off to wrest Jerusalem from Muslim hands. Many never returned from these ultimate pilgrimages, but for them heaven's gates would open wide. In a strictly European perspective, such expeditions offered another advantage, that of thinning the ranks of the newly emerged and often troublesome knightly class.

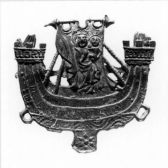

This emblem was pinned to the pilgrim's clothing; two more small pendants could be hung from the rings. Similar badges have been found in England and the Netherlands.

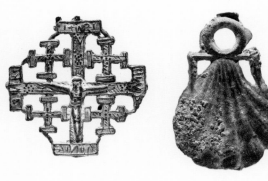

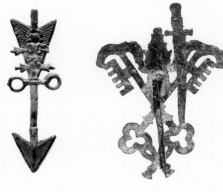

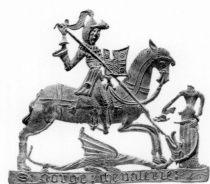

At pilgrimage sites, the faithful liked to collect fragments of relics, such as those said to have been found on the Cross or on Mount Golgotha. They often purchased miraculous water or oil, or gathered modest souvenirs like palm branches from the gardens of Jerusalem, or earth from various shrines. At the beginning of the Middle Ages, ampullae, small terracotta, glass or lead flasks, were designed for transporting and preserving relics.

Another kind of memento eventually appeared – the pilgrim's emblem – a brooch-like badge that the traveller pinned to his hat or clothing as proof of his piety and the success of his pilgrimage. These emblems were made in the shape of the shrines that had been visited or of the relics they sheltered, and were often considered to have healing or protective powers. Between the 12th and 16th centuries, they became so popular that production was expanded to secular emblems: badges of political parties, commemorative insignia, tokens of love, pins in the form of hybrid creatures and so forth.

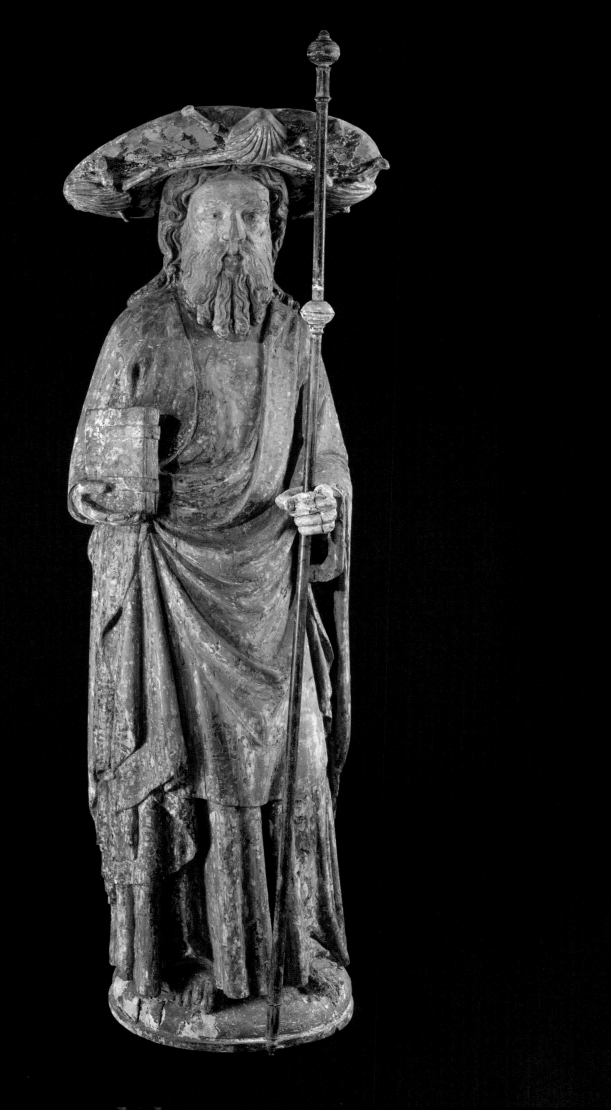

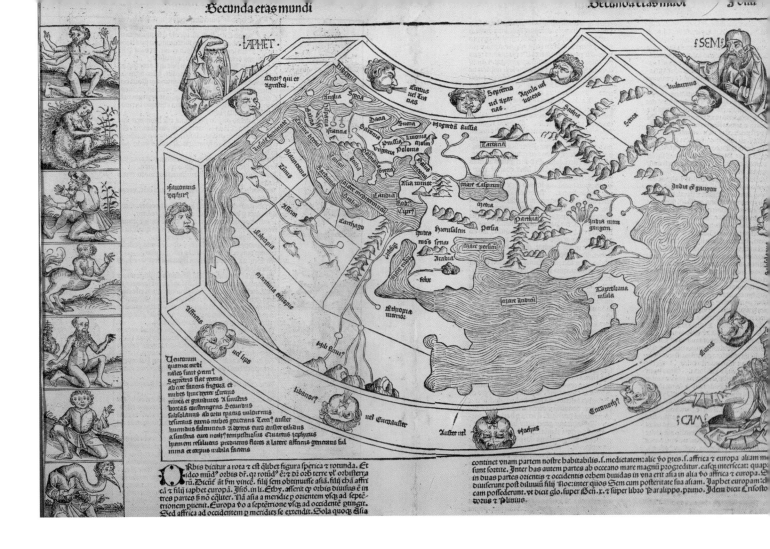

The Valour of Merchants

Thanks to crusades, pilgrimages and deforestation, borderlands were claimed or reclaimed, and the confines of the Western world broadened. As contacts were initiated with Jews, Muslims and Orientals, the medieval conception of space gradually changed. In that respect, the boldest initiatives were those of Italian merchants, notably Pisans and Genoese, who, by the end of the eleventh century, were sailing throughout the Mediterranean to trade in Spain or North Africa.

Around 1200, they adopted a rudimentary kind of compass: a magnetized needle set on a wisp of straw floating in water. Seafarers only used it on rare occasions, at night, for instance, or when bad weather prevented them from observing the position of certain stars. More important was the near simultaneous appearance of sea charts and portolanos, the latter listing the ports and islands that might be found on various routes. Crafted from human experience only, these new tools were of great use to merchants, but would not suffice to transform a world whose abstract representation remained above all cosmographic and theological. While maps and portolanos helped sailors find their way in the unknown world of open water, the sea was still perceived as an element of Creation hostile to man. But as navigational instruments became increasingly sophisticated, the frontiers of the sea were pushed back. By the end of the fifteenth century, men had acquired sufficient skill to cross the oceans and to discover new worlds. ✤

Jerusalem and the Crusades

IN FOURTH-CENTURY JERUSALEM, a church was built over a grave thought to have been that of Jesus; this house of worship would eventually be dubbed the Holy Sepulchre. In 1071, the Seljuk Turks invaded Asia Minor, capturing Jerusalem. The Holy Sepulchre no longer stood on Christian soil. In November 1095, Pope Urban II preached a crusade to "liberate" the tomb of Christ, an appeal that met with immediate success. Feudal lords from Italy and France were the first to answer the call to arms. Following the Pope's counsel, they sewed cloth crosses to their chest and embarked upon a "just war" against the Muslims, "enemies of the Church and of the Christian people," in the belief that they would be rewarded with plenary indulgences.

Led by Godfrey of Bouillon, the Crusaders seized Jerusalem on July 15, 1099. Christian states were established in Palestine and Cyprus, and in areas straddling present-day Iraq, Turkey and Syria. The Templars and Hospitallers, half monks, half knights, were put in charge of their defence. The fall of Edessa in 1144 and the recapture of Jerusalem by the sultan Saladin in 1187 led to the Second and Third Crusades. By 1270, four other crusading expeditions had been organized. Their leadership was claimed no longer by lords, but by sovereigns: kings of France such as Louis VII, Philip Augustus and Saint Louis; an English king, Richard the Lion-Hearted, and a Hungarian, Andrew II; by kings and emperors of Germany such as Conrad III, Frederick Barbarossa and Frederick II. This was not, however, a guarantee of success. No thirteenth-century crusade ever reached Jerusalem. The Latin states of the East slowly crumbled until their last bastion, Acre, fell in 1291.

During the same period, the notion of crusading was applied to groups that hindered or threatened Christian expansionism. At the end of the eleventh century, the kings of Aragon and of Castile launched the *Reconquista*, which would ultimately wrest Spain from Muslim rule. In the thirteenth century, other crusades were proclaimed against the Slavs of Central Europe, the Balts and finally against the Albigensian "heretics."

By the end of the Middle Ages, crusades had become little more than myths. While they might be on everyone's lips, no sovereign would ever again dare to lead one of these expeditions. ∎

The city of Jerusalem, considered to be the centre of the world, is represented in a circular form that symbolizes the perfection of the Heavenly Jerusalem. Also depicted are pilgrims making their way to the Holy City.

Picture of the city of Jerusalem
(© Bibliothèque royale de Belgique, Brussels, Ms 9823-9824, fol. 157r°)

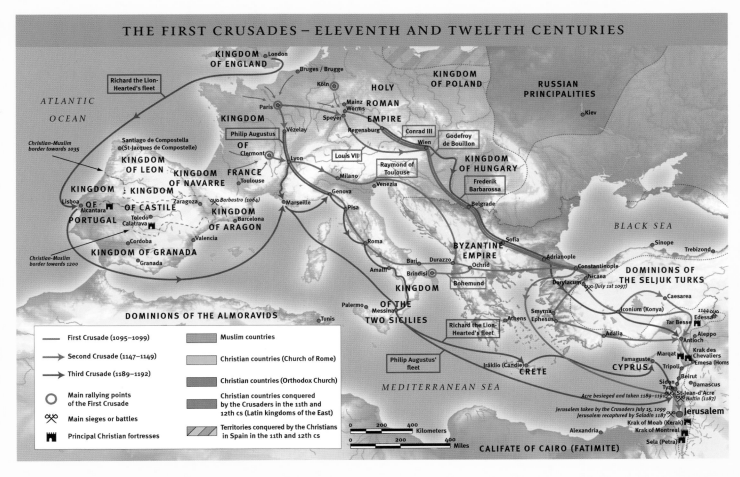

THE FIRST CRUSADES – ELEVENTH AND TWELFTH CENTURIES

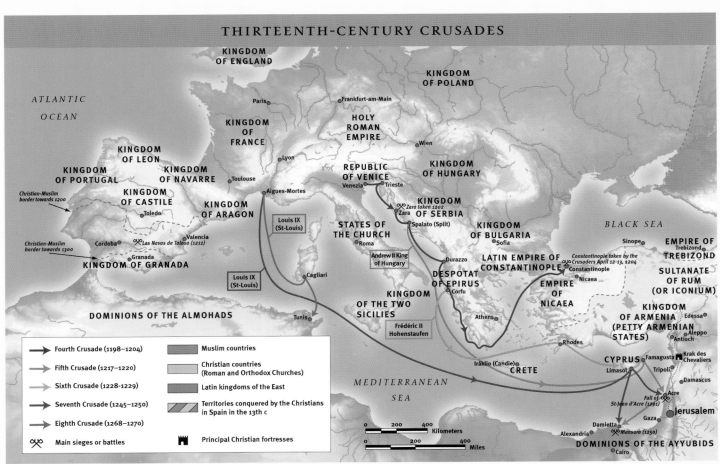

THIRTEENTH-CENTURY CRUSADES

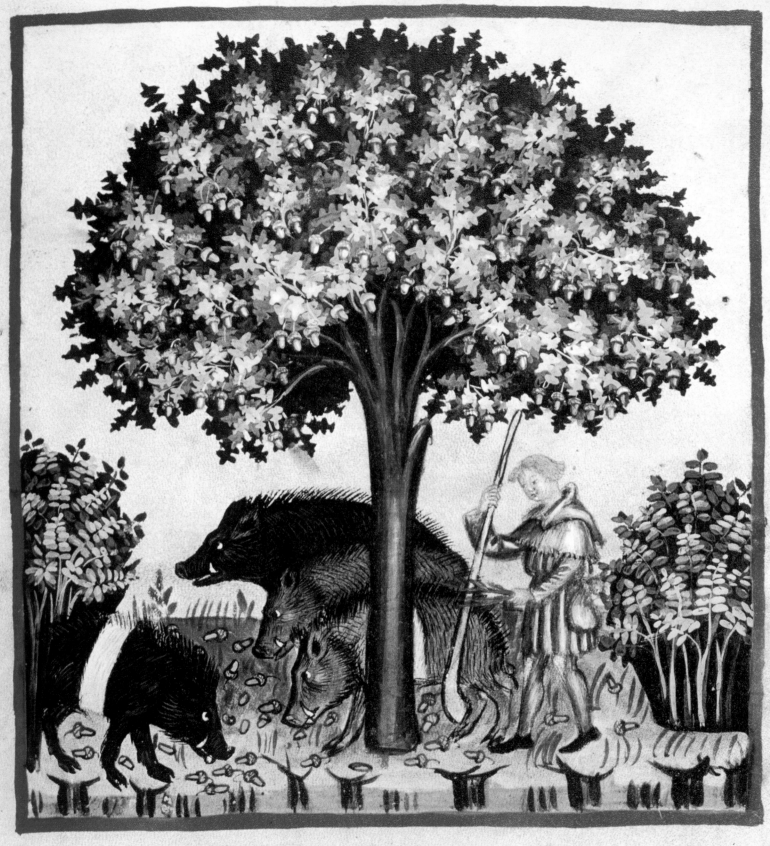

Glandes. ꝯplo. frī. in ꝩ. sic. iuͦ. Electio recētes magne ꝫ plete. uinaȵ, ꝫ fortiꞇ retentiuaȵ.
nocuiͦ. assiduuȵ menstrua. Remo noci si asseṅtur ꞇ comedaṅt. cu zucharo. Qd gñaṅt.
nutimentuȵ modicu. Conuciuṅt. ca. ꞇ hu. iuueṅti. hyeme septentonali.

Land and Peasants

THE MIDDLE AGES WERE RESOLUTELY RURAL. In the twelfth century, about 90 percent of the population lived in the country, a figure that does not take into account the number of people who practised urban agriculture. From a contemporary viewpoint, rurality often seems synonymous with immobility. Yet it was from the rural world that medieval civilization drew its powerful dynamics. Far from the stereotypical image of desolate hamlets where serfs starved under the yoke of an oppressive lord, medieval villages provided peasants with a secure environment that fostered new forms of solidarity among them.

The Birth of Villages

It may seem surprising to state that villages first appeared in the Middle Ages. It could certainly be argued that people have lived in groups and crowded their huts together since the invention of agriculture, some 5000 years before our era. While this is undeniably true, we need an agreement on the precise definition of the word *village*. If it refers to a cluster of houses established permanently in a definite area, houses sheltering a closely knit community of men and women who go to the same church, farm lands together and bury their forefathers in a central cemetery, then it is clear that villages were born in the Middle Ages.

Between the tenth and thirteenth centuries, they emerged at different times in different regions. From Italy to northern Spain, between the years 920–950 and the year 1200, early settlements sprang up around castles. This *incastellamento*, long attributed to fears of Hungarian or Saracen invasions, was in fact not entirely spontaneous. In most instances, it was initiated by secular or ecclesiastical lords eager to extend their dominion to lands or bodies of men they would have no trouble controlling. Many of the hilltop villages common to the Mediterranean landscape date back to an original "encastlement." There is no denying, though, that such hillside settlement brought certain advantages to peasants formerly scattered

*P*easants were granted access to the forest only at specific times, for instance during the October acorn harvest. On such expeditions, they brought with them their pigs, who feasted on acorns and roots. Thus fattened, the animals were ready for slaughter and salting, which took place in November.

FACING PAGE
The acorn harvest
Tacuinum Sanitatis [Portrait of Health], Italy, late 14th century.
(© Österreichische Nationalbibliothek, Vienna, Ms codex 2644, fol. 15r°)

across the plains – notably, light taxation and the protection of a feudal lord, whose dominance they nevertheless had to acknowledge.

Churches also played a major role in the emergence of villages. During the tenth century, old laws promulgated at the end of Antiquity were reinstituted in order to delimit an area of peace around churches. This *atrium* offered Christians sanctuary, temporary reconciliation with their fellow men and, should they be buried there, everlasting reconciliation with God. Abandoning their scattered hamlets, peasants settled near churches. From Catalonia to Flanders, places of worship became the new centre of a rapidly changing society.

Christian Cemeteries

With the advent of villages came a radical transformation of burial practices. The ancient Romans used to bury their dead on the outskirts of towns, particularly along roads, which came to resemble long memorial processions as they approached city entrances. From the third century on, certain Christians chose to be laid to rest near the tomb of a saint so as to benefit from his virtue and more easily achieve salvation. During the sixth and seventh centuries, the custom of digging rows of graves in necropolises spread to many parts of Northern Europe. The tombs were lined up in the middle of the fields, well away from inhabited areas; a small church was sometimes built nearby. From the eighth century on, these necropolises rapidly fell into disuse. A new style of burial was slowly introduced, in which the dead were interred around parish churches. It was only in the twelfth century, however, that this practice became widespread and supplanted all others.

The cemetery eventually became a mandatory, communal and exclusive burial place. No more could one inter a relative in one's house or garden, for he had to lie with his brothers and neighbours in the common earth of the cemetery, which the Church convincingly claimed to be the antechamber to paradise. Shortly before the year 1000, a specific ceremony was established to bless the burial ground. Thus consecrated, its earth could no longer cover strangers or enemies. Jews, heathens, excommu-

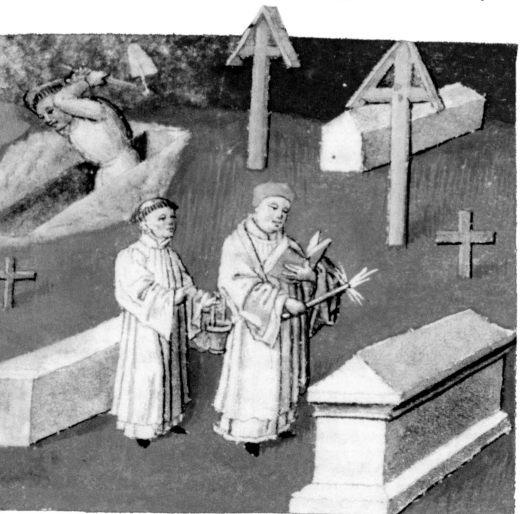

Graves being dug and blessed in a cemetery
Rationale divinorum officiorum
[Rationale of the divine office],
Gulielmus Durandus, 15th century.
(© Bibliothèque municipale de Beaune,
Ms 21, fol. 16 vᵒ)

nicates and heretics could not rest there unless, *in extremis,* they made an act of contrition or otherwise proved that they wished to enter the great family of Christians.

The physical appearance of cemeteries reflected their function. Tombs were rarely identified, for the community took precedence over the individual. At best, they were marked with a small wooden cross topped by a triangular pediment. After a few years, people would forget where the graves were and would dig over them. Because the earth was frequently turned over, the bones of the dead were moved or placed in an ossuary.

Since they formed the heart and memory of communities, cemeteries were also meant for the living. On their grounds, villagers sometimes built houses and occasionally convened to settle disputes, share pieces of news, hold markets or celebrate Whit Sunday. Thus the young, the old and their departed forebears all took part in community life.

Parochial Communities

The gradual formation of Christian cemeteries coincided with the establishment of parochial communities. Here too, agreement on the terms employed is needed, for parishes did exist well before the twelfth century. As early as the fourth century, bishops, who were established in cities, had churches built in rural areas in order to spread Christianity to the countryside. The term *parrochia,* which appeared in the sixth century, referred to such types of Church organization, but there was as yet no clear-cut distinction between parishes and dioceses. Services were regularly conducted in country churches, but bishops maintained a monopoly on baptism. Countryfolk had to leave their land and, in many cases, travel dozens of kilometres to the nearest cathedral to be baptized. The parish was not yet a community.

During the Early Middle Ages, parish churches appeared wherever rural areas had been Christianized. Their numbers soared at the turn of the millennium, a period that also saw the first establishment of villages and community cemeteries. Henceforth, no village was without a parish church.

Parishes were communities of brothers and believers, and their pastors tended the flock to ensure that none went astray. Since they were entrusted with the cure of souls *(cura animarum),* they came to be called curates. Representing their bishops, they administered the main sacraments that marked the significant stages of a Christian's life, and soon became key figures in their villages, leaders and spiritual fathers of parochial communities. To them, in theory, was due the tithe, a tax instituted in late Antiquity to "thank" pastors for their religious services. It was levied on crops at a rate set theoretically at their tenth part, hence its designation as the *decima.*

The Time of the Lords

Settled permanently in villages, gathered into the fold of parochial communities, eleventh-century peasants were also under the jurisdiction of specific seigniories and submissive to the latter's holders: feudal lords known as seigniors.

As medieval Europe witnessed a proliferation of such figures, it would be quite unrealistic to attempt a description of the quintessential seignior in

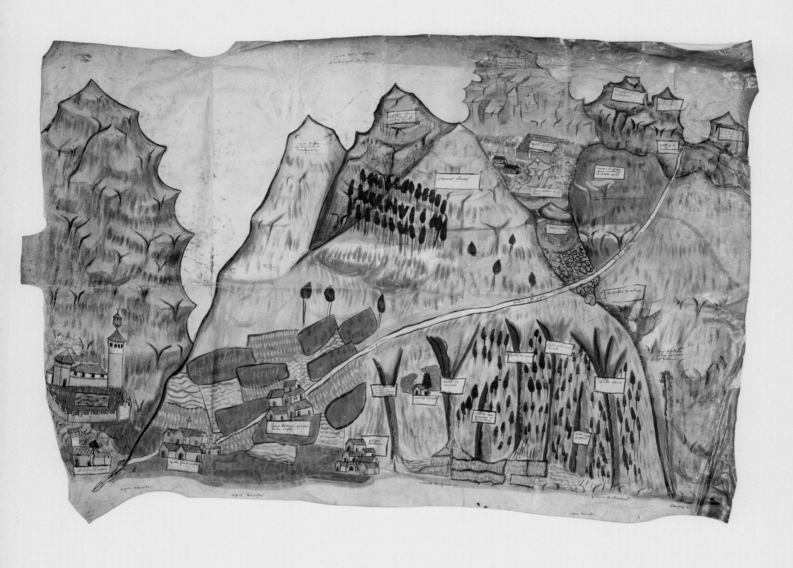

**Diagrammatic depiction of one side
of the Château Dauphin Valley**
Piedmont, Italy, 1422. (Vellum, 100 × 70 cm;
© Archives départementales de l'Isère, B 3710)

**Diagrammatic depiction of the other side
of the Château Dauphin Valley**
Piedmont, Italy, 1422. (Vellum, 100 × 70 cm;
© Archives départementales de l'Isère, B 3710)

*In 1420, border disputes pitted the Dauphin Charles
against the Marquis Louis de Saluces. At issue was
control of the Château-Dauphin and Sampeyre seignior-
ies in the valley of the Varaita River, a tributary of the
Po. This conflict gave rise to one of the first diagram-
matic descriptions (figura debati) of a site, executed here
by a painter. The two views represent the two mountain-
ous slopes rising on either side of the valley.
The name of the lands under dispute, written on
a framed white background, are pasted into the
landscape like road signs.*

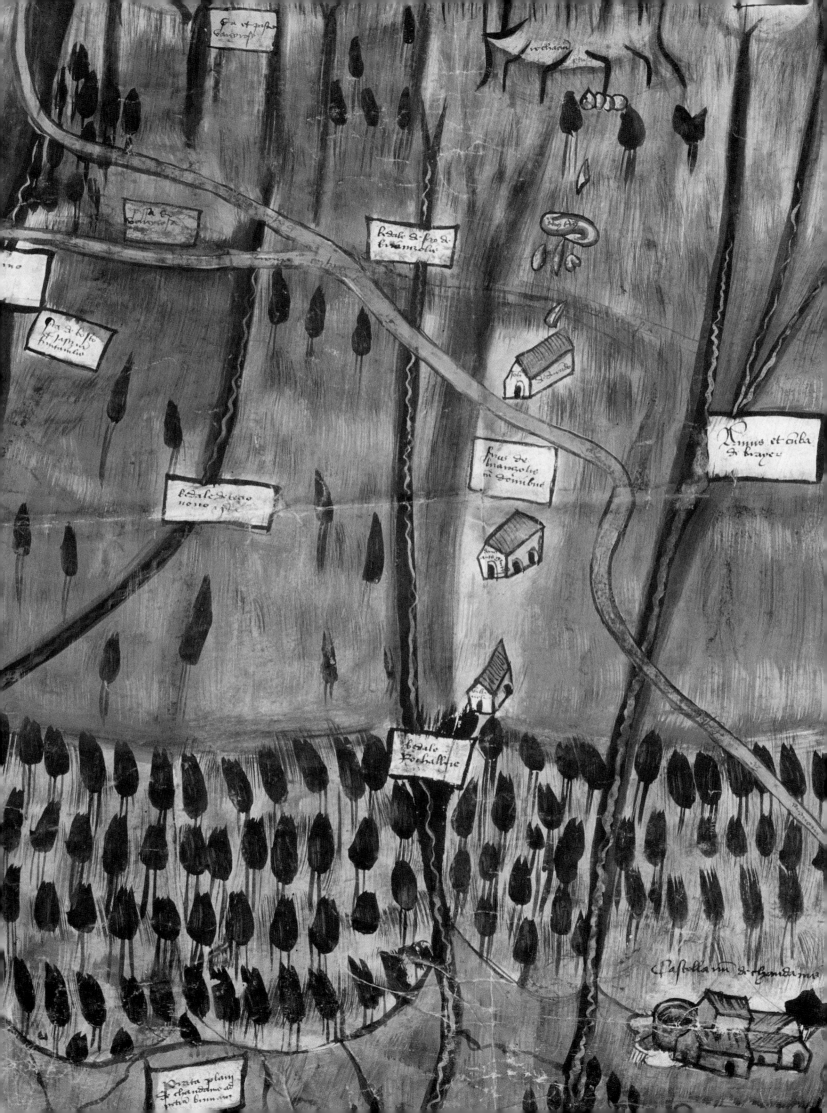

the year 1000. In Latin, a lord was referred to as a *dominus*, since he dominated others in authority, wealth or might; kings, counts or dukes, therefore, numbered among the *domini*. Bishops and monks were also *domini* because they were vested with spiritual and moral authority over the faithful, and had moreover become rich landowners over the course of the Middle Ages. Should a king's officer or a bishop's agent manage to take possession of a large domain, he would be considered a *dominus*. Should a peasant succeed in accumulating more land than his neighbours, he would rise above his fellows. Land was the source of all wealth and all might. To own it was to dominate. And over all men ruled the one, the true Lord, God.

The relations between lords and peasants were based on a contract. The poor farmed lands that did not belong to them and paid fees to the lords, taxes that were sometimes proportional to crops and sometimes set at

Acknowledgement of enfeoffment and homage by Bertrand de la Tour, lord of Olliergues, for the mas (farm) of La Vaissière near Cotteuge
Auvergne, France, 1313. (Parchment, 31 × 40 cm;
© Archives départementales du Puy-de-Dôme,
3 G PS 34; photo: Serge Seguin)

fixed rates. They were paid in kind or in cash, the latter arrangement becoming predominant from the twelfth century on. Peasants were also conscripted for collective labour: they might be required to clean out the ditches of their lord's castle, to repair its walls or to see to the upkeep of various roads. This was part of the *servitium* owed by the weakest members of society to the mightiest. In return, lords had to protect and give refuge to their people in times of danger. Contractual relations followed the circular rhythm of the seasons and of religious feasts. Taxes were often due on Midsummer Day (June 24), Michaelmas (September 29) or Martinmas (November 11), both because these feasts coincided with significant events on the agricultural calendar (harvest, grape picking and harvest's end) and because their celebration was a reminder of the virtues of particularly exemplary saints.

Freemen and Serfs: "Encelled" Peasants

The integration of all farmers into the seigniory led to a certain degree of social standardization. By the first centuries of the Middle Ages, the distinction between freemen and slaves was no longer made in Western Europe.

In the year 1000, admittedly, freemen and those who came to be called serfs were not considered equals. All these men, however, came under the rule of a lord. Serfs had to pay specific taxes such as *chevage*, mortmain and merchet, tokens of their personal dependence on their lord and of the latter's control over their families. Freemen, on the other hand, owed their seignior only host service, which brought them to his side 40 days a year to assist in military campaigns. This difficult and costly service was a heavy burden for freemen, especially when it took them far from their land during the crucial months of May and June. It was therefore not unusual for certain serfs to be more well-off than some freemen.

Finally, in order to adequately portray a medieval peasant, it is much more enlightening to focus on the places where he lived than to dwell on his status. Serfs and freemen alike belonged to a land, a village, a parish, and without quite belonging to their lord, they were most certainly his men. The village, the parish, the seigniory: such were the "cells" of twelfth-century peasants. The "encellment" to which they were subject was less a confinement than an inclusion within communities – communities that promoted varied forms of solidarity; communities in which social relations were modelled on Christian charity or *caritas*; communities subordinated to a lord to whom services were due.

Agricultural "Revolution"

The secure surroundings of parish and village fostered such collective enterprises as clearing land for cultivation, increasing agricultural yields or building new equipment. Seigniorial taxation was usually set at moderate levels and did not put a severe financial strain on peasants. In other words, encellment created an environment favourable to rural development. Combined with these social factors, the climate warming that affected Western Europe between the end of the eleventh century and the middle of the thirteenth century set the stage for major innovations in the domain of agriculture.

Lake Paladru: Horsemen and Farmers of the Year 1000[1]

LAKE PALADRU, near Grenoble, France, is a must for anyone who wishes to know more about daily life in the year 1000. The story begins in 1003, when a colonizing party, most likely assembled by a local bishop, reached Paladru and settled on three separate sites bordering the lake. As the lake's waters rose gradually during the 1030s, the colonists were forced to retreat from the shore and abandon their communities. They gathered up their valuable tools, stripped their houses of basic building materials, and left behind objects that had been lost over the years or simply discarded after use. These artifacts have been buried under water for the last millennium because the water level of Lake Paladru never again dropped to that of the year 1000. This explains their extraordinarily good state of preservation, as well as the durability of certain materials that, under other circumstances, would not have withstood the ravages of time. For more than thirty years now,

archaeological excavations have been contributing to our knowledge of these vanished communities.

The people of Paladru were both horsemen and farmers: while they relied on agriculture, animal husbandry, fishing and craftwork as sources of livelihood, they also knew how to ride their mounts in battle. Their settlements point to a period when villages were not yet established in fixed locations, to a time when lords did not yet live in castles, but on fortified farms. There was no church or cemetery on any of the three Paladru sites, only thatched wooden houses surrounded by palisades and clustered around a larger central building.

The settlers seem to have engaged in a wide range of activities to ensure the group's autarchic subsistence. They used mixed farming systems, and raised mainly cereal crops, as indicated by tools found by archaeologists: sickles, billhooks, pruning knives, pickaxes and pruning hooks. Essential articles such as nailed

horseshoes, knives, hooks and weapons were forged in the settlement itself, evidence that metalworking and smithery were well-known crafts. Woodworking was highly developed, and put to use in the making of utensils, construction materials, tool handles, casks and barrels, chests and combs. The number of pig, cattle, goat and sheep remains that have been recovered leaves no doubt as to the practice of animal husbandry. Judging by the profusion of spindles salvaged from the water, weaving must have been a common activity, as was leatherworking for making clothing and shoes. Finally, the discovery of musical instruments and of pawns used for chess or backgammon suggests that these horsemen-cum-farmers enjoyed not only various kinds of amusements but also a relatively high standard of life. ∎

1. This text draws on M. Collardelle and É. Verdel, *Chevaliers-paysans de l'an mil au lac de Paladru*, Musée dauphinois de Grenoble, 1993.

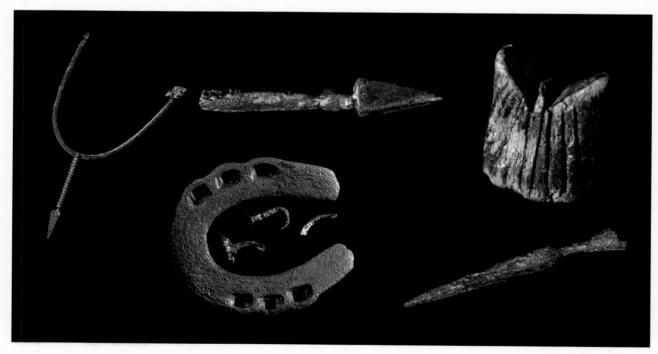

LEFT TO RIGHT

Spur, tip of a spur, castle (for playing chess), horseshoe with its nails and arrowhead
(18.7 × 10.9; 6.7 × 1.3; 3.7 × 2.8; 10 × 9; 6.5 cm; Musêe Dauphinois, Grenoble, 90.14.236, 91.33.9, 88.16.139, 74.51.203, 74.51.208 ; © Patrimoine d'Isère; photo : Yves Bobin)

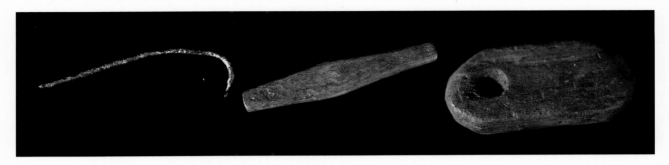

Fish-hook, fishing net floater and fishing line floater
(3.9 × 0.6; 6 × 4; 1.4 × 2.8 cm; Musée Dauphinois, Grenoble, 4258, 88.16.843, 88.16.700;
© Patrimoine d'Isère; photo: Yves Bobin)

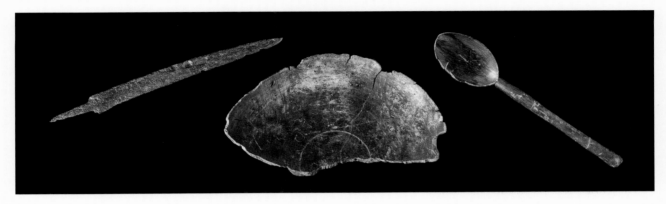

Knife blade, fragment of a dish and wooden spoon
(29.4 × 2.8; 27.5 × 5.2; 33.8 × 6.9 cm; Musée Dauphinois, Grenoble, 5324, 90.14.167;
© Patrimoine d'Isère; photo: Yves Bobin)

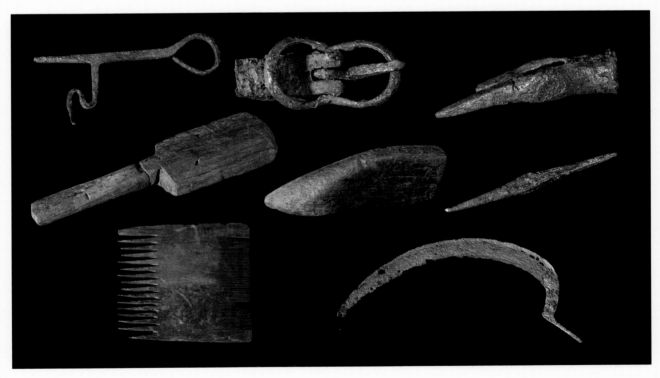

Key, spur buckle, head of a hammer, beetle, shoetree, spindle, comb and sickle
(10.6 × 4.1; 4 × 1.8; 9.8 × 2.5; 35 × 8.9; 23.6 × 6; 21.1 × 1.4; 11.4 × 10.7; 33 × 13.5 cm;
Musée Dauphinois, Grenoble, 87.16.187, 88.16.7, 88.16.608, 88.16.770, 89.50.343, 97.79.41, 86.21.41, 74.51.205;
© Patrimoine d'Isère; photo: Yves Bobin)

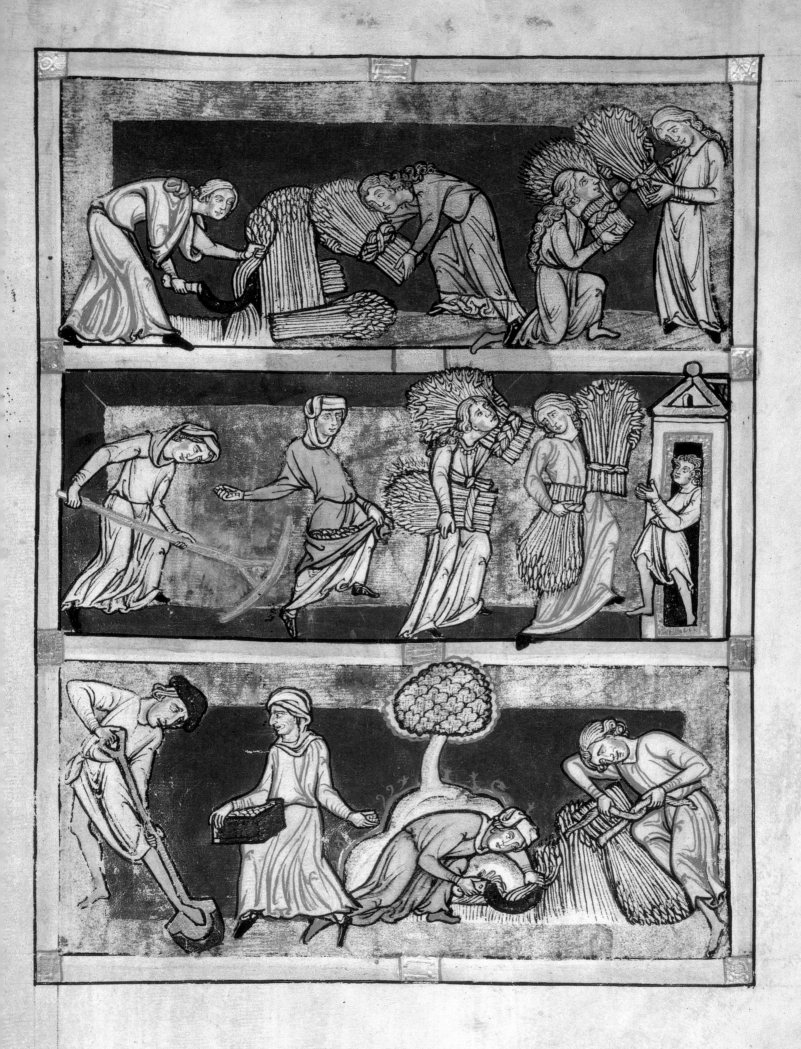

The most noteworthy advances had to do with ploughing techniques. The swing plough, which worked the soil before sowing, was widely used until the year 1000. It was a rudimentary implement made up of a wooden handle, which a ploughman would grasp, and a beam to which was fixed a share made of wood hardened in the fire or coated with iron. While this tool proved adequate for digging furrows, it did not loosen the soil deeply enough to aerate it. There are many indications that the wheeled plough appeared in Europe as early as the eleventh century and was then gradually adopted throughout the Middle Ages. Its technological superiority was based on three innovations: wheels, which doubled traction efficiency; a mouldboard and skewed share used to turn over the soil; and finally a coulter, a vertical blade placed in front of the share to cut roots. The swing plough remained in use in arid regions and on rough terrain, but henceforth it was the wheeled plough that characterized the medieval peasant, as witness its numerous depictions in murals or manuscripts.

Workhorses replaced oxen because they were faster. Farmers also found new solutions to the problem of their animals getting winded or injured: to draw the plough, several pairs of beasts were harnessed in line. The stiff collar to which the bridle was fastened appeared in the eighth century and in the tenth century spread throughout Europe so that horses were no longer choked by their harnesses while hauling loads. By the eleventh century, the nailed horseshoe, apparently introduced in Siberia in the ninth or tenth century, was used throughout the West. This meant that horses had greater endurance and assurance no matter what kind of ground they had to cover. Still, draught-oxen did not became a rarity, as they were often less expensive than horses. Their harnesses were also improved, as the withers yoke gave way to the head yoke.

Fertilization was limited to the use of manure and slash-and-burn techniques, but cultivation methods were considerably improved. The most significant advance was undoubtedly the introduction of three-year crop rotation. Over a three-year period, a plot of land would be sown first with winter and then with spring wheat, and would finally be left to rest, to lie fallow, that is, so as not to exhaust the fertility of the soil. The system was first applied in the ninth century on the rich soils of Northern Europe and was widely implemented in the thirteenth century.

"Industrial Revolution" in the Countryside

New needs in agriculture, particularly concerning the forging of horseshoes, coulters and shares, combined with the demand for weaponry created by the knightly class, led to the development of metallurgy and, in particular, of steel and iron working. There was a boom in the exploitation of iron, tin and lead ores. New deposits were mined and large stretches of forests were cleared to provide fuel for these industries.

The most remarkable innovation, which appeared at the end of the twelfth century, was the joint use of the forge and of hydraulic power. By connecting

Horseshoe
14th–15th century. (10.5 × 11 cm;
© Museum der Stadt Regensburg;
photo: Peter Ferstl)

FACING PAGE

Harvesting scenes
Speculum Virginum [Mirror for virgins],
Germany, ca. 1190, (© Rheinisches Landesmuseum,
Bonn, Inv. no. 15328)

a heavy hammer to a millwheel, which was set in motion by water pressure, medieval man invented the water-powered triphammer, which replaced such techniques as working metal on the anvil or trampling wool underfoot. More and more fulling-mills were built along rivers, and if necessary, water flow was increased artificially to drive millwheels. Water would not be the only source of power for mills for long, however. Windmills, known to the Arabs as early as the tenth century, appeared on both sides of the English Channel shortly before 1200 and eventually covered the Continent.

This listing of medieval advances in agriculture and industry might create the impression that those fields had been swept by radical change, if not by revolution. Such a notion must however be qualified. While there were undeniable breakthroughs, they hardly amounted to a revolution because, important as they were, technical innovations did not lead to a disruption of social structures. Cereal yields are estimated to have tripled between the ninth and thirteenth centuries, but they were still ridiculously low when compared to present-day standards. The average yield seems to have been somewhere between 3 and 7 to 1, that is to say 3 to 7 grains reaped for each one sown! Whether they were due to bad weather or pests, food shortages and famines remained constant threats.

Depiction of a windmill
Roman d'Alexandre [Romance of Alexander], workshop of the Flemish illuminator Jehan de Grise, 1338–1345. (© Bodleian Library, University of Oxford, MS Bodl. 264, fol. 81rº)

Bread

Agricultural and industrial innovations may have affected modes of production, but they had little impact on the choice of crops or on dietary habits.

Cereals remained the dominant crop. They were commonly known as corn or wheat, even though these generic names conflated several bread-making cereals that are now classified separately. Thus the term "winter wheat" was applied indiscriminately to spelt, common wheat, barley, rye, millet, eryngo and sorghum, while "spring wheat" referred essentially to common wheat and oats.

The typical meal of a medieval peasant was based entirely on cereal grain, made into bread, pancakes or porridge. The finest bread was baked from common wheat, but if that ingredient was lacking, people made do with oats, spelt, barley or rye, sometimes in combination. Their bread was most often some shade of beige, grey or brown, not white.

Bread became a staple in large part because of its symbolic value. Consecrated bread was the body of Christ and the cement of the Church community. By sharing bread with family, neighbours or fellow parishioners, people showed that they belonged to the same community. Bread also became the focus of hierarchical relations and conflicts, since lords levied taxes on the use of mills and bake ovens. While cereal pancakes might be prepared at home, bread had to be baked in a community oven, known as the seigniorial oven, on which a lord exacted taxes. Villagers socialized at the seigniorial oven much as they did at the local tavern, heading there, for instance, to hear the latest village news. Thus peasant revolts often started in its vicinity.

During the Middle Ages, as in the modern era, bread was therefore much more than a simple food. It was the symbol of a fraternal community: a religious community bound by the taking of the body of Christ, and a lay community in which bread symbolized friendship and brotherhood.

Wine

Fraternal communion would be imperfect if the bread was not accompanied by wine. In church, wine was the blood of Christ, the necessary complement to the consecrated host; at the table, it was served with every meal; in taverns, it flowed freely. Consequently, wine-growing was as important as cultivating cereals. Grape vines were grown well beyond the southern limits of cultivation where the climate was favourable to producing adequate crops.

Moreover, cultivation techniques were far different from those prevailing today. Since different types of grape were grown together, each variety

ripened at a different time. Manual cultivation precluded the use of ploughs or draught animals, and the soil was enriched only with small amounts of manure. Young vines were particularly fragile and had to be regularly replaced by vine shoots, which were buried in the ground with the hope that they would grow back the next year. Predictably, the yields were very uneven.

Vinification methods were rudimentary. The wine made was very low in alcohol and turned to vinegar after a few weeks. It was diluted with water or flavoured with spices to improve its taste, for in towns or villages, in southern or northern Europe, taste was considered secondary to year-round availability.

As the art of viticulture was as yet unknown – and its practitioners unborn – each man made his own wine. This did not impede the development of an extremely dynamic and lucrative wine trade. At the local level, wine was sold at markets that supplied towns where production was poorly developed. Sales were subject to strict control. Since the *banvin* gave the seigniorial class the right to sell its own wine ahead of that of any competitor, merchants could only offer their products during periods dictated by lords.

Nobles depended on large-scale trade to bring a measure of distinction to their tables. Kings and princes encouraged the trade in wine, provided it was produced in lands under their rule, and they tried to outshine one another by serving their guests vintages from different regions. At the end of the Middle Ages, then, wines from Bordeaux started to acquire an international reputation thanks to the kings of England, as did Burgundies, thanks to the dukes of Burgundy, and those from the Loire valley thanks to the kings of France.

Beans, Roots and Woad

Before the introduction of rice in the thirteenth century and that of potatoes in the sixteenth century, beans were the most common starchy food in Europe. They were prepared in any manner of ways, mixed into soups or pancakes, cooked in fat or water. Many other legumes are mentioned in late medieval culinary treatises, but little is known about the extent of their cultivation. Anything growing underground was called a root, whether it was a carrot or a turnip. The name "gourd" was applied to all cucurbitaceous plants, from gherkins to melons to pumpkins, while "herb" referred to any variety of lettuce.

When fields were not planted with vines or with subsistence crops, they were sown with fibre plants. From hemp and flax were manufactured most of the commonly used fabrics, such as linen. Wool production targeted a clientele made up essentially of burghers and nobles, while cotton, made in the Orient and in lands south of the Mediterranean, remained a luxury item throughout the Middle Ages.

The thirteenth-century introduction of woad, also known as pastel, brought considerable change to crop distribution.

Because wine was used in the celebration of the Eucharist to represent the blood of Christ, the cultivation and harvesting of grapes acquired a profoundly symbolic value. In this 11th-century Spanish illumination, by painting Christ with a billhook in his hand, the artist portrays him as the Father of Farmers. Nearby angels harvest grapes and wheat, another eucharistic symbol, consecrated bread being the body of Christ.

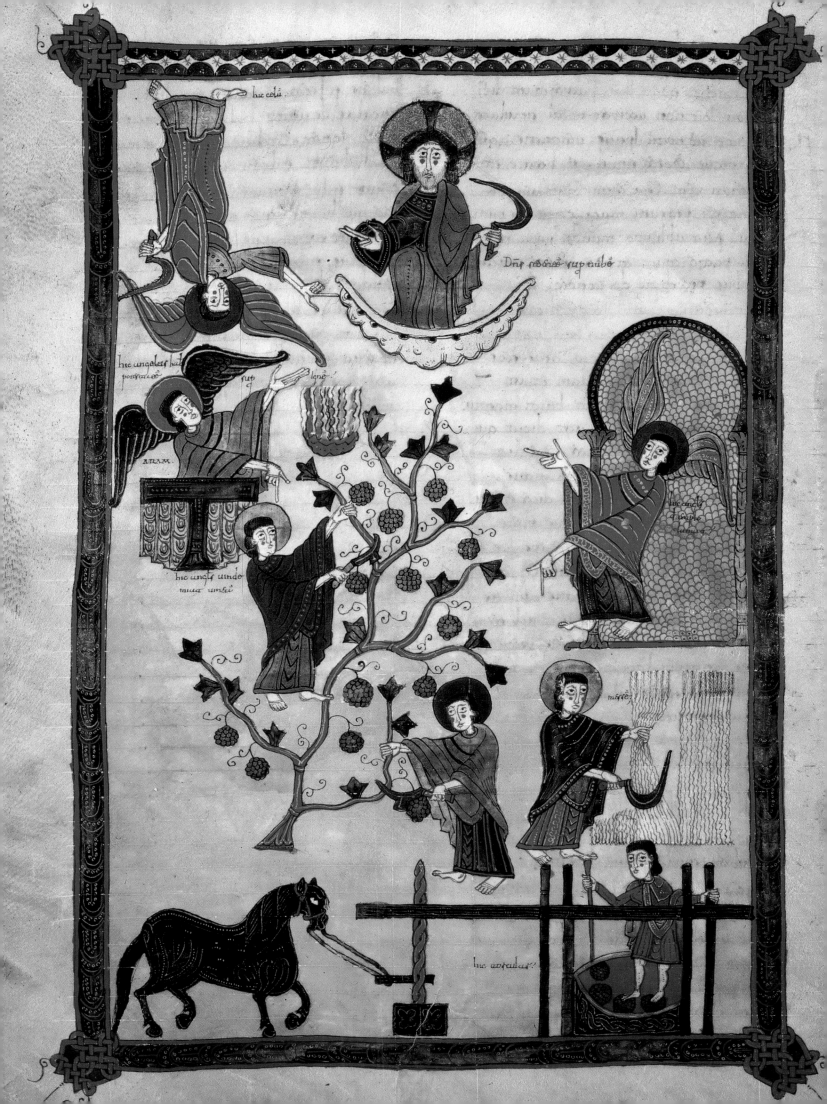

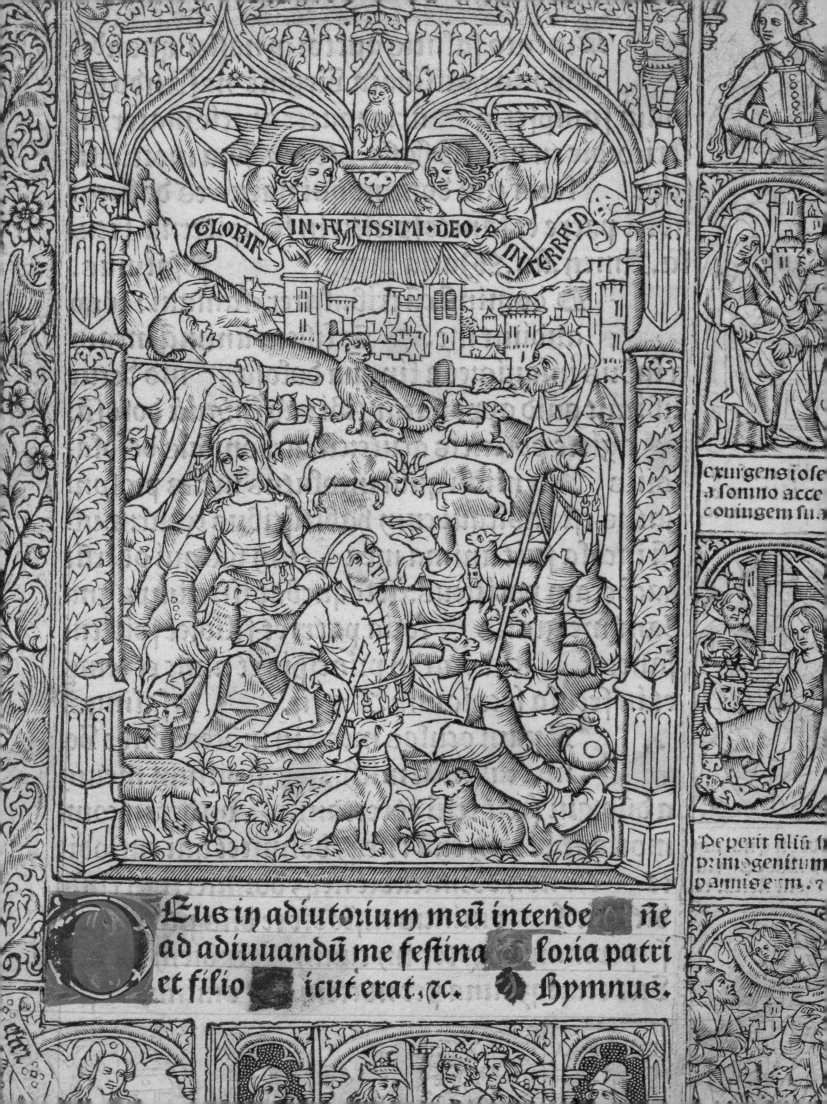

It was soon widely cultivated both because it could grow in unfavourable environments and because blue became a very fashionable colour. After harvesting, woad leaves were ground, kneaded, fermented, crushed and sieved to obtain a dye ranging from mauve to blue-black in colour. Expensive and rare minerals such as lapis lazuli were no longer needed for making blue pigments.

Utilitarian Animal Breeding

Most medieval farmers bred animals as well. Cows, hens, sheep, horses, oxen, bees: all were valuable in one way or another.

Throughout the Middle Ages, horses became more and more indispensable, whether for farming the land or for hauling heavy loads. They were also a means of transportation for the powerful and an essential part of the institution of knighthood. Peasants with more modest means continued to use oxen as draught animals in their fields and on roads. Cows were reared for their leather, milk and meat. Veal was not a common food, but should a calf meet an accidental death, its owner would undoubtedly cut up the carcass to recover its hide, for calfskin was a precious commodity used for making parchment. Sheep were bred mostly for wool. Since peasants seldom had the means to buy very many animals, they often entered into livestock leases in order to raise sheep. Under such an arrangement, the lord would supply the greater part of the flock and the peasant would tend it for several years. When the lease expired, the growth – the number of calves born during the term of the lease – was divided between both parties. After shearing, the untreated wool was sold locally before being forwarded to major trade centres where it could reach international markets. Most of the profits from sheep breeding therefore went to lessors of flocks or to the merchants who supplied wool to markets and fairs.

Every peasant family had some poultry, raised for their meat and eggs: hens, geese, turkeys or roosters, which were most often castrated to provide highly prized capons for princely tables.

Pigs were no ordinary farmyard animals. They were raised as extensively as poultry, but in a far more ritualized manner. Every autumn, peasants led their pigs into the forest, taking advantage of a seigniorial privilege that authorized occasional community use of the woods. There the animals feasted on acorns and roots. By November, they were ready for slaughter, which was a vital part of the peasant calendar. The meat was salted or smoked so it would keep until the following autumn. Salt pork was added to soups on feast days, but never during Lent or on the eve of religious festivals. Salted and smoked hams, which were particularly prized, were saved for special occasions. Of course they were greatly coveted, as is shown by the numerous fables that tell of hams being pilfered from cottages or inns in the depths of night.

In villages and towns, pigs also made an invaluable contribution to street-cleaning. They were allowed to roam freely, to the great displeasure of priests who resented their occasional forays into churches. But since they were such useful creatures, they were generally left in peace.

FACING PAGE
The Annunciation to the Shepherds
Livres d'heures à l'usage de Rome
[Book of Hours for the use of Rome],
Philippe Pigouchet for Simon Vostre, printer,
Paris, ca. 1500. (Paper, © Musée de la civilisation,
dépôt du Séminaire de Québec)

A Symbolic Bestiary

Like all of God's creatures, animals were mirrors in which people tried to decode the mysteries of Creation. Each beast was associated with symbols, vices or virtues recorded in bestiaries. In those volumes, eagles were portrayed alongside roosters, lions, elephants and unicorns – animals with which Europeans were familiar or fabulous beasts drawn from the descriptions or myths of Antiquity. Bestiaries established a veritable animal hierarchy, with each species an element in a puzzle. To piece together that puzzle is to understand the value system of medieval Christian society.

Lambs and sheep were at the top of the symbolic hierarchy of domestic animals: was not Christ the "Lamb of God," a willing victim to sacrifice? Metaphors centred on the lamb were legion. The faithful were known as "the flock" and their guides, the priests, were referred to as "shepherds" or "pastors."

On rare occasions, the nanny-goat was associated with Christ, but most often was depicted as an evil creature. All the sins of the world were laid on the head of the billy-goat, which was often linked with the devil. Though the eagle was a bird of prey, its rising so high toward the sky while staring straight at the sun brought to mind the Ascension of Christ. Thus it became the symbol of Saint John the Apostle, whose writing opens with a call to turn one's eyes towards the heavens.

The bee was feared for its sting, but revered for its virtues. Since people knew nothing about the reproductive process of bees, they imagined it to be chaste. The hive therefore offered an ideal model for the Church and the monastery. The perfect harmony that characterized the community of bees was deemed admirable, as was their being ruled by a queen – who was mistaken for a king. So high was this regard that several sovereigns adopted the hive as a symbol of their realm. Beeswax acquired unprecedented value and prestige. It systematically replaced oil for church lighting, it was cast into moulds and engraved to make seals representing individuals or communities, and was even shaped into figurines used in witchcraft. The bee brought the symbolic bestiary into the heart of society: bee-keeping was valued both because it provided honey, an essential sugar, and because it was invested with the nobility of pure and chaste generation.

The Organization of Villages: Culture and Nature

The rural landscape was methodically structured to meet the needs of agriculture and breeding. Each village had a commons – a tract of land that all villagers could call their own. Like every organization of space and society, the commons was structured by the opposition and complementarity of centre and periphery.

The *ager*, the cultivated zone, was only steps away from peasant dwellings. The further one strayed from the centre, the deeper one entered the *saltus*, the wilderness. The passage from *ager* to *saltus* was progressive. On lands closest to houses, intensive mixed farming systems were used for raising staple crops. In these parts, fields were well irrigated through the harnessing of

springs or the diversion of rivers, crops were frequently rotated and land seldom lay fallow. Beyond lay a second circle of less intensive crops such as winter cereals, hemp or fodder legumes. Fruit trees, usually planted still further away, bordered an outlying area where most of the land lay fallow, aside from a few crops that required little care.

After that came the *foresta* – to the medieval mind, the untamed wilds. Everything beyond the inhabited and cultivated lands was the *foresta*, which of course included woods, but also moors and swamps. Looming on the periphery of all things familiar, the "forest" was perceived as a perilous place from which only harm could come. For it was in the woods that the devil sometimes roamed, and there too, no traveller could hope to be spared the most fantastic encounters or shielded from the revelations spewed by monsters or madmen. Because it lay beyond the confines of the ordinary world, the forest was the ideal refuge for secret lovers like Tristan and Isolde or outlaws like Robin Hood.

Nevertheless, it was an essential source of life. It supplied timber for construction, wood for fuel, berries and mushrooms, which were welcome additions to the medieval diet, wild honey, bark used in tanning and resin for torches. Anyone would covet its riches, though villeins, of course, were well advised to stay away from the woods outside the permitted times. Felling trees, picking fruit and hunting were controlled and subject to taxation.

On the whole, forests were the domain of the masters of society, of lords, for instance, who went there to hunt. Hermits – monks who followed the harshest of self-imposed rules – would settle there to test their mettle. By conquering the forest, by bringing it under their control, men showed they could stand up to the forces of evil. Often they cleared the land so as to reclaim it, and to gather timber for construction or industry or, just as significantly, to demonstrate their ascendancy over space and nature. Between the eleventh and thirteenth centuries, more forests were cleared than during all the centuries that came before or after.

The Ambivalent Uses of Water

Like the forests, water played an essential role in rural development. Because it was a basic necessity, settlements sprang up near rivers, lakes or groundwater. Springs were harnessed to provide villages with running water for laundering or for driving millwheels. Wells were a common feature of the rural landscape, and when geological or topographical conditions precluded their being dug, cisterns were built to collect rain water.

The water thus secured was put to many uses. People drank it, of course, though usually not before boiling it. Water irrigated the soil where plants and vegetables were grown, it powered mills and flowed into the workshops of tanners or parchment makers.

The Christian Church invested water with the power to purify, borrowing the concept from Jewish and pagan traditions. It was therefore part of many rites, such as the initiatory sacrament of baptism, which up to the Carolingian period was administered by waist-high immersion in a tub and thereafter by sprinkling water onto the forehead and limbs. It was from this sacrament that the knightly class derived its own inaugural rite, the dubbing ceremony. The Church promoted unremittingly the ritual cleansing of hands before meals, and while monks were averse to any form of personal hygiene – which could lead so easily to lecherous practices – they regularly practised ritual baths, thereby achieving greater purification than cleanliness. These baths were recommended on the eve of great religious feasts such as Easter, Whit Sunday or Christmas.

No one questioned the benefits of water harnessed by man, indeed "Christianized." Where water flowed wild or open, though, it inspired dread. Navigation on rivers or seas was poorly mastered during the Middle Ages. Despite this handicap, merchants began braving the seas as early as the twelfth century. Such valour was uncommon, however, in the countryside or in ecclesiastical circles. Bathing was unheard of, and hardly a soul knew how to swim. Most men would rather ford a river than cross it by boat or bridge, especially because tales abounded that described the devil appearing on a bridge and casting travellers into the waters.

This ambivalent attitude towards water gave rise to customs that remain unfathomable to modern observers. As it was transparent and purificatory, water was seen as the vehicle of truth. Trials featuring cold or scalding water, known as water ordeals, were carried out in Europe until the seventeenth century. The suspect was plunged into cold water, bound hand and foot. If he floated to the surface, he was guilty; if he sank, he was innocent. Or a presumed culprit might be forced to immerse his arm in boiling water. His scalds would be scrutinized three days later: if they were on the mend, he was pronounced innocent.

The Miracle of Fishes

The status of fishing and of fish was also predicated on the symbolic wealth of water. To nobles fell the command of wild waters, in much the same way that the forest became their preserve. From a river's source to its estuary, various lords levied taxes on water supplies, fishing and crossings. Fish, born and formed in this purifying element, were regarded as chaste

creatures and their flesh was not considered to be meat. People were encouraged to eat fish on fast days, during Lent, for instance, or on the eve of the great festivals. By extension of a monastic custom, the faithful were also obliged to fast on Wednesdays and Fridays, refraining from eating fatty foods and replacing meat by fish. Fish was eaten on Friday because on that day the Lord had been crucified, and the fish was associated with Christ in many ways. Like him, it rose out of darkness to go towards the light. From the letters in the Greek word for fish, *ichthys,* was formed an acrostic standing for "Jesus Christ, God's Son, Saviour." As *ichthys* evoked Christ, the eating of fish had certain similarities to the Eucharist. Monks therefore made it their duty to eat fish frequently and, thanks to the fishponds they put into their monasteries, never lacked the food that ensured their communion with God.

Peasant Housing

Back, now, to a typical village in the year 1000. Its houses were makeshift: low-roofed and sometimes half-buried in the earth, they sheltered both peasants and farm animals. They had but one door, and only a flimsy partition separated the cowshed from an all-purpose hearth room. Openings were few and narrow, because they dissipated what little heat the fireplace generated. Moreover, since people spent the better part of the day outdoors, returning to their homes only to eat and sleep, lighting was not really a problem. Peasant huts were thick with smoke and pervaded with the pungent odour of animals, humans, simmering soup, drying ham and more or less fresh straw heaped on the floor as litter – that is, bedding.

These structures were upheld by wooden posts; the walls were filled with a web of branches thickly covered with a mixture of loam and straw, while the roof was nothing more than thatch resting on a simple frame. Stone was most often saved for constructing the lower parts of houses, as was brick, which was frequently used in regions with clay soil. The basic principle of such construction was to build a light house, whose materials could be used again should the occupants decide to settle elsewhere.

The permanent establishment of villages and parishes brought significant if gradual change to the countryside. Stone became a common building material, first adopted by the rich but soon used by a large proportion of the population. The extraordinary upsurge in the construction of churches and castles led to the exploitation of new quarries. Soon these excavations lay at the gates of every village. The poor obtained crude but nonetheless useful building materials when fields won from the forest were cleared of stones for cultivation. Stone walls were solid enough to support roof tile, and its manufacture stimulated local crafts.

Terrine (*cuenco*)
Paterna, Spain, 14th century. (Earthenware, 13.5 × 6 cm; © Archivo Fotográphico. Museo Arqueológico Nacional de Madrid, 60478)

Stone construction gradually changed the interior layout of houses. While human and beast still dwelled under the same roof, living spaces became more specialized. A separate bedroom was slowly introduced next to the hearth room, and urban-style houses boasting more than one floor made their first appearance. The fire, which was constantly tended by women, remained the only source of heat and the place where all meals were prepared. With stone construction, however, chimneys could be recessed into walls; they provided a much better draught than central hearths, whose fires, poorly drawn into a small hood cut into the roof, filled rooms with smoke.

A Matter of Comfort

Despite these improvements, peasant houses provided a degree of comfort that very few of us would find even tolerable. Furniture was reduced to the bare minimum. A table was essentially a movable board set on trestles at mealtimes. In the best cases, beds were wooden chests filled with straw. Most often, though, entire families slept in a litter laid on the floor. Indeed, though bedrooms were slowly being introduced as separate chambers, most litters remained communal. Parents slept in the same bed as their children until the latter reached adolescence, if not adulthood. Up to the end of the Middle Ages, this practice elicited numerous remonstrances from bishops, who were concerned less by this crowding that none found offensive than by the risk that infants might be smothered during particularly energetic bouts of parental lovemaking.

Seating consisted of benches and of stools with three oblique legs. Clothes were kept in a wooden chest that was often a family's most valuable movable property. Utensils were put away on the bare ground or in recesses in the walls, or hung on nails.

Crockery was neither varied nor opulent. At the turn of the millennium, peasants used rudimentary dishes made of

The name of this vessel (aquamanile), used for washing the hands, is derived from the Latin words aqua, water, *and* manus, hand.

wood or terracotta that had been shaped on a potter's wheel. Pottery was crude, most often grey, unglazed, devoid of decoration and barely diversified. Big pots sufficed for cooking the daily gruel, jugs held all manner of liquids and wooden trenchers were used as serving platters. Various foodstuffs were ground in stone mortars. Platters, bowls and spoons were often crafted from wood; with knives, they were the main individual utensils.

As aristocratic lifestyles spread to the countryside, more attention was given to household comfort, as shown by a variety of gradual changes that occurred from the thirteenth century on. Tableware was set apart from cookware. Glazed pottery became common, finer pastes and forms were used, and painted or incised motifs were introduced. Household items previously rare or unknown became familiar: iron or pewter frying pans, dripping-pans for collecting meat juices and making sauces, ewers for washing the hands. Glass, used by the Church and nobility, remained a rarity in the countryside, and forks would not grace the peasant tables of Europe until the eighteenth century. Of all the utensils available, medieval man favoured his fingers.

Families

In the year 1000 as in the fifteenth century, peasants lived with their kin, sharing their home with two or three generations of family members. In only a very few regions did all the descendants of a common ancestor live together, forming what was called a founding family.

Marriage was both a family and a community affair. Finding a wife involved considerable effort, if only in travel. To avoid intermarriage and also to strengthen rural bonds, young men would visit neighbouring parishes in search of wives, whom they often met at markets or villages fetes.

Once married, a couple was independent, provided, of course, that they had the means to build a house, purchase some livestock and acquire some land. A man had to make provisions for his daughter's dowry, whether he wanted to marry her off or send her to a convent, for taking vows was considered a woman's chaste marriage with Christ. Dowries consisted of movables, money, cattle, utensils, clothes and occasionally a parcel of land, but they only came into a couple's possession after the death of the bride's father. In turn, upon the death of her spouse, a women recovered her dowry in full, managed the family property and was granted the rights her husband had held.

BELOW, LEFT TO RIGHT

Oil lamp
14th century. (Terracotta, 4 × 14 cm;
© Museum der Stadt Regensburg;
photo: Peter Ferstl)

Ladle
Hambraine, Belgium, 15th century.
(Bronze, 27.5 × 30.5 cm; © Musée des Arts anciens
du Namurois, Société archéologique de Namur
coll., Inv. no. 62; photo: Guy Focant, Vedrin)

Close-knit communities

Beyond family ties, many forms of active sociability characterized village life. As early as the twelfth century, specific communities took it upon themselves to attend to the upkeep of their church and the distribution of alms, as well as to manage parish property. These parish councils, known as *fabriques*, were confraternities. The most educated men were called upon to take on administrative tasks: the churchwarden, for instance, kept a register of all the local poor who had received charity. These notables soon became village leaders, whose opinions were as highly regarded as those of priests. Thus the establishment of village hierarchies coincided with the structuring of community life.

Each season was punctuated with religious feasts, which set the rhythm of community life. On these occasions, agricultural work came to a standstill, everyone met at church, and the merrymaking began. Spring and summer were the most favourable seasons for these celebrations. The parish council's annual banquet was usually held during Whitsuntide. Rogation processions, during which the faithful prayed to God or to saints for good crops, began a few days before Ascension Day. The procession went around the village and into the commons and finally reached the peripheral chapels that marked the boundary between *ager* and *saltus*. Stops were made in front of village landmarks, and the ritual ended with a mass in the parish church. Midsummer Day, Corpus Christi and the feast of the Assumption were sometimes marked by similar festivities. Each one provided an opportunity to celebrate the bonds between villagers and to remind them of their community's confines, regulations and hierarchies.

Conviviality, in the original sense of the word, was at the heart of all fetes. During such gigantic popular communions, people shared wine and food, danced and sang, mocking lords and clerics for a day, only to come under their sway once again at the festival's end.

Internal tensions were settled by community games during which the strongest or most adroit men in the village could show their skills. Bowls,

skittles and *arquebuse*, a sort of clay pigeon shooting where players took aim at a wooden effigy, were very popular amusements. Choule was a game played by two teams, sometimes made up of several dozen members, who tried to grab a ball and drive it towards a specific target – a door, a tree, a pond or a mark on the ground. Whether participants used their hands, feet, or a stick was determined by the kind of ball in play: it could be made of leather or wood, and might be round or flat. Such games were in effect no holds barred events. The playing field seldom had any clear boundaries, though it had to be both level and wide.

The choule often pitted two neighbouring villages against each other. Their teams would meet once a year, either at Christmas or during pre-Lenten carnivals, on land bordering on both parishes. Latent inter-community aggression was thus sublimated into game; moreover, such contests proved useful in the delimitation of each village's territory, since the playing field constituted a boundary of sorts.

Village solidarity was sometimes channelled in an altogether different direction. As early as the end of the eleventh century, some urban communities, by joining forces, achieved the status of self-governed communes. The communal movement spread from Italy to most regions of Europe and, from the thirteenth century on, extended its influence to several villages. Inspired by the drafting of city charters, villagers managed to obtain from their lords their own charters of franchise. While such documents did not free peasants from seigniorial control, they liberated them from arbitrary rule and granted them certain managerial rights. Franchises consolidated the community of interests between lords and peasants that had first been sealed by the establishment of seignories, but they were also proof of a new subordination of rural areas to urban ones. Henceforth, the pace of medieval life would be set in towns, which were seen by many as well protected, prosperous and attractive citadels. ✚

Pitcher
14th century. (Earthenware, 22 × 15 × 13 cm;
© Museum der Stadt Regensburg;
photo: Peter Ferstl)

And thenne Brynne repaired home ovir see in to his
owne lordeshipe of Burgoyne and there abode al his
lyf. And kyng Bellyne abode at Newe troy And
bilde there a noble gate fast by the watir of Tamyse
and callid it Bellynggesgate aftir his owne name &
Regned nobly al his lyf and lieth at newe Troye

Porta S.
Iohis

Porta
Noua

alta
crux

Porta S. Leonardi

Porta S. Nichi

Towns and Merchants

IN THE MIDDLE AGES, the town and the countryside were not regarded as separate or antagonistic worlds, but as complementary, inseparable ones. Townspeople farmed the land and countryfolk worked for the city. Markets gave rise to a steady flow of travel between these areas. The powers that be had seats of governance in both town and country. For everyone, however, land ownership remained the key to power.

Merchants benefited greatly from these dynamics between town and country. As early as the twelfth century, they had established themselves as a rapidly rising social group. Emerging from a feudal society only to remain on the fringe of its trifunctional order, they would challenge its values and force it to evolve.

Different Aspects of Medieval Towns

Were we to visit Europe in the year 1230, when medieval civilization was at its peak, we would discover there a wide variety of urban developments, each with its distinctive name.

Bishoprics were established in cities (*civitates*), which were both bigger and less numerous than towns or burghs (*burgi*). There were castle towns clustered at the feet of a castle, port towns at the confluence of two rivers or at the mouth of another, and church towns whose houses crowded around a parish church. While most towns were surrounded by walls, their population sometimes extended beyond the ramparts, either because a peripheral church had attracted new settlers or because certain people were less than welcome in the "town centre." Thus were formed small settlements called *suburbs,* from the Latin *suburbium*, meaning "close to a city."

People living in burghs were soon called burghers or bourgeois, from the Latin *burgensis*. At first, this term referred mainly to their place of residence, but by the twelfth century, it had become synonymous with a new kind of life. To be called a burgher, one had to be legally free and to have lived in a town for at least a year and a day.

A third generation of towns appeared between the twelfth and fourteenth centuries, created at the behest of feudal lords who sought to colonize new lands, to develop trade or to establish strongholds in strategic areas. The names of these new towns often testified to their status: thus *Neustadt* in the Holy Roman Empire and *Villeneuve* in France. Where newcomers were

FACING PAGE

Idealized depiction of the city of Bristol
Kalendar, Robert Ricart, 15th century.
(© Bristol Record Office, no. 04720, fol. 5vᵒ)

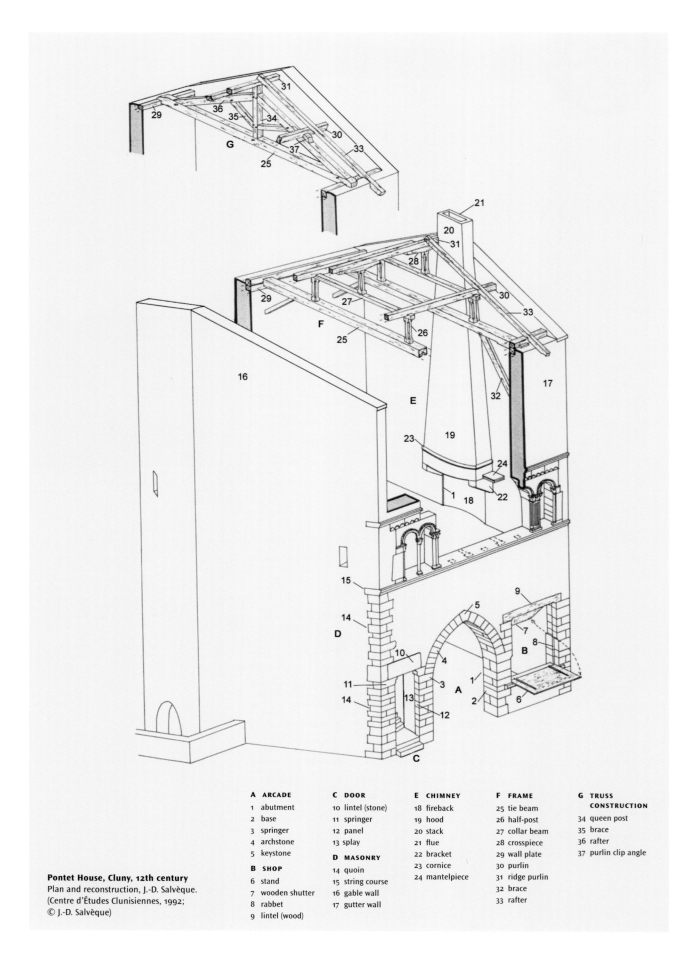

Pontet House, Cluny, 12th century
Plan and reconstruction, J.-D. Salvèque.
(Centre d'Études Clunisiennes, 1992;
© J.-D. Salvèque)

A ARCADE
1 abutment
2 base
3 springer
4 archstone
5 keystone

B SHOP
6 stand
7 wooden shutter
8 rabbet
9 lintel (wood)

C DOOR
10 lintel (stone)
11 springer
12 panel
13 splay

D MASONRY
14 quoin
15 string course
16 gable wall
17 gutter wall

E CHIMNEY
18 fireback
19 hood
20 stack
21 flue
22 bracket
23 cornice
24 mantelpiece

F FRAME
25 tie beam
26 half-post
27 collar beam
28 crosspiece
29 wall plate
30 purlin
31 ridge purlin
32 brace
33 rafter

G TRUSS CONSTRUCTION
34 queen post
35 brace
36 rafter
37 purlin clip angle

enfranchised, towns were given names such as *Freiburg*, *Villefranche* or *Villafranca*. In southwestern France, a region constantly fought over by the kings of France and England, towns were called *bastides* – whence the word *bastion*.

Town Planning: Polarization

In *bastides* as in other towns, the organization of space mirrored the structure of society. Each church was a separate focus of activity, a landmark. Its porch or nave often served as a meeting place for parishioners when the time came to apportion taxes or to discuss the restoration of a public building. Community archives were entrusted to churches for safekeeping, as were the standards of local measures.

The seats of judicial or fiscal governance, such as the lord's castle or the bishop's or royal officer's palace, also dominated the townscape. In more "emancipated" cities, the town hall served as a seigniorial palace. There justice was dispensed, town meetings were held and city archives safeguarded. In Italy and in North Sea countries, city belfries rose as high as church steeples, and both jealously chimed the hours.

Castelnau-de-Montmirail, France
Central square of the *bastide* founded in the 13th century, with surrounding Gothic houses. (© Photo: Didier Méhu)

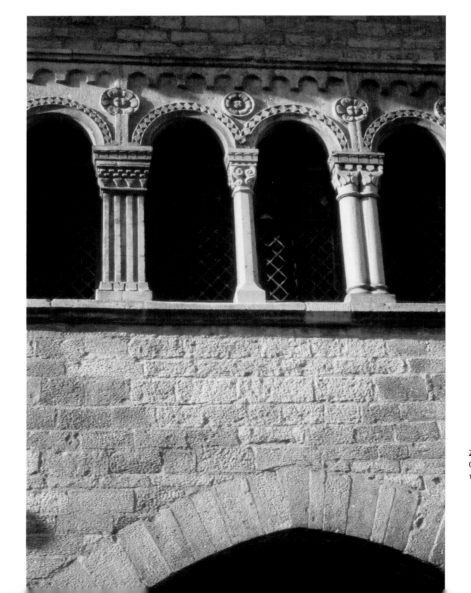

25 rue de la République, Cluny, France
Open-work facade of a Romanesque house, 12th century. (© Photo: Didier Méhu)

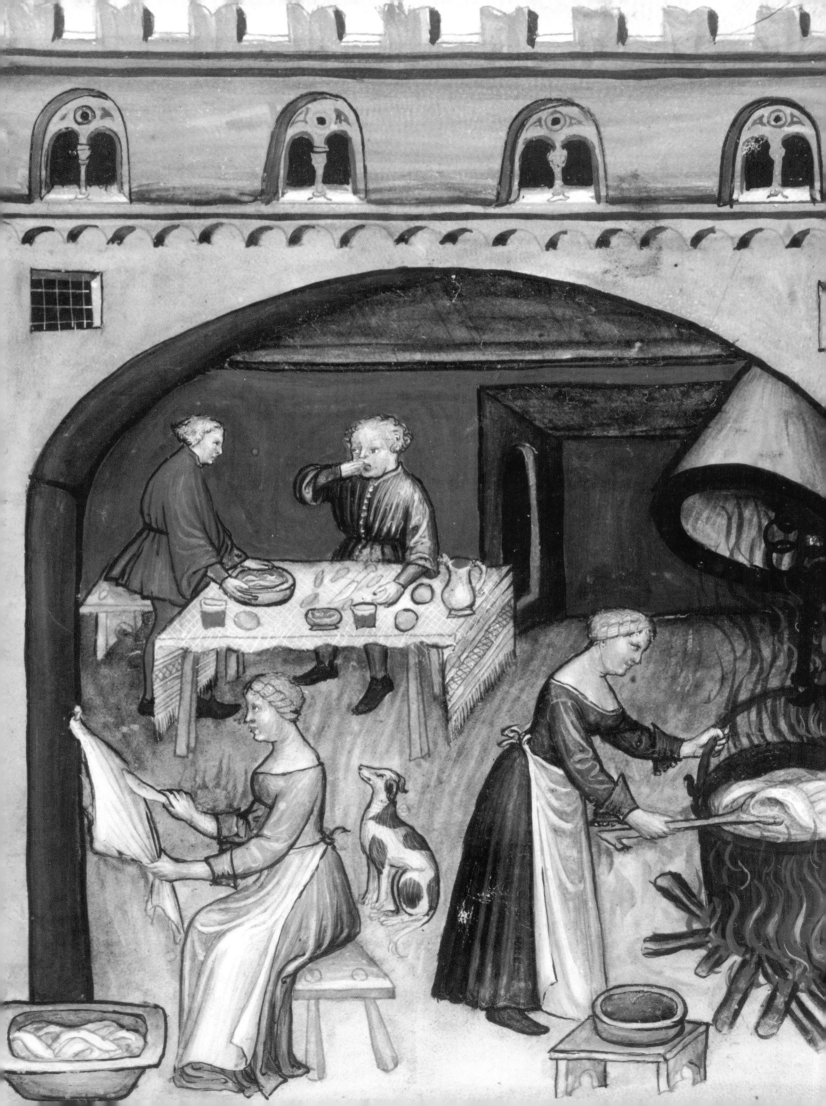

The status and internal tensions of urban communities were reflected in their main square. At its centre stood a monumental cross, and sometimes a building designed to house markets. The town hall's most beautiful facade also gave onto the plaza. Only steps away, however, loomed the stony reminders of the powers that be: the porch of a collegiate church, perhaps, or the entrance to the count's law courts. On days when fairs were held, the square filled with merchants, town criers, beggars, prostitutes, king's *prevots,* and friars perched on makeshift pulpits, threatening usurers with hellfire.

Surrounding walls were the distinctive mark of towns, even though some villages also had such defences. Townsfolk often had them sketched on their communal seal, as a symbol of a closely knit community, and everyone had to take part in their construction and upkeep. People took turns standing watch, although some bribed their way out of their duties or simply paid replacements to perform them.

Pastoral Towns

The urban fabric was something of a patchwork. There were distinct pockets of population gathered about churches or clustered around the castle, seigniorial palace or main square. These urban islands were separated by gardens, vineyards, wasteland and streams. Certainly more pastoral than many a present-day village, the medieval town afforded a subtle harmony between nature and culture.

There was water everywhere, in wells, naturally, but mostly flowing freely. In medieval towns, which seemed like miniatures of Venice, countless watercourses turned millwheels, filled tanners' basins or washed out latrines.

Each body of craftsmen settled in a specific area. It would have been out of the question, for example, for tanners and butchers to work upstream and thereby pollute the town's water with blood and dye. It was also deemed preferable that the water which supplied fishponds not first flow under houses and serve as municipal latrines. These problems were solved by diverting rivers into several secondary arms or by harnessing as many springs as possible in the neighbouring countryside and redirecting them towards town.

Law enforcement was sometimes delegated to town governments. If a city had its own representatives, they were entitled to elect a police *prevot* and a few sergeants from within their own ranks. If such was not the case, these appointments came under seigniorial jurisdiction. Although road works were also the concern of town authorities, it was only in the mid-thirteenth century, and even then in royal cities alone, that streets slowly started being cobbled. Pigs took care of sanitation work, roaming the town and devouring anything thrown into the street. To avoid getting spattered with refuse, people would stay to one side of the path, ever wary of what might be thrown out of an overhead window.

Houses: Symbols of Social Standing

Houses belonging to poor townspeople could hardly be distinguished from those of peasants. Wood, thatch and mud brick were the most frequently used building materials. A whole family, and perhaps one or two farm

Saint-Antonin-Noble-Val, France
So-called house of love, 13th century; detail from a facade sculpture showing two lovers embracing. (© Photo: Didier Méhu)

FACING PAGE

The inside of a 15th-century urban house
Tacuinum Sanitatis [Portrait of Health], 15th century. (© Österreichische Nationalbibliothek, Vienna, Ms codex 2644, fol. 15rº)

animals, would live in a single room equipped with a central fireplace. In urban areas, however, such humble abodes stood right next to opulent residences, which were far more numerous in cities than in villages.

Varied building materials were used. In towns that were former Roman cities, stone was free for the taking, so to speak, from ancient buildings. In other areas, materials were chosen according to the kind of subsoil to be built on and to the proximity of limestone deposits. Construction in brick or timber frame sometimes proved to be more convenient and less expensive than stone construction.

At the beginning of the twelfth century, a new kind of house appeared, simultaneously it would seem, in several parts of Europe. These "Romanesque" houses, which took their name from the style then prevalent in church architecture, were at least two storeys high. The ground floor was used for craftwork or agricultural labour; it might contain a barn, a cowshed, a storeroom or a workshop. Cellars that opened directly onto the street were frequently set up in the basement. People actually lived only on the upper floors.

Great care sometimes went into the design of these residential quarters. A pattern of openings was sometimes chiselled out of the front wall, creating an open-work facade. The sculptures that adorned the facades often rivalled those of churches. The backs of town houses were usually quite plain, for what mattered most was to show off the owner's status to passers-by. There was enough space inside for two rooms or more, including a bedroom. Stone construction made it possible to build chimneys into walls. Beaten-earth floors remained common, but were replaced in the wealthiest homes by terracotta tiles.

Houses were rarely more than two or three storeys high, whether built of stone, brick or timber. In the latter case, corbelled construction techniques were used: each level rested on wooden corbels jutting out from a lower one, thereby decreasing the load on walls and making possible the construction of additional floors. Such houses resembled inverted pyramids, and their roofs almost shut out the street below from the light of day.

Bourgeois Materialism

Proud of their homes, townsfolk tried to show in every aspect of their daily life that they did not live like peasants. Consequently their crockery became more and more specialized and varied. Stoneware was in use by the thirteenth century, and the grey pottery ubiquitous in the countryside gave way to terracotta ware glazed both inside and out. With the development of trade, locally crafted pottery met new competition from richly coloured terracotta ware fashioned in Spain, North Africa and Southern Italy. By the end of the Middle Ages, these items were produced throughout Europe. Knife handles and blades were also more finely wrought though, as a rule, people still ate with their hands. Indeed, while forks appeared on some noble tables in the fifteenth century, their use only became widespread in the eighteenth century.

The advent of stained glass in church architecture inspired the domestic use of glass, which went into the making of tumblers, cups, glasses, jugs, bottles

Dish
Manises, Spain, second third of the 15th century. (Glazed earthenware with a metallic lustre; © Archivo Fotográfico. Museo Arqueológico Nacional de Madrid, 60423)

Dish
Manises, Spain, first half of the 15th century. (Glazed earthenware with a metallic lustre, diam. 35 cm;
© Archivo Fotográfico. Museo Arqueológico Nacional de Madrid, 51116)

ABOVE

Bowl
Manises, Spain, third quarter of the 15th century.
(Glazed earthenware, diam. 46.8 × 5.7 cm;
© Archivo Fotográfico. Museo Arqueológico
Nacional de Madrid, 60417)

LEFT

Plate
Manises, Spain, late 15th century. (Glazed earthen-
ware with a metallic lustre, diam. 24 × 3.6 cm;
© Archivo Fotográfico. Museo Arqueológico
Nacional de Madrid, 60446)

LEFT

Flat plate
Paterna, Spain, 14th century. (Glazed earthenware, diam. 21.5 × 6.3 cm; © Archivo Fotográfico. Museo Arqueológico Nacional de Madrid, 60475)

BELOW

Terrine (*cuenco*)
Paterna, Spain, 14th century. (Glazed earthenware, diam. 18.8 × 6.3 cm; © Archivo Fotográfico. Museo Arqueológico Nacional de Madrid, 60471)

FACING PAGE

Pitcher
Paterna, Spain, 14th century. (Glazed earthenware,
30 × diam. 11.8 cm; © Archivo Fotográfico.
Museo Arqueológico Nacional de Madrid, 60486)

BELOW, LEFT TO RIGHT

Apothecaries' pot (*Albarello*)
Manises, Spain, 1450–1475. (Glazed earthenware
with a metallic lustre, 26 × diam. 13 cm;
© Archivo Fotográfico. Museo Arqueológico
Nacional de Madrid, 60226)

Apothecaries' pot (*Albarello*)
Manises, Spain, late 15th century. (Glazed earthen-
ware with a metallic lustre; © Archivo Fotográfico.
Museo Arqueológico Nacional de Madrid, 60444)

*A*n alfardón *is a hexagonal terracotta tile used with other, differently shaped tiles to create decorative compositions.*

Alfardón
Manises, Spain, 15th century.
(Glazed terracotta, 10.5 × 21.1 cm;
© Archivo Fotográfico.
Museo Arqueológico Nacional
de Madrid, 59800)

Tile (*azulejo*)
Manises, Spain, 15th century. (Glazed terracotta,
9.5 × 1.9 cm; © Archivo Fotográfico.
Museo Arqueológico Nacional de Madrid, 60089)

Tile (*azulejo*)
Manises, Spain, 15th century. (Glazed terracotta,
11.7 × 11.7 cm; © Archivo Fotográfico.
Museo Arqueológico Nacional de Madrid, 60133)

Composition of *azulejos*
Manises, Spain, 15th century.
(Glazed terracotta, 35.5 × 36 cm;
© Archivo Fotográfico.
Museo Arqueológico Nacional
de Madrid, 60133)

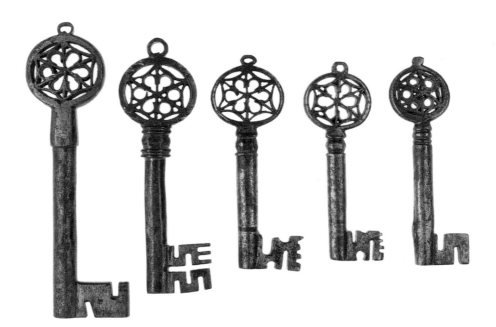

and window panes. By the fourteenth century, mirrors were made out of glass, and no longer from steel or rock crystal. Thanks to the fifteenth-century invention of silvering, they were able, for the first time, to reflect the features of their devotees and soon became an emblem for the women of the bourgeoisie, a sign of wealth, but also a token of lechery. The Church tried to prohibit the use of these diabolical instruments that dared reproduce the human form. While cautionary tales spun by preachers and vivid accounts of women entranced by their mirrors found their way into many a fable, they seemed to arouse little fear.

Advances in metalworking had a direct impact on everyday life. In the eleventh century, locks had been gradually introduced into seigniorial circles. By the thirteenth century, these devices, adorned with finely chiselled hinges, were commonly used by townspeople to secure doors and cupboards, linen and wedding chests. All sizes of keys were crafted, and sometimes very finely worked, including the oversized symbolic keys given to triumphant combatants or to the king when he ceremonially entered a town. Alongside traditional pottery, all manner of metal dishes were set on bourgeois tables: plates, tankards, tripod pitchers, pewter jugs, brass spoons and iron pots. Candleholders, oil lamps and candlesticks were more and more often crafted from bronze, and washbasins were made of brass instead of wood. Construction relied increasingly on metal, notably for nails, tie-beams, rods and cramp irons. The same was true of clothing, as can be seen from the heavy belts fashioned from metal plates and the tagged shoelaces worn in the fourteenth century.

During the same period, burghers began to have inventories made of their property after their death. Materialism had come to town! Of course, the bourgeois took their role models from the upper crust. They sought to imitate lords and to show that they too had risen to a dominant position. And for this, they were greatly indebted to merchants.

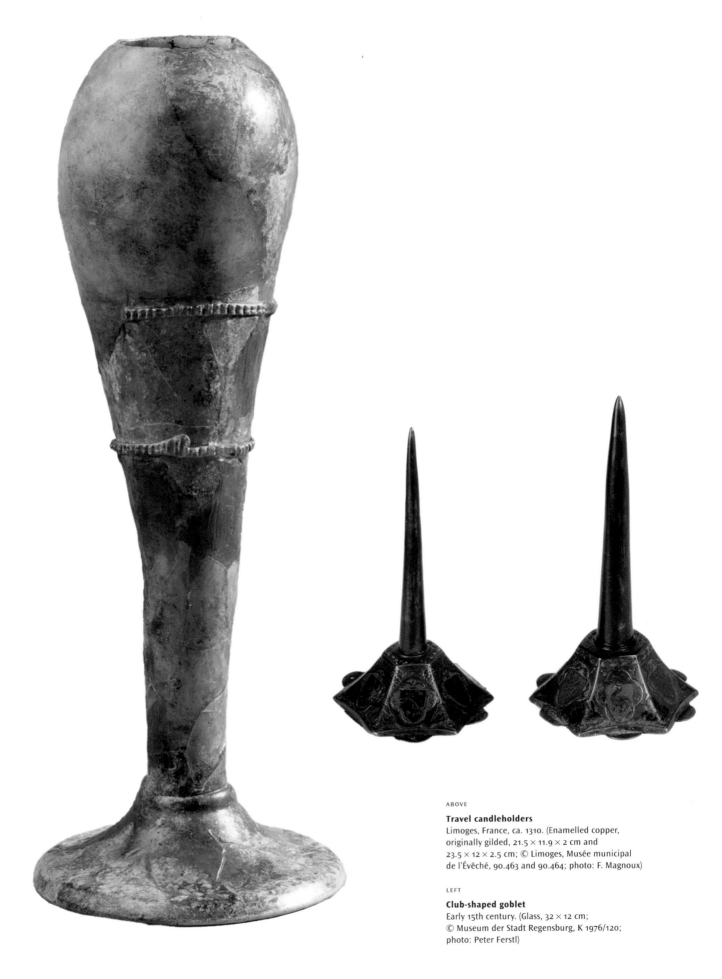

Travel candleholders
Limoges, France, ca. 1310. (Enamelled copper,
originally gilded, 21.5 × 11.9 × 2 cm and
23.5 × 12 × 2.5 cm; © Limoges, Musée municipal
de l'Évêché, 90.463 and 90.464; photo: F. Magnoux)

Club-shaped goblet
Early 15th century. (Glass, 32 × 12 cm;
© Museum der Stadt Regensburg, K 1976/120;
photo: Peter Ferstl)

The Fate of Merchants

At first glance, the merchant seems something of a misfit in the ideal medieval structure of the three orders. He was not a member of the *oratores*, those who pray, nor could he claim to belong to the *bellatores*, those who fight. Furthermore, the Church refused to recognize him as one of the *laboratores*, those who work, for it saw the selling of goods not as labour, but as profiting from the labour of others. The merchant's profits were thus likened to usury, a sin considered particularly offensive because it was tantamount to selling time, and time belonged only to God. The fact that Jesus had expelled the merchants from the Temple seemed to foreshadow the fate that awaited their latter-day counterparts on Judgement Day. They would be cast straight into hell or, at best, suffer purgatory for innumerable years.

In 1120, Bishop Adalbero of Laon flatly condemned business. Only fifty years later, however, his successors had no qualms about blessing merchant vessels before they left shore or about keeping a few pennies – coins stamped with a cross – in their purse. As in so many other instances, the Church managed to keep abreast of the times. In about 1260, Thomas Aquinas, the Grand Master of the University of Paris, defined mercantile endeavours as work, provided that those engaging in them did not reap more than a "reasonable profit." He also legitimated usury – as defined in the Middle Ages – so long as profits or interest charges were set at a "just rate," that

is, at no more than 20% a year. Merchants and money lenders could henceforth hope to earn both a living and a life everlasting, indeed, to attain in heaven the enviable status that was already theirs in society.

Booming Markets

European commerce developed considerably from the eleventh century onwards. Peasants settled permanently on the land and agricultural conditions improved: the result was surpluses that fostered trade. Sensing that opportunity was at hand, the lay and ecclesiastical aristocracy encouraged the creation of markets. This they did, of course, in a spirit that was far from disinterested, since they also exacted taxes from traders transporting goods, crossing bridges and entering or leaving towns. Even the sale or rent of benches used by merchants at fairs was taxed.

In rural areas, most merchants were also producers, farmers who went to village markets to sell their surplus poultry, eggs, grain or wine. Until the end of the eleventh century, they bartered produce more often than they sold it, but as the use of coinage spread to the countryside, they became full-fledged merchants.

The blessing of the Lendit fair in Saint-Denis
Pontifical à l'usage de Seno
[Pontifical for the use of Seno], Paris, 14th century.
(© Bibliothèque nationale de France,
Ms Lat. 962, fol. 264r°)

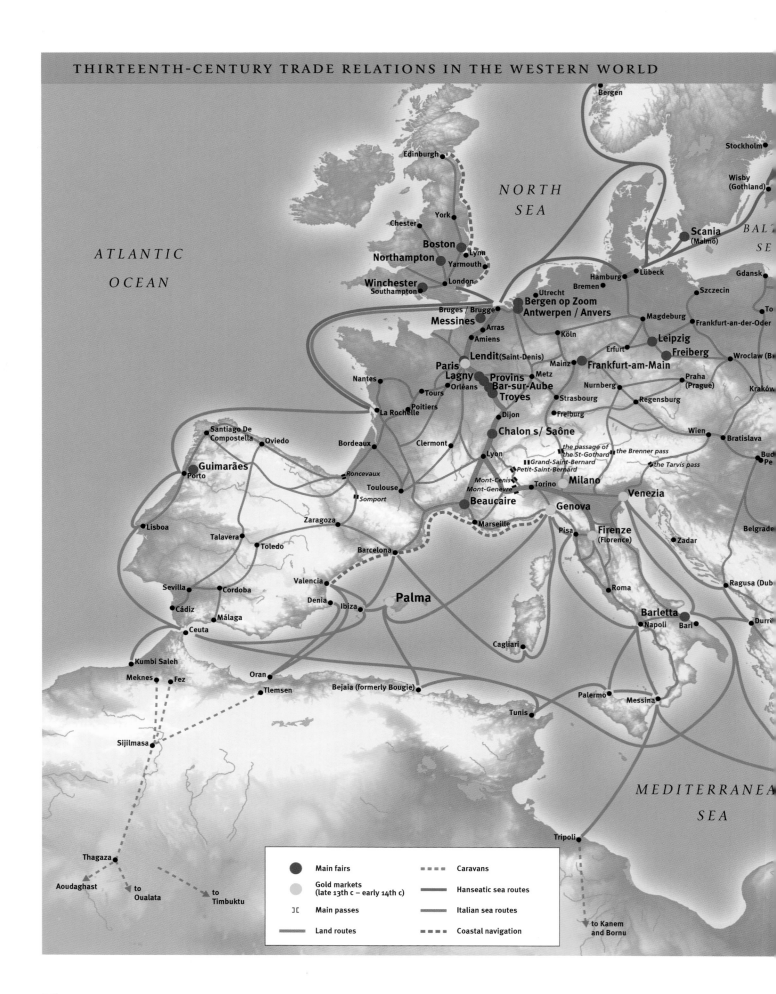

Bergen

Stockholm

Edinburgh

Wisby
(Gothland)

*NORTH
SEA*

York

Chester

Scania
(Malmö)

BAL...
SE...

Boston

Northampton

Lynn

Yarmouth

Gdansk

Hamburg

Lübeck

Winchester

London

Bremen

Szczecin

Southampton

Utrecht

Bergen op Zoom

Magdeburg

To...

Bruges / Brugge

Antwerpen / Anvers

Frankfurt-an-der-Oder

*ATLANTIC

OCEAN*

Messines

Arras

Köln

Amiens

Leipzig

Freiberg

Wroclaw (Br...

Lendit (Saint-Denis)

Erfurt

Frankfurt-am-Main

Nantes

Paris

Mainz

Metz

Praha
(Prague)

Kraków

Lagny

Provins

Nurnberg

Orléans

Bar-sur-Aube

Tours

Troyes

Strasbourg

Regensburg

Poitiers

Dijon

Freiburg

Wien

Bratislava

La Rochelle

Santiago De
Compostella

Oviedo

Chalon s/ Saône

the passage of
the St-Gothard

the Brenner pass

Bud...
Pe...

Bordeaux

Clermont

Lyon

Grand-Saint-Bernard

Petit-Saint-Bernard

the Tarvis pass

Roncevaux

Mont-Cenis

Mont-Genèvre

Torino

Milano

Guimarães

Toulouse

Venezia

Porto

Somport

Beaucaire

Genova

Lisboa

Zaragoza

Marseille

Pisa

Firenze
(Florence)

Belgrade...

Talavera

Toledo

Barcelona

Zadar

Sevilla

Cordoba

Valencia

Palma

Roma

Ragusa (Dub...

Cádiz

Denia

Ibiza

Málaga

Barletta

Ceuta

Napoli

Bari

Durr...

Cagliari

Palermo

Kumbi Saleh

Messina

Meknes

Fez

Oran

Tlemsen

Bejaia (formerly Bougie)

Tunis

Sijilmasa

*MEDITERRANEA...

SEA*

Tripoli

Thagaza

●	Main fairs	▪ ▪ ▪	Caravans
○	Gold markets (late 13th c – early 14th c)	───	Hanseatic sea routes
⊃⊂	Main passes	───	Italian sea routes
───	Land routes	▪ ▪ ▪	Coastal navigation

Aoudaghast

to
Oualata

to
Timbuktu

to Kanem
and Bornu

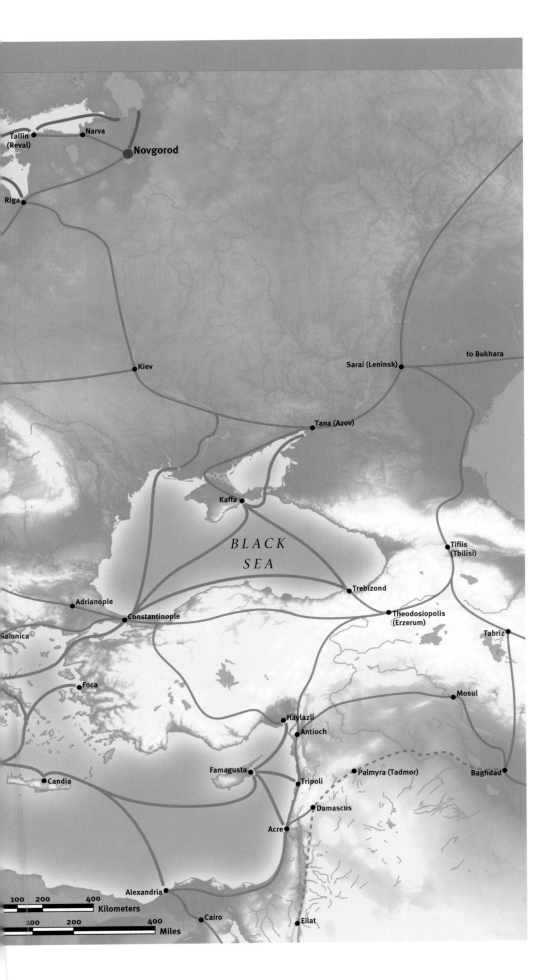

Tallin
(Reval)

Narva

Novgorod

Riga

Kiev

Sarai (Leninsk)

to Bukhara

Tana (Azov)

Kaffa

*BLACK
SEA*

Tiflis
(Tbilisi)

Adrianople

Trebizond

Constantinople

Theodosiopolis
(Erzerum)

Tabriz

Salonica

Foca

Mosul

Haylazli

Antioch

Candia

Famagusta

Palmyra (Tadmor)

Baghdad

Tripoli

Damascus

Acre

Alexandria

Cairo

Eilat

100 200 400
Kilometers

100 200 400
Miles

The precise origins of the merchant class remain obscure. Its first members may have been recruited from the younger sons of landowners, who could not expect to inherit a significant part of the family estate. Be that as it may, by 1150 its ranks were swelling. Merchants very likely bought produce directly from farmers and sold it in town, where there was less agricultural competition. In return, at village markets, they sold craftwork that could not be made in the vicinity. Markets were usually held once a week, in the main square or under a roof that sheltered both dealers and produce. In town, people sometimes sold wares made on the premises directly at their window, hence the "window sale." Craftsmen plied their trade in the street or in ground-floor workshops always wide-open onto the street so that passers-by could appreciate the quality of their work. Finished goods were sold on the spot.

Merchants travelled on foot, their wares loaded onto a donkey, a mule, or, if they were more well-off, a cart. The ancient Roman roads were still in good condition, but rarely followed local travel routes. Built for military use or to connect two cities, they cut straight through the countryside, bypassing the new villages that had sprung up since the Carolingian period. Merchants had little choice but to journey along rocky, muddy roads pitted by potholes.

The Golden Age of Fairs

These conditions, unthinkable to a man of our times – remember that it took a month and a half to cross France from north to south – did not prevent the development of a form of large-scale trade based on fairs. These were held once or several times a year, usually on dates that coincided with feast days and that took into account the agricultural calendar. Summer fairs began after Easter and could be held at intervals until Michaelmas, on September 29. Whitsunday, Midsummer Day, Saint Peter's day and the feast of the Assumption were particularly propitious times for trade. With autumn came the season of winter fairs, a time of high days and spirits: Martinmas, Candlemas and Shrovetide carnivals.

In most cases, fairs went on for no more than two or three days, but major ones could last several weeks. These followed a genuine ritual, which began with the arrival of merchants, who set up their benches and the tents they would live in for more than three weeks. On opening day, local Church dignitaries blessed the fairground and travelled around it in procession. Then business begun. During the first week, goods were not sold but merely exhibited. Sales took place during the second week and were paid for only during the third, called "fair's end." Business did not preclude festivity. Minstrels, acrobats and animal handlers mingled with merchants and moneychangers. Inns were full up, and those women who traded their bodies attracted many visitors. In the fifteenth century, theatrical performances were added to the festivities.

The reputation of some fairs was such that they attracted an international clientele. The fairs of Champagne best illustrate this phenomenon. Established at the end of the twelfth century by the counts of Champagne, who were eager to promote trade on their lands, they reached their peak between 1180 and 1280. Each year, six fairs were held in close succession, forming an

almost uninterrupted annual cycle among four towns: Troyes, Bar-sur-Aube, Provins and Lagny. The success of these fairs was due in great part to their location midway between the textile-producing regions of Flanders and the Italian ports that brought Oriental and North African products to market.

The Cloth Trade

This commerce mobilized many artisans and workers, from the men who bred sheep to the craftsmen who transformed raw wool into high-quality dyed cloth, and finally to the merchants who sold it.

From the twelfth century on, Brabant and Flanders were the hub of the cloth trade, which brought enormous prosperity to such cities as Ghent, Ypres, Lille and Brugge, in no small part because they stood near both the North Sea and the great ports of the Meuse and Rhine. Most of the requisite raw wool was brought there by sea from England. The remainder came from markets all over Europe, transported by land or by river. By the fourteenth century, English wool was being challenged on the markets by Spanish merino wool.

Flemish craftsmen processed the untreated wool. This entailed some thirty successive operations and required numerous raw materials, such as alum, a double sulphate of potassium and aluminium essential for fixing dyes. Blue and red tinctures were obtained from woad and madder, both widely cultivated in Europe, while yellow ones were based on ochre, a naturally occurring mineral. Luxury dyes such as purple, indigo or lapis lazuli were imported from the East. Alum was brought in from Asia Minor, since Western deposits would not be discovered until the mid-fifteenth century.

The Quest for Spices

International trade was also fostered by the demand for spices, those exotic condiments so prized by the well-to-do. They were used at the table (pepper, sugar, cinnamon, saffron, ginger), in medicine (aloe, cardamom), as perfumes (musk, ambergris), in craftwork (cotton, mastic, pitch). In the kitchen, spices were used to preserve and flavour dishes or such drinks as wine or beer, and, if need be, to mask the taste of tainted food.

The fact that spices made their way to Europe over the Mediterranean Sea brought prosperity to certain port cities, most notably to Genoa and Venice. Once these precious goods were in Europe, they were traded by wholesalers at international fairs, then retailed by grocers or apothecaries. Since they were expensive, their use was a sign of good social standing. Pepper and saffron would not be found on peasants' tables; lords, however, would flaunt their wealth by making liberal use of spices.

The cloth and spice trades fostered new business relations between Western merchants and their Eastern counterparts. By the end of the eleventh century, Genoese, Pisans and Venitians were crossing the Mediterranean to trade in North Africa or the Near East. To secure the transport of alum, aloe or cinnamon, they had to control certain passages to Asia or find trustworthy agents in foreign lands. Merchants thus broadened the horizons of their contemporaries and opened up the confines of the medieval world. They were the first to venture onto the hostile seas, sailing ever further and

PAGES 81-82-83

Orphreys with depictions of St. Peter and St. Mary Magdalen; St. Catherine and St. John are portrayed on the two removed pieces
Attributed to Jacques de Malborch (?), Utrecht, the Netherlands, ca. 1504. (Linen embroidered with silk, gold and silver thread, 78 × 12 (22.5 × 8.5) cm, 79 × 11.5 (21.5 × 9) cm; © Museum Catharijneconvent, Utrecht, ABM t2165 a1-2 and b1-2; photo: Ruben de Heer)

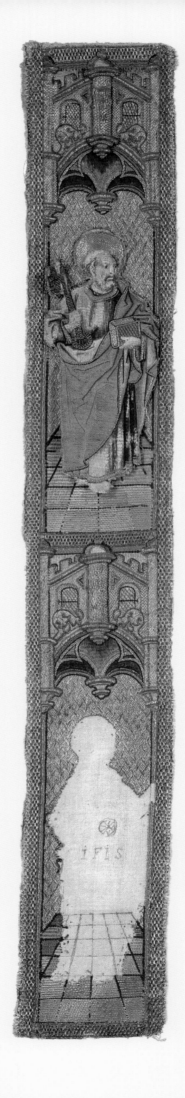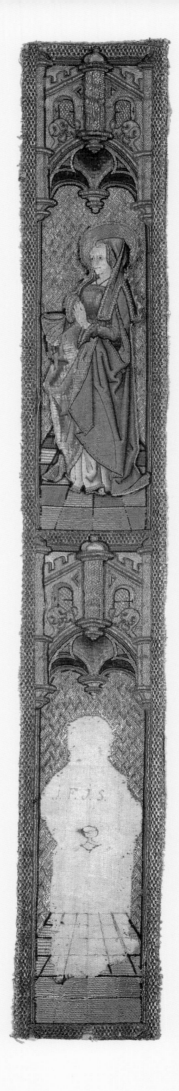

more confidently thanks to portolan charts and compasses. Eager to discover a new spice route, Italian, Spanish and Portuguese princes started funding transoceanic expeditions at the close of the fifteenth century. Genoese merchants, who sailed on new-fashioned caravels – narrow-hulled ships that were easy to manoeuvre – thereupon set out to conquer the New World. In 1492, Christopher Columbus set sail to find a new passage to India, the land of spices. By rounding the southern extremity of Africa in 1497, Vasco da Gama achieved the old dream of reaching the Orient without crossing the Mediterranean or traversing Muslim lands.

Silver and Gold

Commercial expansion brought about a tremendous increase in the amount of money in circulation. The medieval monetary system had been developed in the seventh and eighth centuries. It was based on silver monometallism, that is the minting of coins in that metal only. The gold penny used by barbarian peoples had virtually vanished from Western Europe by 675. It was kept in circulation only in areas that had established relations with or fallen under the rule of the Byzantine Empire.

Accounts were kept in pounds and shillings, but the only coins in circulation were silver pennies. In order to understand this complex system, one must distinguish the real currency, that in circulation, from "theoretical currencies" that were no more than accounting units used to facilitate calculations. By the end of the seventh century, only one currency was legal tender throughout Western Europe: the silver penny. Nevertheless, people still relied on two accounting units, the pound and the shilling. A shilling was worth 12 pennies, a pound was worth 20 shillings or 240 pennies. This system seemed more intricate because the value of the "pound" used as an accounting unit was different from the "pound" that was a unit of weight. At the end of the eighth century, Charlemagne had decreed that a pound of silver weighing 408 grams had to be cut into 240 pieces to make a silver penny. It comes as no surprise, then, that monetary devaluation became a very concrete process during the Middle Ages. Instead of cutting 240

Double *tournois*
Touraine, France, 13th century. (Silver, diam. 2 cm;
Musée de la civilisation, dépôt du Séminaire de
Québec, 1994.5725)

pieces out of a pound of silver, 250 or 260 might be cut, producing coins that, although lighter, would still be worth a silver penny. Consequently, a widening gap developed between the metal value of coins, which constantly declined, and their theoretical value, which never varied. Towards the end of the Middle Ages, coins containing almost no silver, called "small pennies," were in wide circulation. Much like our modern-day banknotes or coins, they had no value other than that commonly ascribed to them.

From the Carolingian period onwards, as the ranks of the aristocracy swelled, so did the number of mints. Although it was at first a royal privilege, dukes, counts and ecclesiastical lords were granted the right to strike coins. Local pennies were stamped with as many effigies as there were bodies invested with the right to mint. Before long, some drove others out of circulation, either because they contained a smaller amount of silver – metal-rich coins were hoarded instead of being put in circulation – or because they had been issued by powerful authorities. Accordingly, in the twelfth century, the *denier parisis* (minted in Paris) and the *denier tournois* (from Tours) circulated widely in the northern half of France, because the King of France had adopted them as standards.

The thirteenth century brought further change to the monetary system. In 1203, Venice began striking heavy silver coins called groats, worth 12 pennies each. Florence took up the Venetian practice in 1235, as did the kings of France in about 1265. Flanders followed suit towards 1275, the kings of England, in 1279, and those of Bohemia, in 1296. Between 1250 and 1280, certain Italian cities went back to the striking of gold coins, which soon circulated throughout Europe. Florentine florins, Genoese *genovini*, Venetian ducats and French *écus* were the currency of international trade and important business transactions. In rural areas, however, the silver penny remained the standard coinage.

The Dawn of Banking

With the spectacular development of seigniorial mints and the return to bimetallism, pennies, *écus* and florins struck in all parts of Europe changed hands during international fairs. These coins were not of equal value, and

their rates fluctuated with each monetary devaluation. It therefore became necessary to establish exchange rates. Moneychangers first plied their trade during French and Italian fairs at the end of the eleventh century, but it was from 1250 onwards that they truly extended their influence.

The fairs of Champagne, where so many trade routes met, became the hub of foreign exchange. There moneychangers set up their tables, received deposits, offered conversions into most of the common currencies, opened accounts and meticulously checked the weight of coins on their small scales. Soon, these men who exchanged currencies over a bench, a *banca,* came to be called *banchieri*: and so the bank was born.

To bear the costs and risks of their trade, Italian moneychangers created companies in which family capital and customer deposits were invested. To avoid the risks involved in the transport of hard and heavy currency, these firms devised new methods of transferring funds. The promissory note was a small, sealed parchment, slightly larger than a modern-day check, which confirmed that a client had deposited money with a company. On production of the note, he could recoup his cash in any other money market where the company had a correspondent. The bill of exchange, a variation on the promissory note, was introduced towards 1250. It involved the same kind of transaction, but also allowed clients to recover their money in currencies other than those used for deposits. During international fairs, moneychangers realized a small profit on each currency conversion. While bills of exchange enabled clients to borrow money from the companies that issued them, they could not be used to make a payment. In that regard, they were quite different from modern-day cheques.

Tuscan companies dominated this business for some time, but they eventually met stiff competition: in southwestern France, players from Cahors and Narbonne acquired an enviable reputation. In the fourteenth century, the Castilian fairs of Medina del Campo outshone those of Champagne and, in the fifteenth century, Lyon became the main focus of currency exchange in Western Europe.

Penny
Obverse (*left*): full face depiction of Edward I, London, 1272–1307, (Silver, diam. 1.9 cm; Musée de la civilisation, dépôt du Séminaire de Québec, 1994.4807)

Promissory note in which Jean d'Avrenches, furrier to the king, orders Pierre de Maizières to pay the sum of 93 pounds and 10 shillings to Jean d'Ailly, an Amiens merchant, August 21, 1333.

Transcription:

A saige homme et discret monseigneur Pierres de maisieres, doyen et receveur de piquegny, Jehan davrenches pelletier notre sire le roy, salut. Chiers sires et amis, je vous pri que vous paiez et delivreis pour moi a Jehan dailly, marchant damiens porteur de ces lettres, quatre vins treize livres et diz soulz parisis en rabat et deduction de ce que monseigneur me doit, en laquelle somme je sui tenus a lui pour vente de pelleterie, et des maintenant je men tien pour paie et vous en quitte par la teneur de ces lettres, si vous pri ci a ceites comme je puis qui ni ait nulle faute. Donne a paris souz mon seel, le samedi apres la notre dame avoust, lan de grace mil trois cenz trente et trois.

Promissory note
1333. (Parchment, 6 × 27.5 cm; © Archives départementales de la Côte-d'Or, B 11689; photo: Maurice Bathelier)

Acknowledgement of payment by the Duke of Burgundy's receiver in favour of Thomas de Bauffreniez, following the latter's journey to England to discuss the price of goods brought from England to Flanders, April 9, 1404 (old style).

Transcription:

Je Thomas de bauffreniez chevalier, cognois et confesse avoir eu et receu de Jehan de bellery, maistre de la chambre aux deniers de monseigneur le duc de Bourgoigne, conte de flandre et dartois, et commis a la recepte de ses finances, la somme de quarante et cinq frans dor, monnaie de france, pour mes gaiges et desservis de quinze jours a trois desdiz frans par jour, sur le voyage que mondit seigneur ma ordonne de fere presentement a Granvelanghes avec messire Guilleme de Halebbin et maistre Therry Gherbade, pour entretenir de par mondit seigneur le traitie encommencie avecques les commis et deputez de la partie dangleterre sur le fait du cours de la marchandise entre engleterre et flandre, de laquelle somme de XLV frans, monnaie dessudite, je me tiens content et en quitte ledit belery et tous autres a qui quictance en appartient. Tesmoing mon seel mis a ces lettres le IX^e jour davril avant pasques, lan mil quatrecens et quatre.

Promissory note
1404. (Parchment, 11 × 33.5 cm; © Archives départementales de la Côte-d'Or, B 11689; photo: Maurice Bathelier)

Northern European Merchant Guilds

North Sea merchants came together in associations that integrated the crafts of entire cities. Referred to as guilds or hanses, from the Old High German *hansa,* meaning *company*, such alliances mushroomed from the twelfth century on. Hanses were first formed in towns, where they included the entire merchant community, as they did in Cologne, Lübeck and Hamburg. At the end of the thirteenth century, these municipal hanses merged into a single company, called the Hanseatic League, if not simply the Hanse, for it had supplanted all the local guilds. It incorporated more than 200 trade centres in Northern Europe, including the towns of Brugge, London, Lübeck, Bremen, Hamburg, Rostock, Danzig and Riga. From the English Channel to the Baltic Sea, the Hanse exercised a virtual monopoly of the wool, salt, wax and fur trades. Its nerve centre was Brugge, which sold fruits from the Mediterranean, oriental spices, Polish grain, Russian wax, Hamburg beer and English cloth.

Medieval Associations

Merchant guilds did not owe their power to commercial expansion only. Their ascendance was secured in large part by a deep spirit of communality. In isolation, medieval man was lost, unavoidably marginalized. In a group, he could make his way in the world, earn the respect of his peers and take part in communal work. In both town and country, medieval society was based on the community. Every individual, from the wealthiest to the most destitute, was taken under the wing of professional, religious, residential or family associations, and every one of these provided a system of mutual aid and of welfare.

Oaths and communal meals were the cornerstones of medieval associations. An oath was a mutually binding promise made by association members with regard to their conduct and future actions. It was also a contract with God. He who betrayed such an oath was henceforth a perjurer, fated to suffer the ire of his colleagues and the wrath of God. Association members gathered at least once a year for a collective meal during which they shared bread and wine – a distant echo of the Last Supper – and thus loosely patterned their group on the Church community. Accordingly, these meetings were usually convened at Easter or on Whit Sunday.

Medieval associations were given many names: confraternity or fraternity, guild, *societas*, consortium, corporation, commune, corpus, *conjuratio*, university. Each was predicated on a community of intentions and the contribution of all members to drawing up a collective enterprise. Such alliances also formed a way of life based on *caritas,* the brotherly love which is the source of all selfless communion.

The Birth of Communes

In both urban and rural settings, the parish provided the first framework of sociability. When this institution was found lacking, people looked for new ways to collectively structure urban life. One of those means, and a most effective one, was the *conjuratio*. As its name implies, it was an association based on oath: *con juratio*, mutual oath.

In its early days, the commune was nothing more than a particular kind of *conjuratio*. A town's leading burghers would bind themselves by oath to help each other and to assist in the governance of municipal affairs. By so doing, they attempted to secure some form of transfer of power, not to deny seigniorial authority. The burghers claimed the right to levy certain taxes independently, to manage their own defence and to bring to justice delinquents in their ranks. The great majority of lords realized that by winning the support of the bourgeoisie rather than alienating it, they would be acting in their own interests. Many communes were thus granted official powers, described in charters that detailed the rights and duties of all parties involved.

The communal movement, which had sprung up in the twelfth century in the bustling commercial towns of Flanders and Italy, spread to many parts of Europe in the following century. In their most extreme form, communal towns became autonomous city-states that ruled the surrounding countryside, as witness the brilliant reigns of Genoa, Florence, Siena or Venice. Compromise, however, was the rule for most communes. Their residents had the right to appoint their own representatives, called consuls, mayors or *échevins*, and to rule on local misdemeanours. They were also given responsibility for maintaining specific public buildings and were authorized to levy taxes for that purpose. Only a lord, however, could

Coat of arms of Bordeaux
Fort Louis de Bordeaux, 1535.
(Limestone, 85 × 100 × 30 cm; Musée d'Aquitaine, Bordeaux, 11881; © DEC, photo: J. Gilson)

**Charter granted to the residents of Billom
by Gui de La Tour-du-Pin, Bishop of Clermont**
France, 1281. (Parchment, 73 × 59 cm;
© Archives départementales du Puy-de-Dôme,
3 G PS 1; photo: Serge Seguin)

*Sealed with the seal of the Cathedral Chapter of Clermont (incomplete)
and the seal of the town of Billom (incomplete). One seal is missing.*

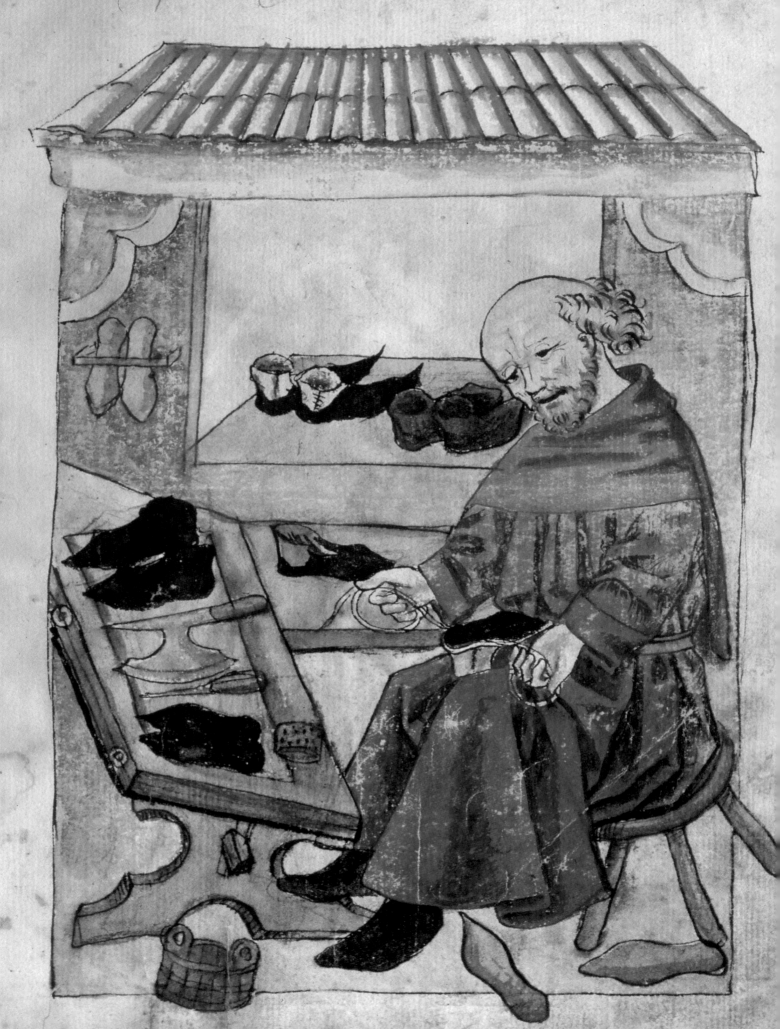

dispense justice where blood guilt was concerned. Similarly, the right to raise an army and to levy a tallage remained seigniorial prerogatives.

The governments of these towns were neither participatory nor elective democracies. Most often, they were "plutocracies," systems of rule controlled by the rich. Clerics, notaries and wealthy merchants vied for consulships or other municipal offices, which were awarded by a group of residents considered the town's "best and wisest" – according to standards rarely defined with any degree of precision. Consequently, corruption was rife and, from their inception, communes consolidated hierarchies within the urban community.

Professional Corporations

With the development of towns and urban crafts, people engaged in the same trade started forming alliances to defend their interests, coalitions referred to as crafts or corporations. All members were sworn in, that is bound by oath, and placed on an equal footing. Admission requirements and craft rules were defined by statute, as were the positions of masters and apprentices. It was the responsibility of the corporation "guards" or "guardians" to make sure that all statutes were complied with.

Regulations were introduced both to prevent certain abuses and to protect craft members. For example, craftsmen had to work in full view of all passers-by, which made it harder for them to palm off slipshod imitations or to engage in false advertising. With some exceptions, they were also prohibited from working at night, on Sundays or on holidays, on pain of excommunication and expulsion from the corporation. Since there were some one hundred Church holidays per year, craft members worked on average two days out of three. Furthermore, where they were concerned, unemployment was virtually unknown. Should one of them move, his fellows had to provide him with board, lodging and work.

As was true for all medieval corporations, crafts were religious associations whose members were bound by a spiritual kinship similar to the one into which all Christians are admitted upon baptism. Most striking, in this regard, was the election of a patron saint by every craft: Saint Eligius for goldsmiths, Saint Barbara for quarrymen, Saint Nicholas for sailors, Saint Luke for painters, and so forth. Moreover, inspired by the *caritas* that united them, craft members were expected to help each other out in cases of misfortune, such as the death or injury of a colleague.

Entering a craft amounted to leaving one's earthly family to join a spiritual family of fellows. This is why crafts played a pivotal part in defining individuals. Surnames came to be used by aristocrats in the middle of the eleventh century. In the next century, the custom spread to some members of the bourgeoisie, who were often named after their craft. Designations such as Smith, Weaver, Fuller, Dyer or Thatcher became nicknames and later family names when they were passed down from father to son.

Brothers and Sisters: Confraternities

Those who belonged neither to a commune nor to a professional corporation could nonetheless turn to one or several confraternities for support. Such groups were formed in the countryside and in towns, and in every

Saddler's thimble
10th–11th century (?) (Bronze, 4 × 2 cm;
© Archivo Fotográfico. Museo Arqueológico
Nacional de Madrid, 1933/186/1)

ABOVE

St. Eligius of Noyon
Probably from the old church of Samart, Belgium,
ca. 1530. (Stripped oak, 67 × 21 × 12 cm;
© Musée des Arts anciens du Namurois,
Société archéologique de Namur coll.;
photo: Luc Schrobittgen, Bruxelles)

FACING PAGE

The Shoemaker Ott Norlinger
Hausbuch der Mendelschen Zwölfbrüderstiftung, 1476.
(© Stadtbibliothek, Nuremberg, Amb. 317, 2°, fol. 96r°)

These lead, copper or silver tokens attested to membership in a community. From the 13th century on, they were used mostly by confraternities and professional guilds, for instance as proof of payment of annual dues or of attendance at confraternity meetings. The confraternity's patron saint or the profession's attributes were often depicted on such tokens.

Token in the shape of an alms-purse
France, 14th century, ancienne collection Forgeais.
(Lead; Paris, Musée national du Moyen Âge–Thermes de Cluny, inv. Cl. 4341; © Photo: RMN-Franck Raux)

Token of the confraternity of the Holy Sepulchre
Paris, 15th century, ancienne collection Forgeais.
(Lead; Paris, Musée national du Moyen Âge–Thermes de Cluny, inv. Cl. 3625; © Photo: RMN-Franck Raux)

Token of the confraternity of the Saint-Jacques de la Boucherie Church
Paris, 1540, ancienne collection Forgeais. (Lead; Paris, Musée national du Moyen Âge–Thermes de Cluny, inv. Cl. 3603; © Photo: RMN-Franck Raux)

Token in the shape of an alm's-purse
France, 14th century, ancienne collection Forgeais.
(Lead; Paris, Musée national du Moyen Âge–Thermes de Cluny, inv. Cl. 4338; © Photo: RMN-Franck Raux)

One side shows a baker putting bread in an oven, while the other portrays St. Honoratus, the patron saint of bakers.

Bakers'guild token
France, ca. 1500, ancienne collection Forgeais. (Lead; Paris, Musée national du Moyen Âge–Thermes de Cluny, inv. Cl. 3503; © Photo: RMN-Franck Raux)

*T*he tools depicted include a
pick, a square and a compass.

Masons'/stonecutters' guild token
France, ca. 1500, ancienne collection
Forgeais. (Lead; Paris, Musée national
du Moyen Âge – Thermes de Cluny,
inv. Cl. 3550; © Photo: RMN-Franck Raux)

*S*t. Eligius is portrayed on one
side; the reverse side shows
two keys on a cord.

Locksmiths' guild token
France, ca. 1500, ancienne collection
Forgeais. (Lead; Paris, Musée national du
Moyen Âge – Thermes de Cluny, inv. Cl.
3575; © Photo: RMN-Franck Raux)

**Token of the guild of palmers (pilgrims having
returned from Jerusalem)**
France, 15th century, ancienne collection Forgeais.
(Lead; Paris, Musée national du Moyen Âge – Thermes
de Cluny, inv. Cl. 3558; © Photo RMN-Franck Raux)

Coopers' guild token
France, 15th century, ancienne collection Forgeais.
(Lead; Paris, Musée national du Moyen Âge – Thermes
de Cluny, inv. Cl. 3579; © Photo RMN-Franck Raux)

Fragment of St. William's tomb: depiction of a stonemason
York Minster, 1317–1340. (Limestone, 54 × 36 × 32 cm; © York Museums Trust (Yorkshire Museum), YORYM 1980.51; photo: Jim Kershaw)

social stratum. Much like other medieval associations, a confraternity was a new family, a family of fellows – of brothers and sisters – united by social and spiritual affinities. It might bring together members of a specific parish, residents of a particular neighbourhood or devotees of a particular saint.

Much like present-day associations, confraternities collected annual dues from their members, although the subscription charge was usually quite reasonable. There were often minimum age requirements for admittance, but neither gender nor social standing was grounds for exclusion. Only aristocratic confraternities required proofs of nobility. Reputation, however, was taken into account: anyone found guilty of a criminal offence or of tax delinquency had to serve his sentence before he was allowed to join a confraternity.

Charitable Confraternities

Charitable works were a central concern of all medieval associations, whether these were confraternities, corporations or communes. Fellows had to devote part of their time to caring for the poor of their parish, and upon the death of one of their own, they had to attend to the funeral services. Some confraternities, by creating hospices, became especially dedicated to charitable works.

The medieval *hospitium* provided a wealth of services that have now been passed on to distinct, specialized establishments: hospices, hotels and hospitals. *Hospitia* took in the poor, the sick and those who were deemed unable to support themselves, such as pilgrims separated from kith and kin. People who were granted admittance were provided with board and lodging, and

The nuns represent the four cardinal virtues: Prudence, Temperance, Fortitude and Justice.

were cared for in soul and body. Attending Church services, going to confession or receiving communion were considered as important as taking food, syrups or baths. Bloodletting was the universal, if somewhat drastic cure.

The length of each stay was vigilantly controlled. Unless they were ill, pilgrims were lodged for no more than two nights. The destitute had to leave as soon as they had regained enough strength to beg on the streets.

During the Early Middle Ages, hospices belonged to religious communities, but from the eleventh century on, rich laymen as well as certain towns created new institutions. A compromise was then reached: though hospices would be managed by towns, monks and nuns would continue to tend the sick, with the assistance of a few laymen. In the twelfth and thirteenth centuries, there were several hospices in each town. With the increased number of pilgrimages to Rome, Santiago de Compostela and Jerusalem, they sprang up throughout the countryside just as spectacularly. Hospices lined the roads near important shrines or on routes all pilgrims had to take, such as mountain passes.

Leprosy and Lepers

At the close of the twelfth century, specialized institutions appeared along the roads of Europe, far from any town: leprosariums or lazarets, which took their name from Lazarus, the leper Jesus raised from the dead. As their name

Nuns and the sick at the hôtel-Dieu (*hospitium*) of Beaune (Côte-d'Or, France)
Livre de Vie Active [Book of active life], Jehan Henry, ca. 1482, (© Musée de l'Assistance Publique–Hôpitaux de Paris, AP 572)

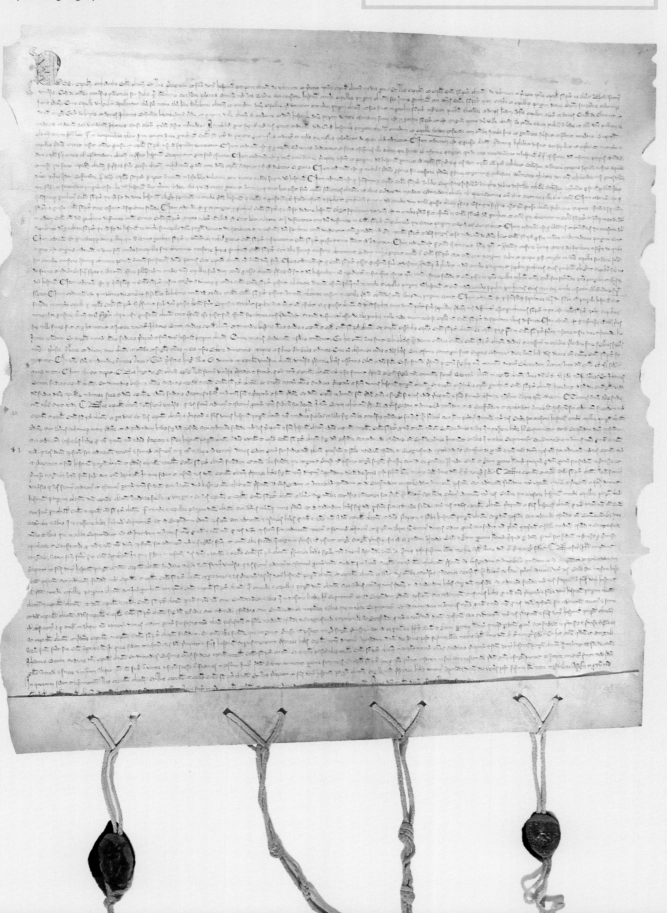

On the Fringes of Urban Society: Jews

JEWISH COMMUNITIES were probably established in Western Europe as early as the first century. In the opening years of the Middle Ages, Jews lived in relative harmony with their Christian neighbours, and prospered throughout the Carolingian period, during which they were granted certain commercial privileges.

As the Church became a powerful, hierarchical institution, attitudes towards them gradually changed, and turned to persecution with the First Crusade, whose motley armies looted and massacred Jewish communities in the Rhineland. Anti-Semitic decrees were introduced throughout the twelfth century, as rumours spread that Jews engaged in ritual murders of children and conspired to destabilize Christendom itself. In the thirteenth century, European economic development proved detrimental to the Jewish community. For the first time, the Church allowed its members to charge interest on ventures and loans, provided it was set at a "just rate," thereby breaking the Jewish monopoly on this business. Moreover, by being denied access to various artisan guilds, Jews were effectively barred from working as craftsmen.

Over the course of the Middle Ages, however, many relations were established between the Jewish and Christian communities, particularly in Spain, Italy and southern France. In those lands, Jewish scholars played an important role in the introduction of Arab astronomy, medicine and philosophy into Europe, and took part in debates concerning the two biblical religions.

But rumours prevailed over tolerance. In 1215, Pope Innocent III instituted discriminatory measures against Jews. Several kings followed suit, increasing the tax burden of Jews, reducing them to serfdom or forcing them to wear the rowel, a circular patch of yellow or bicoloured felt sewn on clothing. In 1321, Jews in France were accused of plotting with lepers to poison wells.

In 1331, and again in 1394, they were expelled from France. In 1492, they were driven from Spain, where they had made a significant contribution to one of the most original civilizations in Europe. ∎

In the first frame, a child takes communion, receiving the host from the hands of a priest. In the second frame, the outraged father tries to throw his son into an oven, much to the dismay of the boy's mother. All three figures are wearing the rowel that Jews were forced to sew on their clothes as a sign of their distinctive identity. In the third frame, the father is punished for having tried to immolate his son, who is baptized in the last frame.

Miracle of the Jewish glassmaker of Bourges
(© Bibliothèque nationale de France, Ms FR. 22928, fol. 75r°)

suggests, leprosariums were small hospices devoted to the shelter and care of lepers. Their administration usually came under the authority of urban communities.

They were not created because of any increased threat of leprosy, but because Western attitudes concerning that terrible disease had changed. Unlike the plague, leprosy had never caused great devastation in medieval Europe. The affliction was ever present, it never disappeared, but it remained marginal. Symbolically, however, it was invested with enormous power.

Leprosy fascinated medieval man as much as it terrified him; it crystallized all the fantasies and fears of his society. Not knowing what caused the disease, people perceived it as a scourge brought on by having sexual relations at times forbidden by the Church, notably during Lent or during a woman's menstrual period. The leper was thus the fruit of a parental sin for which he was not responsible. He bore its stigmata, nonetheless, and it was a Christian's duty to help him and treat him with charity.

However, the repulsion caused by the flesh-eating disease and its association with sin led to discriminatory attitudes. Measures designed to keep lepers away from other men were repeatedly introduced throughout twelfth-century Europe. In 1179, Pope Alexander III ordered that lepers be separated from those who were sound in body, forbidding them from entering a church or public area, drinking water from fountains or going near a child. To warn of their approach, they had to shake a leper's rattle – called a *clapper* or *cracelle* – or a bell, because the latter was a liturgical object intended to ward off ill fortune. Nobody was permitted to touch the bowl they used for begging. Nonetheless, the greatest sign of charity was to kiss a leper, as Jesus and Saint Martin, epitomizing Christian *caritas*, were said to have done.

※ ※ ※

The example offered by the fate of Jews and lepers is particularly enlightening: medieval towns generated solidarities, hierarchies and expulsions. Slowly, from 1100 onwards, they became the mainspring of medieval civilization. On the eve of the Black Death, they regained the prominence lost for several centuries after the collapse of Roman civilization.

Towns created new wealth and served as beacons to rural areas, from which they drew a good part of their resources. Burghers did not live like peasants: their food was finer, their houses more opulent and their clothes cleaner. Nor did they work in the same way. While countryfolk still produced most of what they consumed – from grains to clothes, from furniture to pottery – burghers had become specialists. The sheer volume of crafts practised in their towns was bound to stimulate trade. Moreover, travelling merchants created new demand by displaying on their benches the spices, furs, gleaming ceramic ware, silk fabrics and dyed cloths that they imported from the four corners of Europe and from beyond the seas.

Every man knew that only in town could he acquire prestige, even if it was minimal. While land remained an undeniable source of wealth, towns had once more become the driving force of society. This fact was not lost on lords, whether magnates of the lay aristocracy or members of religious communities. All those who claimed to exercise authority realized that they would have to extend their dominion to towns. ✣

A leper begs while shaking his rattle at the city gates
Speculum historiale [Historical mirror], Vincent de Beauvais, 14th century. (Bibliothèque de l'Arsenal, Ms 5080, fol. 373r°, © Bibliothèque nationale de France, Paris)

Authority

OWNERSHIP OF LAND and levies on revenues from labour ensured power, *potestas*, but in order to exercise it in all legitimacy, one had to enjoy authority, *auctoritas*. The one, the true authority was God, and any particle of authority came from him as a gracious delegation, which the people would recognize by humbly submitting to it.

In the Beginning Was the Word...

The Creator, the one God, was the origin of all. He created light, the earth, the sky, the heavenly bodies, the waters, the plants, the animals and man. But man, in his weakness, let himself be tempted and defied the Lord's commandment concerning the forbidden fruit. Banished from the Garden of Eden, he had to work to bring forth the fruits of the earth, while his spouse must henceforth suffer to give birth.

In order that his favourite creature might come to him, God made a covenant with him – a testament. Then, to make this covenant perfect, he sent his Son. His Son is man and he is God. He is the anointed of the Lord, the Messiah, the Christ.

Christ lived as a man and he spoke the word of God. He died as a man, crucified, along with others who had rebelled against the authorities of the Roman Empire. But his death was a sacrifice. It was willed by God to allow all men, for all eternity, to redeem the original sin of their common

In this painting, Westphalian artist Gert van Lon presents various scenes that explore the meaning of Christ's sacrifice in terms of human salvation. In the lower section, the Virgin, flanked by two apostles, Philip on the right, and James the Less on the left, receives the Annunciation from the archangel Gabriel. The upper part of the work is structured around the Crucifixion. On the right is a depiction of Christ the Good Shepherd, carrying a lamb on his shoulders. The choice of such a theme is significant, for it establishes Christ as the sole guide for lost sheep. On the left, Christ prays in the Garden of Gethsemane, a scene that heralds the replacement of the old covenant by the new, symbolized by the Cross. This motif is further developed in the background, where the sun is setting in front of the Temple of Jerusalem, and angels are rejoicing over the Good News.

The pictorial message is underscored by the text on the scrolls. The Cross bears the name of the kinds of wood it was believed to have been made from: cedar, palm, cypress and olive. These evergreen trees were symbols of eternity.

FACING PAGE

Allegory of the Redemption
Gert van Lon, Westphalia, Germany, ca. 1475.
(Painting on oak panel, 53.5 × 38.5 cm;
© Westfälisches Landesmuseum für Kunst und
Kulturgeschichte, Münster / Permanent loan
from the Westfälischer Kunstverein,
57 WKV; photo: Sabine Ahlbrand-Dornseif
and Rudolf Wakonigg)

St. Jerome translating the Bible
Albrecht Dürer, *Epistolae*, Basel, Switzerland,
Nicolaus Kesler, printer, 1497. (Wood engraving;
© Museum Catharijneconvent, Utrecht, inv. no. BMH
Warm i 1263G4; photo: Ruben de Heer)

FACING PAGE

The Trinity or Paternity
Grandes heures de Rohan [Rohan Hours]
Rohan Master, ca. 1420, (© Bibliothèque nationale
de France, Ms Lat. 9471, fol. 210r°)

ancestors. The Cross was no longer an instrument of torture, but the proclamation of a victory, the final victory over the forces of evil.

Men now knew the path they must follow to reach heaven: that of Christ. And his teachings would be repeated to the end of time, thanks to his mediators.

...Which Begat the Holy Writ

The written text was the first mediator. The word of God had been conveyed to man by the Jewish patriarchs, by the prophets and by his Son, the Christ. Unfortunately, these men wrote nothing, and since the message might be lost, the Word had to be transformed into Writ and into History. Thus was the Bible born.

It took shape over a little more than a thousand years. Divergent versions of the Word were composed in a number of languages: Aramaic, Hebrew, Coptic, Syriac, Greek – a written testimony to the diaspora of the Jews and early Christians. The Bible text became fixed towards the fifth century, at the dawn of the Middle Ages; or rather, it was when the Bible began to take definite form that the Middle Ages, a civilization based on the Bible, were ushered in.

In that development, Saint Jerome, at the turn of the fifth century, played a major role. To provide the West with a comprehensible text, he translated into Latin, from their Greek versions, the Jewish books of the Old Testament and the Gospels. Thus the Vulgate, the first great version of the Latin Bible, which would permeate the Christian world until the Reformation, in the sixteenth century, began to take shape.

The Bible of Saint Jerome bore little resemblance, however, to editions found in bookstores today. The Bible was not yet one single book, but a set of disparate texts. The copyists who followed in Saint Jerome's footsteps worked with incomplete versions, which they sometimes transcribed awkwardly. Texts were copied separately in response to needs: thus the Song of Songs, which expressed *caritas* through the sublimated language of love, thus the Gospels in evangeliaries and the psalms in psalters.

In the ninth century, Carolingian sovereigns sought to obtain a uniform Bible text throughout their kingdom. Two centuries later, the Popes took a similar initiative in the hope of transforming the West into a unified Christendom. Then began a new age of the Bible: finally stabilized, its text became the object of commentaries, or exegesis. Each verse was considered to have several meanings – four in the view of twelfth-century theologians – all of which begged to be explored.

During the same period, the Bible emerged from the monasteries and ecclesiastical schools. In towns and seigniorial castles, it was on Holy Writ that oaths were taken. On battlefields, some would brandish the Bible against the enemy; others would tuck it under their clothes when undertaking a dangerous mission. It was reproduced in increasingly smaller formats and almost reached pocket size by the thirteenth century, before the printing revolution made it widely available. Church walls, portals, stained glass and manuscripts too were saturated with biblical imagery. Thus anyone could take in the message of the Scriptures visually, if unable to read them.

The Light of Angels

On the first day, God created light so that there might be knowledge, and so that men might be guided by it. Along with light, he created the angels. The Bible did not quite say so, but all the exegetes since late Antiquity agreed on this point. *Fiat lux:* "Let there be light: and there was light," and the angels along with it, since they were creatures of light.

Creatures of light and creatures of spirit, the angels were invisible, except in rare cases when they had to warn men of imminent danger or, in other words, when they had to open the eyes of a human and give him a measure of enlightenment.

In the fifth century, Saint Augustine, the Church Father to whom the Church owes so much of its dogma and structure, defined the chief characteristics of angels. Thereafter, they would haunt the medieval universe and imagination. In the hierarchy devised during the seventh and eighth centuries by Pope Gregory the Great and by Pseudo-Dionysius, the angels were distributed into nine celestial choirs: the Seraphim, the Cherubim and the Thrones, the Dominations, the Powers and the Virtues, the Principalities, the Archangels and the Angels. Exegetes and image-makers invented attributes to differentiate them. The Seraphim, at the top of the scale, were graced with six wings, the Cherubim with four, the others with only two. The Archangels were characterized by specific functions: they fought the devil and protected the Christian flock. After much wavering, opinion settled on three of their number: Michael, Gabriel and Raphael.

One angel, the most resplendent of all, was called "the bearer of light:" Lucifer, from *lux*, light, and *ferre*, to bear. He was the most beautiful as well as the most beloved of God. Spurred by pride, he aspired to yet more splendour, but his vanity brought him down, along with other rebel angels, into the depths of hell. From angels, they became demons; from bearers of light, heralds of darkness. Beware of such creatures, ever prompt to assume seductive guises in order to deceive men and turn them away from the light.

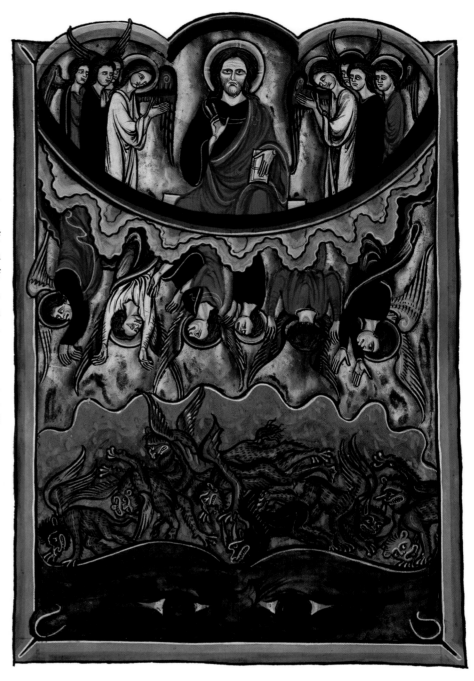

ABOVE

The fall of the rebel angels
Psautier de Blanche de Castille et de Saint Louis
[Psalter of Blanche of Castile and St. Louis],
between 1220 and 1230.
(Bibliothèque de l'Arsenal, Ms 1186, fol. 9v°,
© Bibliothèque nationale de France, Paris)

FACING PAGE

Angel reliquary
From the treasure-house of the Abbey of Grandmont,
France, ca. 1120–1140, 13th century (upper part).
(Enamelled, gilded copper, rock crystal, 23.6 x 7.2 cm;
Attributed to the parish of Saint-Sulpice-les-Feuilles
in 1790; Dépôt de la commune de Saint-Sulpice-les-
Feuilles at the Musée de l'Évêché de Limoges,
M.H. 20.06.1891; © Musée municipal de l'Évêché,
Limoges; photo: F. Magnoux)

The Saints as Protectors

The cult of saints took root in early Christian times both because it was vigorously promoted and because Christians felt they were in dire need of protection. The saints became the best agents of the divine. In the fourth century, Saint Ambrose considered that in order to benefit from the protection of a saint, there was no need to proceed to his tomb; mere physical or visual contact with his remains would do. Thus was born the cult of relics, which led to saints being disinterred and their skeletons being scattered literally to the four corners of Christendom. Since it represented the whole, a minute part of the remains sufficed: a finger bone, a lock of hair, a tooth. Saints became the object of an international trade that lasted until the eleventh century. They were taken from the Roman catacombs and from other great sanctuaries. Monks lacking a holy founder would invent one or would steal famous relics from a neighbouring monastery.

Once they had safely arrived, relics would be mortared into altars or chased with gold and precious stones. Saints protected towns, villages and monasteries. Their relics were brought to battlefields or judicial assemblies. Princes wore them in pendants. The faithful took oaths on them and thanked them effusively when their intercession had been beneficial, but did not hesitate to take them violently to task when the saint did not do his job.

To differentiate the increasingly numerous saints, attributes were assigned to them. Saint Peter carried the keys of the heavenly kingdom, which Christ had entrusted to him. Many saints brandished as an emblem of

FACING PAGE

Reliquary
Parish Church of the Décollation-de-Saint-Jean-Baptiste, Nexon, France, 13th century. (Enamelled, gilded copper, wooden core, 27 × 9.2 × 20 cm; Commune de Nexon, M.H. 20.06.1891; © Musée municipal de l'Évêché, Limoges; photo: F. Magnoux)

BELOW

Reliquary
Church of the Assomption-de-la-Très-Sainte-Vierge, Bellac, France, ca. 1120–1140. (Enamelled, gilded copper, stone and glass-paste cabochons, wooden core, 20 × 11.7 × 26 cm; Commune de Bellac, M.H. 20.06.1891; © Musée municipal de l'Évêché, Limoges; photo: F. Magnoux)

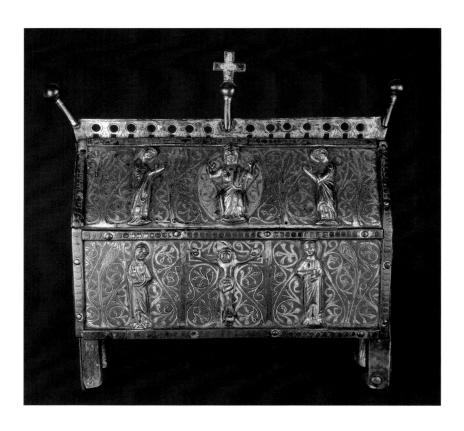

Magi reliquary
Church of Saint-Étienne, Lapleau, France, second
quarter of the 13th century. (Enamelled, gilded
copper, wooden core, 21 × 7.8 × 22.5 cm; Dépôt de
la commune de Laval-sur-Luzège at the Commune
de Lapleau, M.H. 25.06.1891; © Musée municipal
de l'Évêché, Limoges; photo: F. Magnoux)

Crucifixion reliquary
From the Chapel of Saint-Antoine, Saint Frion,
France, third quarter of the 13th century.
(Enamelled, gilded copper, wooden core,
25.5 × 8.3 × 24.5 cm; Musée de Guérêt, OAZ;
© Musée municipal de l'Évêché, Limoges;
photo: F. Magnoux)

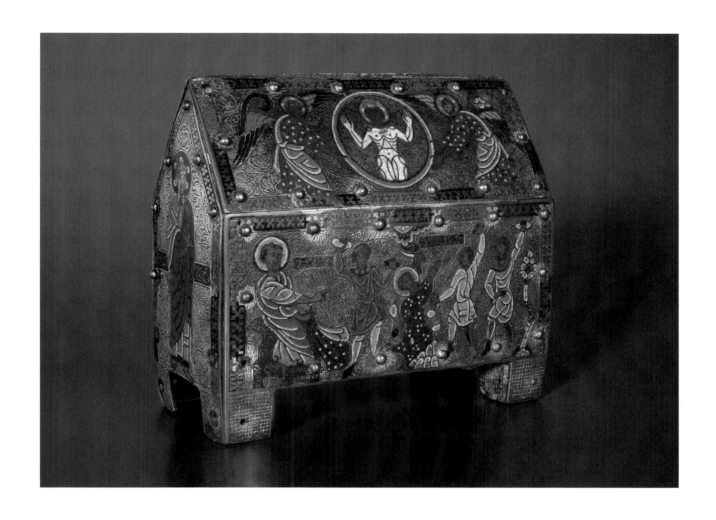

ABOVE

Reliquary of St. Stephen

From the Parish Church of Malval, France, last decade of the 12th century. (Enamelled, gilded copper, wooden core, 13 × 14 × 6.7 cm; dépôt de la commune de Malval at the Musée de Guérêt, OA 6, M.H. 14.06.1898; © Musée municipal de l'Évêché, Limoges; photo: F. Magnoux)

RIGHT

Reliquary of Thomas Becket

Limoges, France, 1200–1210. (Enamelled, gilded copper, wooden core, 12.9 × 12.5 × 6.6 cm; © Musée municipal de l'Évêché, Limoges, 90.458; photo: F. Magnoux)

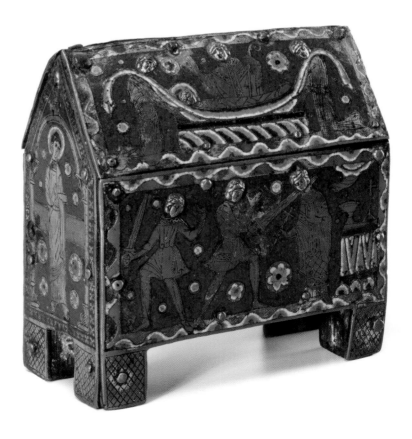

triumph the instrument of their martyrdom: thus Saint Paul, the sword, Saint Stephen, the stones, Saint Catherine, the wheel. Others derived their identifying sign from their names, as in the case of Saint Lucy and light (*lux* in Latin) or Saint Agnes and the lamb (*agnus* in Latin), the latter deriving from the partial homophony of the two words. Saint Martin embodied charity because he had shared his mantle with a pauper, while Saint James displayed the emblems worn by pilgrims on their way to Santiago de Compostela.

Virgin and Mother of All Christians

Even closer to God stood the Virgin Mary. She had sheltered in her virginal body the Son of God, and this placed her in a privileged position to intervene and protect the great spiritual family she had thereby engendered.

By the year 1000, the image of the Virgin in Majesty, sitting on a throne, erect and ageless, had gained general acceptance in the West. On her knees, she carried Christ, a child in stature but already adult in his gestures and his bearing, erect as well, and eternal. Even more than the image of Christ, that of the mother was important. She was invested with authority and seated in majesty, like God.

Virgin despite her marriage, pure although she had given birth, Mary was a model for women and an ideal for monks, who extolled her as Mother of Mercy. As her meekness appeased the wrath of the Father, she could intercede for all. She could be trusted to fight the forces of evil, since she was free of all sin. If prayers were addressed to her, Satan shunned her power and fled.

The image of the Virgin also merged with that of the Church, which was a community of the faithful founded on spiritual bonds. Within the Church, Christians were brothers and sisters by faith and charity, not by blood. The Mother who gave birth without experiencing sexuality and without shedding a drop of blood was an emblem and a model for the medieval Church.

Clerics: Mediators on the Way to Salvation

God made a covenant with his people and, to perpetuate it, he charged the apostles with spreading the Good News. They were twelve, thirteen if one includes Saint Paul, who was

*T*he Virgin of Mercy protectively shields the different orders of society under her outspread mantle. In the foreground are the flagellants, who commissioned this painting with which they adorned their processional banners.

Paintings of the Apostles
[*Left to right*: St. Matthias, St. Thomas,
St. Bartholomew, St. Andrew, St. Philip, St. Peter.]
Left wing of the altar of Vinnenberg, workshop of
Johann Koerbecke, Westphalia, Germany, ca. 1460.
(Painting on oak panel, 53.5 × 58.5 cm;
© Westfälisches Landesmuseum für Kunst und
Kulturgeschichte, Münster / Permanent loan from
the Westfälischer Kunstverein, 40 WKV;
photo: WLMKUK Sabine Ahlbrand-Dornseif
and Rudolf Wakonigg)

first among them to travel long distances around the Mediterranean. After the apostles, others took over. As the lands they evangelized were Greek-speaking, they were called *episkopoi*, supervisors. Thus were bishops born.

The establishment of bishops in Western Europe coincided with the end of the persecution of Christians, following an edict by Emperor Constantine in 312. As the Christianization of the West progressed, new bishoprics were created, most actively between the seventh and twelfth centuries. Like Saint Peter, their great predecessor, bishops could bind and loose, that is bear witness to the membership of Christians in the community of the faithful through baptism and communion, or exclude the unworthy by excommunication.

The seat of the bishop, the *cathedra*, gave its name to his church. Cathedrals were located in cities, and each bishop administered a district, called a diocese or a see, whose limits often matched those of ancient Roman

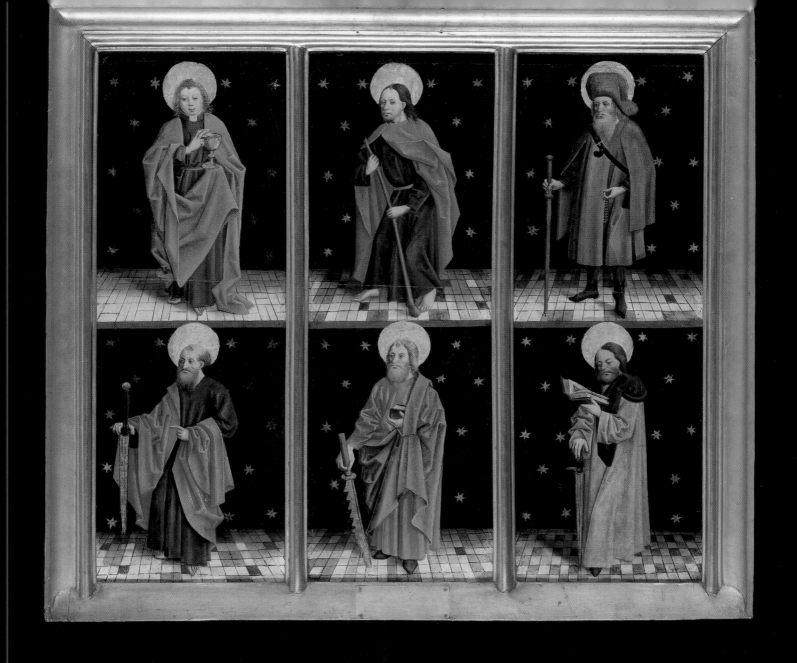

provinces. Bishops had a number of deputies available to them in the country. While archdeacons and archpriests officiated in part of a diocese, curates looked after parishes, at the local level. Certain bishops, called archbishops, supervised an entire province, including a number of sees. The bishop of Rome, called the Pope, literally father, initially exercized only a limited form of authority over his colleagues; what power he did wield was due to the location of his see in the city of the apostles Peter and Paul. Throughout the Middle Ages, however, Popes asserted their pre-eminence to the point of becoming the undisputed heads of the Western Church.

The eleventh and twelfth centuries marked a turning point for the Church, for it was then that a radical separation was effected between clerics and flock. Celibacy, which had previously been only a recommendation, became an obligation for the whole of the clergy. Those who persisted in

Paintings of the Apostles
[*Left to right*: St. John, St. James the Less, St. James the Greater, St. Paul, St. Simon, St. Matthew.] Right wing of the altar of Vinnenberg, workshop of Johann Koerbecke, Westphalia, Germany, ca. 1460. (Painting on oak panel, 53.5 × 58.5 cm; © Westfälisches Landesmuseum für Kunst und Kulturgeschichte, Münster / Permanent loan from the Westfälischer Kunstverein, 39 WKV; photo: WLMKUK Sabine Ahlbrand-Dornseif and Rudolf Wakonigg)

cohabiting with a woman or in marriage were condemned as "Nicolaitan." As for curates and bishops who bought their charge or obtained it through undue influence, they were taxed with "simony," a word derived from the name of Simon the magician, depicted in the Acts of the Apostles as having tried to purchase from Saint Peter and Saint Paul their sacred powers. The monopoly of priests on mediation between God and the faithful was also reaffirmed. At the same time, the ecclesiastic hierarchy was consolidated by the emergence of an army of men in monk's habits, celibate, withdrawn from the world and dedicated to prayer for the salvation of all.

Monks: Specialists in Prayer

The first monks appeared in the West at the beginning of Christianization. From the outset, they formed a kind of elite that withdrew from the restless world of the towns, which they considered irreconcilable with Christian precepts. Retired from the world, these "athletes of God" would be able to devote all their time to prayer, preparing themselves better than others for the day of salvation.

Fragments of a stole and a maniple
Probably France, 14th century.
(*Opus anglicanum* [English work]
embroidery in polychrome silk and gold
thread on linen, 137.5 × 61 cm; © Musée des
Tissus de Lyon, Inv. 1183, 1184, 26973/ 1 and 2,
Rb 121/ 1 and 2; photo: Pierre Verrier)

*T*he maniple (an ornamental band worn on the left forearm by priests), almost intact, depicts the Virgin and St. John on its wider parts. It bears the arms of England, of Castile and of León, as well as those of the Beauchamp family.

What remains of the stole (an insignia of "authority of office" sometimes worn around the neck by bishops, or worn around the shoulders by priests and deacons) pictures St. Stephen and other saints accompanied by an unidentified king.

Bishop's mitre
Italy, 13th century with 14th-century alterations.
(Silk and metallic thread, 88 × 32 × 8 cm; © Musée des Tissus de Lyon, Inv. 23917; photo: Pierre Verrier)

In the sixth century, a monk in the region of Rome wrote a rule for a few brothers at Monte Cassino, a code of regulations destined to a brilliant future. The rule of Benedict of Nursia, soon to be Saint Benedict, was simple, practical and sufficiently flexible to be adapted to various circumstances. As early as the seventh century, it prevailed in a large number of Western monasteries, gradually replacing more rigorous rules such as that of the Irish Columban, which had spread to the British Isles and to Northern Europe.

The monasticism of Saint Benedict, which came to be called Benedictine, was cenobitic. This means that the monks led a communal life under the direction of a superior called the abbot. He saw to the respect of the rule and of the vows made by monks upon entering the community: individual poverty, chastity, stability and obedience. The monastic community was the paragon of spiritual fraternity, of which medieval society knew many variants. Its members were brothers, or sisters, bound by charity rather than by blood. Their role was to pray for their own salvation, but also for that of all Christians who associated themselves in some way with their community.

Such associations became exceptionally widespread between the seventh and twelfth centuries. First kings, then lesser nobles such as dukes and counts, founded monasteries, gave them landed property, churches or seigniorial revenues, in exchange for spiritual benefits. Monastic communities harboured many younger sons of these noble families, who would intercede with God on behalf of their kin. During their golden age, in the eleventh and twelfth centuries, monks practised a seigniorial monasticism, living off the income of their lands and playing a key role in maintaining harmony between the three orders of society.

Medieval monks and religious were specialists in prayer for the dead. The picture on the facing page, structured around a mortuary chapel, features from bottom to top the Benedictines (the black monks), the Dominicans (white robe and black cape), the Franciscans (brown habit tied with a thrice knotted cord) and the Carmelites or White Friars (black robe and white cape).

Cluniac monasticism was the embodiment of this acme. The abbey of Cluny was founded in 910 in southern Burgundy and soon emerged as the mother-abbey of a congregation whose ramifications extended from England to Castile. Eventually, the great monastic family would spread into many branches, complementary rather than opposed. Some monks rejected the most obvious entanglements resulting from seigniorial status and adopted an austere way of life derived from the eremitic model of early Christianity. This occurred at Camaldoli and Vallombrosa in Italy, and later at Cîteaux, Grandmont and the Grande Chartreuse in France, where three new orders appeared around 1100 that would have great futures: the Cistercians, the Grandmontines and the Carthusians.

Leaving the Cloister: Friars and Canons

The regular dimension of the Church continued to adapt as society changed. In the thirteenth century, faced with the growing might of the mercantile bourgeoisie, the Church put forward a model designed to counter that of triumphant commerce and materialism. This gave rise to the mendicant orders, of which the two most prominent were the Franciscans and the Dominicans. The Franciscans emphasized mendicity and the most radical renunciation, whence their name of Friars Minor. The Dominicans were the Friars Preachers, who travelled the roads and public squares to combat the religious deviations termed heresies. Distinctive vestments were adopted to distinguish among the ever more numerous communities. The Benedictines, on the model of Cluny, were the black monks. Advocates of greater rigorism, such as the Cistercians and the Carthusians, opted for the white or ecru robe. The Franciscans wore a brown habit tied at the waist with a thrice knotted cord, while the Dominicans chose a white robe worn under a black cape.

Around the same time, canons also joined the religious landscape. They were first introduced during the Carolingian period to assist bishops in the area around their cathedrals, but they branched out into various communities from the twelfth century on. Unlike monks, they were allowed individual possessions and were assigned missions that took them outside the cloister. The Norbertines and the canons of Saint-Ruf or of Saint-Victor devoted themselves to teaching; the Hospitaller canons cared for pilgrims and the sick, and were particularly active on pilgrimage routes and in the Latin states conquered by the Crusaders. There they worked alongside the Templars – knights who undertook to defend Christian possessions in the Holy Land while living as canons.

As for women, who until then had been poorly integrated into the Church, they were offered the religious life as an alternative to Christian marriage. Cloistered monasteries, as well as convents for canonesses, where women devoted their lives to God while carrying out charitable works, became increasingly common features of towns from the twelfth century on.

The Eucharist: A Ritual Mediator

Not everyone was in a position to give lands to monks or to send one of their offspring to a religious community. Most people hoped to find their salvation through worship, in particular through regular mass attendance.

As in most religions of Antiquity, Christian worship was marked by sacrifice. But unlike religions in which an animal was sacrificed, that of the Christians was symbolic. The crucifixion of Christ had made ritual animal sacrifice obsolete, for the man-God had sacrificed himself. Christian worship thus took the form of the ritual and symbolic commemoration of this founding sacrifice. Every Sunday, a priest re-enacted in the church the ceremony of the Last Supper, when Christ announced his imminent sacrifice to his disciples. This was the Eucharist, in which a priest consecrated the bread, symbol of Christ's body, and the wine, symbol of his blood. The symbolic sacrifice was performed by consuming the consecrated species. The priest ate the host and drank the wine in the chalice, and the members of the flock participated by consuming the body of Christ in the form of the consecrated host. By so doing, they declared that they belonged to the fraternal community of the faithful; hence their act was called communion.

PAGES 122-123

Fragments of a funerary ornament
Winged hourglasses, Cross with the Instruments of the Passion and coffin topped by a portable altar. Northern Netherlands, ca. 1550–1580, (Linen embroidered with silk, gold and silver thread, 13.5 × 12 cm, 35 × 17 cm, 19 × 9.5 cm, 13 × 17 cm; © Museum Catharijneconvent, Utrecht, BMH t9591 a,b,c and d; photo: Ruben de Heer)

While the mass originated in the Last Supper, the overall ritual was put together only gradually during the Middle Ages. Sunday observance became generally established during the sixth century, but the readings before communion would vary considerably from one region to another, despite attempts at standardization by Charlemagne and by Pope Gregory VII. The missal was created in the eleventh century: it brought together in one volume the texts of prayers and readings for the mass that were previously contained in separate books. Portable altars were also introduced so that mass could be celebrated in unconsecrated places.

PAGES 124 AND 125

Missale itinerantium **[Travelling missal]**
Northern Netherlands, for the diocese of Utrecht, ca. 1480–1490. (Parchment, 10.2 × 7.2 cm; © Museum Catharijneconvent, Utrecht, ABM h5; photo: Ruben de Heer)

In the ninth century, debate arose over the Eucharist. Did the consecrated bread and wine really contain the body and blood of Christ? The issue was not settled, but would come up again during the eleventh and twelfth centuries, before becoming the object of an article of faith at the Fourth Lateran Council, in 1215. Pope Innocent III, who presided over the Council, proclaimed the dogma of transubstantiation: in other words, through a change in substance, the host and the wine consecrated at mass were no longer bread and wine, but the true body and the true blood of Christ. Accordingly, the consecrating priest might be perceived as a sort of magician, and his role as an intermediary between God and man become more firmly established.

The actual presence of the body of Christ in the host led to new practices. Consecrated hosts were regularly displayed on church altars so that the faithful, while they were unable to see God, might see the body of Christ. In 1264, Innocent IV initiated the practice of showing the consecrated host

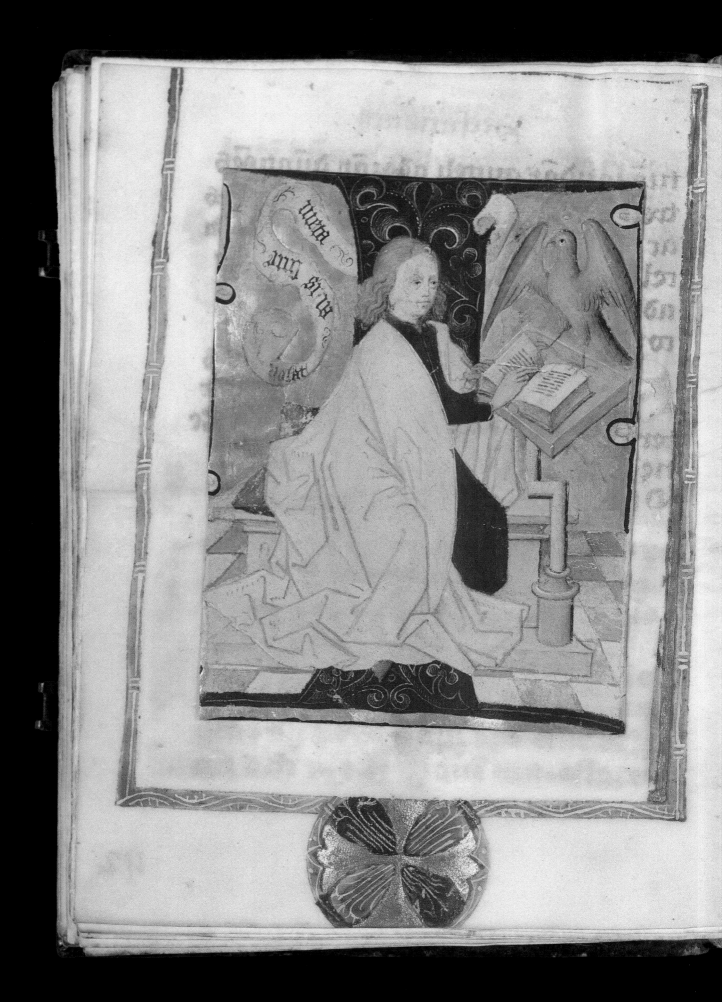

E igitur clemē
tissime pr̄ per
iḧm xp̄m filiū
tuū diñ nr̄m
supplices roga
mꝰ ac petim̄?. vti accepta
habeas t bn̄dicas Hec ✠ do
na. Her ✠ munera. Her ✠ s̄cā
sacrificia illibata ✠ In pri
mis q̄ tibi offerimꝰ pro ec
clesia tua s̄cā catholica. quā
pacificare. custodire. adunare
t regere digneris toto orbe t
rar̄ vna cū famulo tuo P̄P̄ pa

Chalice used by Archbishop Melton of York
Ca. 1335. (Gold, diam. 11 × 14 cm;

Ring worn by Henri Bowet, Archbishop of York
Ca. 1407. (Gold and sapphire, diam. 2.5 cm;

Paten used by Archbishop Melton of York
Ca. 1335. (Gold, diam. 13.5 × 0.8 cm;

(Dean and Chapter of York; reproduced
with the kind permission of
© Dean and Chapter of York)

during a procession on Corpus Christi (Feast of the Blessed Sacrament). Miraculous hosts became the stuff of legends that, in various ways, lent credence to the concept of transubstantiation. In contrast, the profanation of hosts was from then on held to be the best way of showing hostility to the Church; when wounded, they would bleed.

A Lifelong Framework of Sacraments

Through communion, the faithful were spiritually united to Christ. This action was a sacrament, a sacred sign, whose visible element was accompanied by an invisible consequence – the virtue of the sacrament.

During the early years of Christianity, there were only two sacraments: baptism and the Eucharist. Their number increased until it was set at seven in the mid-twelfth century: baptism, confirmation, the Eucharist – three sacraments of Christian initiation – penance, matrimony, the unction of the sick and holy orders. From then on, the seven sacraments framed the entire life of Christians, from birth to death.

Baptism marked admission into the fraternity of Christians. Confirmation was a second baptism given at the "age of discretion," between the ages of 12 and 14. Penance was the punishment imposed on the faithful in the event of sin. Matrimony consisted in the exchange of consent between a man and a woman in the presence of a priest who blessed the union. The unction or "sacrament of the sick," which was administered by a priest, involved the laying on of hands and an unction of oil on the body of the sick in order to bring about their recovery. By the twelfth century, this sacrament was usually administered only to the dying to ensure a last remission of their sins – hence the name extreme unction. The holy orders were the sacrament by which one became a priest, and was entitled to celebrate mass and administer the sacraments.

Even after their number had been fixed at seven in the twelfth century, the sacraments continued to evolve. As indicated, the doctrine of the Eucharist underwent a major shift at the Fourth Lateran Council, in 1215. On that occasion, the sacrament of penance was also modified. Secret, auricular confession to a priest was established as obligatory for all once a year. Sin became a personal, internalized transgression, declared in the secrecy of the confessional.

The Church: A Vast Spiritual Family

Since there were no clear boundaries between Church and society, Christian sacraments were invested with eminently social virtues. Baptism was seen as a second birth: godfather and godmother acted as new parents who would transmit Christian education to their godchild. In addition to his earthly family, a newly baptized child would henceforth belong both to a small spiritual family, composed of his godfather and godmother, and to a vast one, the community of the faithful.

Clerics represented a particular branch of this spiritual family. Although theoretically excluded

Pyx
Limoges, from Montgauthier, Belgium, second quarter of the 13th century. (Champlevé copper, enamelled, engraved and gilded, 11.1 × 6.2 cm; © Musée des Arts anciens du Namurois, Société archéologique de Namur coll., Réserve Inv. no. 7; photo: Luc Schrobittgen, Bruxelles)

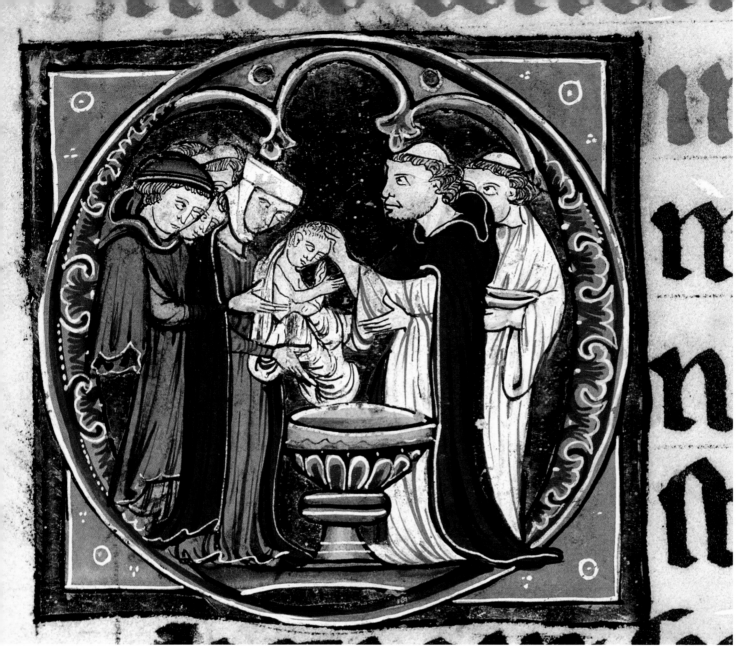

Baptism of a child by infusion
Pontifical à l'usage de l'église de Beauvais
[Pontifical for the Church of Beauvais],
13th century. (© Bibliothèque municipale
de Besançon, Ms 138, fol. 143v°)

from marriage and sexuality, they were nonetheless highly productive. As the only ones allowed to administer the sacraments of baptism and confirmation, they constantly created new Christians and generated new members for the spiritual family of the *Ecclesia*. It could even be said that they self-reproduced when they ordained one of their own to the priesthood, thereby increasing the number of Fathers of the family that was the Church.

Nor was the laity excluded. The parish was a spiritual community of equals gathered together around the same place of worship. In both town and country, crafts, confraternities, communes, parochial church councils, and merchant guilds each constituted a spiritual family.

Blood Ties and Sexual Constraints

As the spiritual family was meant to supersede bonds of the flesh, the Church spared no effort to control marital unions. This process began in the fourth century and culminated in the twelfth, when matrimony became a sacrament. Henceforth, the union of man and woman was sealed by God and modelled on the union of Christ and the Church. Marriage was indissoluble, which prohibited divorce and repudiation, which had been authorized under

Roman law. The consent of the spouses had to be exchanged in the presence of a priest who blessed the union. Since such contracts had to be concluded in public, it became mandatory to publish the banns in the parish of each spouse. This delay between the public announcement of the wedding and its conclusion made it possible to enquire into possible consanguinity. Indeed, the notion of incest had been extended to intermarriage up to the seventh degree of consanguinity. Marriage to a person previously married to blood relations, and later to a godfather, a godmother and their blood relations, was also prohibited.

Such control extended to the intimate relations of couples. Treatises were written and then debated between masters in universities to determine the right – and the wrong – way of performing "the act." Copulation must aim at reproduction, not at pleasure, otherwise it was mere fornication. It was recommended not to couple on Wednesdays and Fridays, which were fast days, nor on Sundays and feast days. Theologians only authorized the man-on-top sexual position and those who would try others were warned they might beget monsters or lepers. The Church also vigorously condemned the practice of contraception by consuming decoctions of mandrake, by stifling the foetus in the womb or by provoking "accidents" following birth. As for sodomy and *coitus interruptus* practised to avoid pregnancy, they were denounced as amounting to fornication.

In bedrooms, however, such condemnations and threats were soon forgotten. Couples were less concerned with avoiding transgression than with finding ways to avert its visible consequence. It would seem that contraception and abortion were practised at all levels of society during the Middle Ages. Ecclesiastical tribunals appointed to see to the respect of regulations pertaining to marriage apparently met with little success. And how could consanguinity be traced to the seventh degree? Not to mention that registries of civil status did not exist in the Middle Ages... Prohibitions were all the more difficult to enforce since, from the eleventh century on, seigniorial families arranged marriages with their closest relatives in order to firmly establish their status and to strengthen their ties with their peers. In rural areas, many couples exchanged their consent without the presence of a priest, thereby avoiding the mandatory marriage gift to the curate. For most people, what mattered most was still mutual consent, a principle that dated back to Antiquity.

The attempt to exert control over divorces and repudiations was hardly more effective. And since the Church had broadened the grounds for annulment of marriage, one such ground could always be

A shivaree
Roman de Fauvel [Romance of Fauvel], Gervais du Bus, 14th century. (© Bibliothèque nationale de France, Ms 146, fol. 34r°)

invoked to justify separation. Impotence in husbands, the exceeding youth of one of the spouses at the time of the wedding, performance of marriage during prohibited periods such as Advent or Lent, or a blood relationship suddenly "discovered," all could serve as arguments in either direction. The Church then had to adapt its position. In the thirteenth century, the definition of incest was revised to extend only to the fourth degree of consanguinity. As for annulments, Popes granted them in increasing numbers, for a consideration, to persons of high rank who requested them.

The Church's effective failure to control practices relating to marriage offers us a glimpse into the very heart of medieval society. There is no denying that the Church was, above all others, the institution that was intended to structure society. However, as it sought to exert day-to-day control over society in general and social relationships in particular, it kept triggering resistance rooted in tradition or in newly emerging interests.

The Problems of the Kings

Royalty was polarized between two Biblical models. At one extreme, David and Solomon, chosen by the Lord and anointed by his prophet, guided their people on its way to salvation. At the other, Herod Antipas, the "negative" king of the New Testament, was responsible for the slaughter of the Innocents.

In addition to Biblical models, the Augustinian conception of the City of God was widely adhered to. According to Saint Augustine, only the heavenly city deserved the name of kingdom, and only God, reigning over the souls of the blessed, was a true sovereign. Earthly kings had no legitimacy unless they were guided by priests. Their prime function was to restrain the flesh for the good of the soul.

In the seventh century, the Visigothic kings of Spain revived the Biblical tradition of anointment and were soon followed in this by Frankish and Anglo-Saxon kings. Like the Jewish kings of the Old Testament, they thus became "the Lord's anointed," blessed by a miraculous oil deemed to have come from the Holy Spirit. Royal anointing made kings into thaumaturgists, miracle workers. By the laying on of their hands, blessed by sacred oil, they could cure scrofula, an inflammation of the glands in the neck caused by drinking polluted water. Similar in this to clerics, kings became mediators

qs noz. pecado, ypolia ali ali
filoz frange. vin h d ul meal ige
pie g illoz ofesu divini.

between God and men. On their charters, their coins and their seals, their style bears witness to this: *Gratia Dei rex*, "king by the grace of God."

The Church, however, exercised no direct power over sovereigns. On the contrary, by fulfilling ever more assiduously the "program" of the Church, kings gained such legitimacy that they came to consider themselves independent sovereigns. During the thirteenth century, when they assumed the leadership of Crusades, royal sovereignty became even more firmly established. Thus promoted to the rank of Knights of Christ, kings emerged as undisputed heads of their realms and leading figures in the seigniorial class.

It would be wrong to interpret this as a sign of secularization in medieval society. It was because kings had perfectly integrated their mission on behalf of the Church that they drew from it a new legitimacy. Certain far-seeing clerics already glimpsed at the time the inevitable consequence – that one day kings would no longer need the Church to govern; but such an evolution was foreign to the Middle Ages. Although a number of monarchs, between the thirteenth and fifteenth centuries, equipped their kingdom with a centralizing capital, an Audit Office, States General and a Parliament, secularized states would not appear before the seventeenth century and even so, would emerge very slowly until the nineteenth century. Before that time, kings were kings first of all for the salvation of their people.

Imperial Nostalgia

The Janus-like alliance between priesthood and royalty found particular expression in the imperial institution. For remember that the Middle Ages were ushered in by the collapse of the Roman Empire, and the memory of this empire would remain very much alive as an achievable, if distant, ideal.

BELOW AND FACING PAGE

Leopard-patterned embroidery
England, ca. 1300–1330. (Velvet, silk, partially gilded silver thread, cabochons, pearls, 124 × 51 cm; Paris, Musée national du Moyen Âge, Thermes de Cluny, Inv. Cl. 20367; © Photo RMN-Hugo Maertens)

*M*ade into a chasuble in the 18th century, these fragments are thought to have originally been part of a ceremonial horse cover used at the court of King Edward III of England (1327-1377).
The leopards, symbols of the English crown, stand out from a foliated background of figures young and old, representing the world of the court.

From the 9th century on, the education of monarchs was entrusted to clerics. An illiterate king is a crowned ass, as the saying went. So a new literary genre was born: the mirror of princes, a list of virtues of sorts, designed as a guide to proper royal conduct. Example was added to virtue in history books, whose imagery focussed on the temporal path leading from virtue to salvation. Recording world history in full required time and money, however, especially when it reached such colossal proportions as the encyclopedia written by the Dominican monk Vincent de Beauvais. The king of France, Louis IX, participated in this undertaking, which was dedicated to him. A hundred years later, it would cost Charles V a considerable amount of money to have the monumental work translated into French.

ABOVE AND FACING PAGE

Speculum historiale [Historical mirror], part 1
Vincent de Beauvais (ca. 1190–1264), Monastery of St. Ulrich and St. Afra, Augsburg, Germany, 1474,
(Wood and paper, 30 × 41 × 8 cm; Musée de la civilisation, dépôt du Séminaire de Québec, Inc. 28)

Incipit Prologus Fratris Vincencij
Burgundia Ordinis predicatorum in lib[ro]
qui dicitur Speculum Hystoriale.

ILECT=
deo et homini
viro christia
simo Franco
dei gratia cla
simo Prima
Ludouico
ter Vinceno
christi seruu[s]
utilis i futuro
gno cu salute

pace ppetua. Sup dece ciuitates habere p
statem. in pñti quoqʒ seculo non modo pp
vnius anguli principatu ac regale fastigiu
magis aute ob totius ecclesie militantis ac
dei christiane qdda singulare presidiu: deb
nichilominus a cunctis mortalibus reuere

After the fateful date of 476, the Empire survived at first East of the Mediterranean, with its capital in Constantinople, the former Byzantium. However, the Byzantine Empire – or the Roman Empire of the East, as it was then called – was unable to reassert its control of the West, where several independent kingdoms eventually arose. On December 25 of the year 800, Charlemagne took a momentous step. He had himself crowned by Pope Leon III as "Augustus Emperor governing the Empire of the Romans." Byzantium's claim to the West was voided.

Charlemagne defined the new figure of the medieval emperor, crowned by the Pope, governing in close cooperation with the Church and, if need be, dictating its conduct. What singled out such sovereigns was a greater degree of authority than that of kings, even though they might rule over smaller territories. Several Carolingians were crowned emperors in the ninth century. The succession was assumed in 962 by a Saxon dynasty, the Ottonians, who restored the Empire. In the twelfth century, it took the name of Holy Roman Empire.

From the ninth century on, the imperial title was the prerogative of Germanic kings, Ottonians and later Salians and Hohenstaufen. Relations between Church and Empire remained cordial until the eleventh century, but the later evolution of the two institutions undermined the dialogue on which their alliance had previously rested. Strengthened by its network of dioceses, monasteries and parishes, the Church became a powerful institution dominated by the Pope. Emperors, drawing their legitimacy from their mission of defending the Church and inspired by nostalgia for imperial Rome, claimed the right to exercise their *dominium* over the Western world. Between the two, confrontation became inevitable. At the height of the struggle, Popes excommunicated and deposed emperors, who in turn engineered the election of "antipopes." Their contest reached heights of hostility under Gregory VII and Henry IV (1075-1077), under Frederick I Barbarossa and Alexander III (in about 1160-1180) and under Frederick II Hohenstaufen and Innocent IV (1245). Italy was at stake in all these conflicts. Towns and merchant guilds made the best of a bad situation by negotiating their allegiance to one side or the other. Families were torn between the Guelphs, supporters of the Pope, and the Ghibellines, supporters of the Emperor.

The Days of Princes

Whether they were kings, emperors or even bishops, the holders of *auctoritas* and of *potestas* were princes, from the Latin *principes* meaning "the first." This title, already used in the Roman Empire, acquired particular significance in the Middle Ages. Kingdoms were not centralized states at the time: although most people knew the name of their king, they were aware that justice, the army and taxes were in the hands of local princes by delegation of the king's authority.

In the seventh century, Merovingian kings appointed princes in the more remote regions of their kingdom. These were called counts (from the Latin *comes*, companion), dukes (from *dux*, chief), rectors or *patricii*, the first two terms rapidly taking precedence over the other two. Carolingian kings created yet more princes, whose titles varied according to the

FACING PAGE

Alb given by Emperor Frederick I Barbarossa to the bishop of Utrecht
Sicily, Italy, ca. 1150. (Linen embroidered with silk and gold thread, 180 × 173 cm; © Museum Catharijneconvent, Utrecht, OKM t91; photo: Ruben de Heer)

type of region entrusted to them. If they administered a march, a frontier zone, they were called marquis, or margraves in Germanic lands. These various designations did not denote any particular hierarchy. Some influential dukes ruled over several earldoms, while others, poorer than a marquis, held their exalted title only because it had been granted long before under that appellation.

Hierarchies were established mainly as a result of the personal history of princes. Following judicious marriages, some princes came to rule over vast principalities. Such was the case of the dukes of Aquitaine, the counts of Barcelona, the counts of Flanders and the dukes of Savoy, Burgundy, Brittany or Normandy. In Germanic lands, the weakness of imperial authority and conflicts with the papacy served to reinforce regional autonomies. The princes of Saxony, Thuringia, Brandenburg or Bohemia ruled over hereditary principalities that they organized like kingdoms.

Throughout Europe, territorial princes conspicuously modelled their rule on that of kings. They borrowed from royal style the formula *gratia Dei* – by the grace of God. They went on Crusades, built themselves magnificent castles, created parliaments and assemblies on the model of royal institutions and sometimes went so far as to wear the crown. Like the kings, they were expected to behave as Christian princes, to protect clerics and churches and to lead their people to salvation.

Lords, Vassals and Fiefs

Deep-seated alliances united members of the lay aristocracy. Their daughters were given in marriage to the sons of their own kind; oaths of homage made by vassals reminded them, if need be, that they belonged to a class apart. Feudal homage involved two persons, an overlord and a vassal, the latter acknowledging his inferiority to the former by "commending" himself to him. First introduced into Merovingian society, this institution took final shape in the tenth and eleventh centuries.

He who wished to "commend" himself to a more powerful figure would come forward bare-headed and unarmed, then kneel and place his clasped hands in those of his master to-be. The overlord would close his hands over those of his vassal as a sign of acceptance. Standing, his right hand resting on a sacred object – a relic, an altar or a Bible – the vassal then took an oath of fealty. In exchange, he obtained the protection and friendship of his lord. Their union was sealed by a kiss on the mouth.

Keeps and Castles

AMONG THE MANY EXPRESSIONS of a man's *auctoritas* was his lifestyle, and few could claim to live like princes without dwelling in a castle. In the year 1000, however, only a handful of lords enjoyed princely quarters. To the modern observer, castles from this period seem like oversized huts. Most often, they amounted to little more than a wooden keep built on a small, manmade hill called a motte, which was surrounded by a circular ditch and a timber palisade. Clustered around these defences were shacks serving as shelter for livestock, harvested grain or serfs in the lord's service.

In the twelfth century, as aristocratic lineages settled permanently on their lands, stone construction became more common. Mottes gave way to naturally fortified sites that dominated the nearby landscape, enabling the castle's occupants to engage in long-range surveillance and to better prepare their defence. Palisades were replaced by crenelated stone walls flanked by circular towers. Projecting parapets were pitted with hoards and machicolations, through which various missiles could be dropped on assailants. Standing at the centre of the fortifications was the keep, also known as the *donjon*, the dungeon. Its initial square design was eventually replaced by a circular one, better suited to deflecting projectiles and ensuring effective watches.

Beyond their primary function as strongholds, refuges and workshops, castles were also designed simply to impress. Residential quarters spread out around a closed courtyard. At the centre of the first floor was a large hall, the *aula*, where the prince's lavish banquets took place. The walls were adorned with tapestries, the furniture was sumptuous, and the family's coats of arms were carved above doorways and recessed fireplaces. The castle's chapel was often built near the *aula*. Kitchens and workshops were on the ground floor, while servants were lodged yet further away, in the castle's outer court, known as the bailey.

At the end of the Middle Ages, residential concerns overrode defensive ones, and fortified castles became a thing of the past. They would be replaced by U-shaped castles, and then by rectilinear designs, which became prevalent in the sixteenth century. ∎

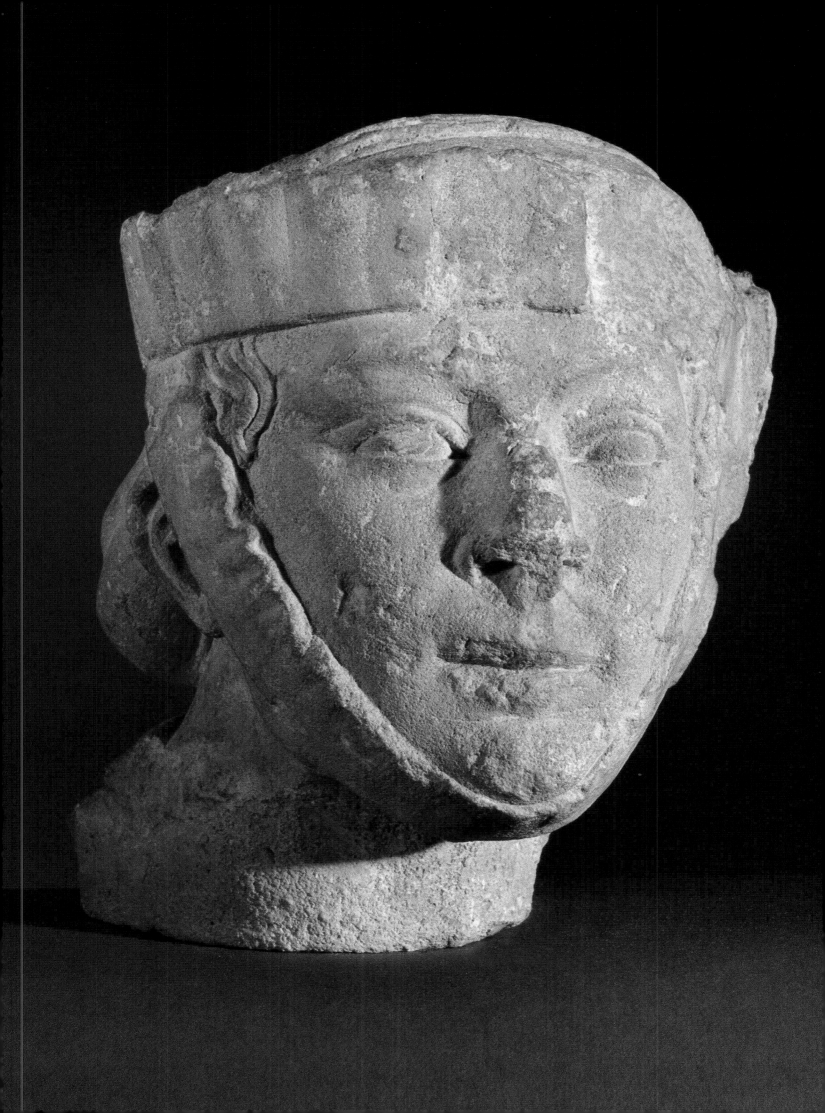

Vassalage was an honourable dependence. To declare oneself vassal of another admittedly implied acknowledging his authority, but it also marked one's membership in the great family of the ruling class. Any lord, from the most insignificant village lordling all the way up to the king, was bound by a number of oaths of homage. He was at once the overlord of one weaker than him and the vassal of one more powerful. Theoretically, kings were vassals to none, save to God, the true Lord, but one king might swear homage to another to consolidate their alliance.

Homage almost always involved an enfeoffment. The overlord would entrust to his vassal a certain number of lands to enjoy and bequeath, on condition of regular renewal of his homage, of service of arms and sometimes of the yearly payment of small dues. During this ceremony, the lord would hand over to his vassal a symbolic object representing the fief or the beneficiary, for instance a staff, a wisp of straw, a lump of earth, or even a lance or a cross. Should the contract be broken, the symbolic object was thrown at the perjurer's feet by way of defiance, that is, as notice of renunciation of the sworn fealty.

Battles and *Bellatores*

In the opinion of Saint Augustine, as well as that of medieval theologians, clerics were not suited to war. And those who worked the land had neither the time nor the means to wage war. In accordance therefore with the distribution of functions inevitable in any social organization, war was reserved for those who governed, soon termed "those who fight," the *bellatores*. Another factor, in addition to task sharing, was the principle that war should be just. In Christian terms, this meant that it should be a means to restore peace and that, as far as possible, it should not pit Christians against one another.

It is easy to see how such principles would evolve. As the seigniorial class expanded and the Church sought increasingly to control social relations, ethical standards were imposed on the conduct of warfare. Shortly before 1000, certain bishops and abbots called together the *bellatores* of their region to preach to them the "Peace of God." The meeting was held in grand style,

Homage of Edward I, King of England to Philip IV the Fair, King of France (1286)
Grandes chroniques de France
[Great Chronicles of France], illumination by Jean de Fouquet, 15th century. (© Bibliothèque nationale de France, Ms FR. 6465, fol. 301v°)

aultres choses quil auoit ou royaume
de france z que de cellui roy tenoit z
possidoit. Et puis icellui roy sen vint
a orleans z cheuaucha tant quil arri
ua en la cite de bourdeaux la maistre
cite de gascoongne z y tint vng trait
parlement ou quel lieu il receut plust
messages despaigne z fut souspecone
quil ne pourchassent aucune traison
enuers le roy philipe de france de
son royaume mais toutesuoiez paura
icellui edouart la deliurance du prie
de salerne son cousin qui estoit prins
des seillens enuers alphons le roy
darragon qui tenoit icellui en sa pri
son. Et en cestu an ensuiuant ou
moys de septembre trespassa de cesie
cle mahy abbe de saint denis en frace
princapal conseill du royaume de
france / lequel abbe mahy le moustie
de saint denis de sa maison comencie
de merueilleuse et coustable euure p
moult de temps par vng peu de la
moyenne partie iusques au dernier
consoma z fist z parfist labbaye de
saint denis en la quelle sont moult
de choses edifiees auoit trouuee de va
stee aussi comme de nouueaulx murs
z de maisons z de salles z de belle
de noble euure rappareilla et rendit
en son temps aussi amendee et en ri
che et en moult de bonnes rentes la
creut z esleua par lendoctrinement
du quel z mesmement de sa religion les
moynes dicellui lieu esmeuz et ente
chiez furent pluss ad ce establie et
faiz abbes en diuers moustiers ap
lequel fut abbe de saint denis mons.
regnault qui fait de la nacion de paire
le. ij. chap. parle coment le roy de chipre
fut coronnie a roy de ierusalem.
en lan de grace ensi mil ij. iiij.
xiij. en acre la cite de surie le roy
de chipre se fist ou preiudice du roy
de seale coronner a roy de ierusalem z
pour que icelle chose les templiers z
les hospitalliers sauoient souffert
tous leure biens quilz auoient par

le premier chap. parle coment le roy edouart
dangleterre fist hommage au roy de france.
pres ce que le roy phe qui fut
filz de mons. saint loys
fut mort regna en france
philipe le bel son filz et re
gna xxviij. ans z comen
ca a regner lan de lincarnacion mrs.
mil deux cens quatre vins z six. En
ceste annee alphons filz du roy darra
gon commenca a regner ou royaume
darragon apres la mort son pere et
iaques son frere auecques sa mere con
tence z occupa la terre de seale contre
conbiaon z comendement de leglise
de rome. En ce temps ensuiuent pape
honnore la sentence que son deuancier
auoient pronunciee contre pierre dar
ragon z iaques son filz z alphons
constance leur mere en icelle enfermette
et en cest enditement conferma. En
ce mesmes temps z annee edouart
filz au roy dangleterre en france appel
le fut hommage du roy phe de france po
la duchie dacquitaine et de toutes

The Symbolism of Hunting

Over the course of the Middle Ages, lords came to claim the forest as their private preserve, and hunting as their exclusive privilege. Two such kinds of seigniorial sport were particularly popular: hunting with trained dogs and falconry.

Hunts with dogs took place in the forest, far from castle and village. Following the hounds on horseback, nobles stalked big game, especially the deer family and, to a lesser extent, the boar. After the dogs had flushed it out of cover, the quarry was run to exhaustion and killed by sword or spear.

Birds of prey, most often falcons and hawks, were also trained to assist nobles in the hunt. Falconry and hawking did not lead the men and women of the aristocracy into the forest, however, but brought them near villages and lakes, and sometimes onto cultivated land. On such expeditions, hunters rode with a few dogs, who flushed small game later retrieved and killed by the birds of prey. Minor forms of hunting included the setting of traps and snares for hares, foxes and wolves.

The two main types of hunting represented a symbolic code. The horn, which nobles and valets slung around their shoulder and used at different stages of the hunt, was a symbol of fidelity, one of the cardinal values of medieval society. The dog, symbol of domesticity, was given positive and female attributes. The falcon, an emblem of violence, if not savagery, was seen as a male animal. Hunting with dogs led men to the fringes of populated areas, falconry brought them to their centre; the former was an expedition on land, the latter followed an aerial course while remaining an essentially static exercise for the hunter.

The seigniorial hunt was thus a rite developed in direct relation with the organization of space and social relations: the oppositions between centre and periphery, man and woman, good and evil, earth and sky, carnal and spiritual. Of secondary importance was its use as a substitute for warfare or as a means of providing venison for princely tables. ∎

A Falcon being trained for hunting
Traité de fauconnerie, French translation of Frederick II Hohenstaufen's Treatise on falconry, *De arte venandi cum avibus*, late 13th century. (© Bibliothèque nationale de France, Ms FR. 12400, fol. 152r°)

among relics brought from local churches to bear witness in the presence of the Almighty to the oaths made and to their eventual violation. The convenors invoked the Christian duty of protecting paupers, widows and orphans, and reminded all that violence against men or the property of the Church could only lead to dire spiritual sanctions. In some cases, the Church authorities decreed the "Truce of God," persuading lords to cease hostilities from Wednesday night to Monday morning and also during religious feasts. There was to be no fighting during Advent, at Christmas or during Lent, nor from the Easter season to Whit Sunday.

From the end of the eleventh century on, the Church tried to make "knights of Christ" out of medieval warriors, by urging upon them the value of taking the cross or of joining a military order. At the same time, combat itself became ritualized: specific days were chosen for military clashes, with Sunday carefully avoided. Two armies faced each other in a pitched battle, that would be a celebration of their honour and a submission to divine judgement. Monks sang psalms on the battlefield to call down God's favour; they also brought relics there before the armies met, and sometimes did so even amidst the fighting. Knights in battle took little notice of the foot-sloggers – foot soldiers – trampling over them in their eagerness to unhorse and capture knights of the opposing party. They did, however, take particular care not to kill such opponents but to take them into custody in order to hold them to ransom.

Then Came Knights

Cavalry had become a component of Western armies in response to destructive raids by Huns, Goths, Saxons and Hungarians, who had swept through the Continent on their well-harnessed horses.

The first knights, however, were vassals of Carolingian kings. Those who could afford a horse and its full equipment performed their military service as cavalrymen and took great pride in being mounted. They soon became aware of their unique position in the lay aristocracy and came to consider themselves as a distinct group in society. The gap deepened between mounted vassals and those who, lacking a horse, continued to be foot-soldiers. As the ranks of the seigniorial class swelled, so too did those of the knightly class, henceforth vassals of feudal counts and lords.

Around 1050, a new word came into use to mark this evolution. The *caballarius* gave way to the *miles*: cavalrymen became knights. They found their place in society through a gradual acceptance of the ideals of the Church, but the entire evolution of the knightly class was marked by a constant struggle to divert religious models and to elaborate its own value system.

Arms and Armour

COMPREHENSIVE EXAMINATIONS of the economy and society of the Middle Ages rely considerably on the study of weapons production to assess both technological progress and the expansion of trade networks.

Though undeniably influenced by the defensive equipment of Antiquity, medieval armour was characterized by two distinct periods of development, separated by a transitional phase falling roughly between the years 1320 and 1400.

The first period, which began towards the eleventh century, witnessed the widespread use of chain-mail armour, based on interlocking, scale-like iron plates (*lorica squamata*) or metal rings (*lorica hamata*). Chain mail offered flexible protection against cutting blows, and was used to make such remarkable specimens as the thirteenth-century coif, a hood that covered the head, and the great hauberk, a knee-length cloak perfected at the beginning of the fifteenth century.

The second stage, ushered in towards the mid-fourteenth century, was characterized by the development and widespread use of plated armour, derived from the *lorica segmentata*. Various pieces, forged from sheet iron, were introduced to protect specific parts of

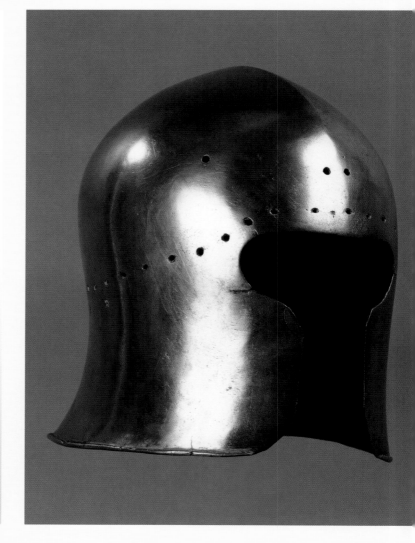

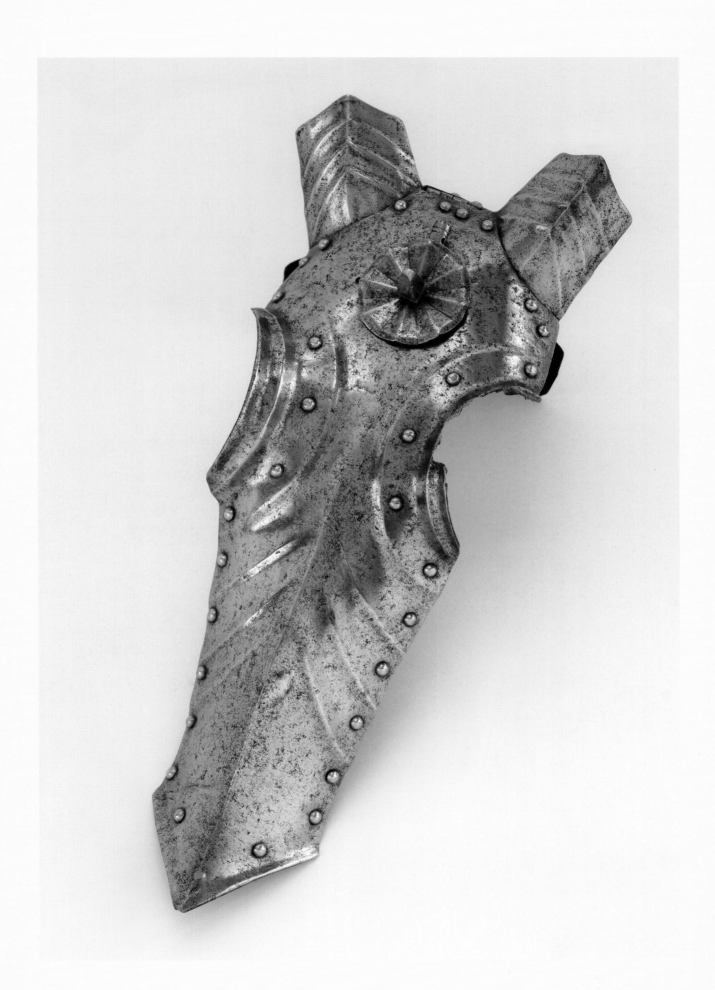

the body, starting with the joints (see the illustration of a pair of couters dating from about 1470) and gradually extending to the limbs and chest to form full-body plate armour. In the late fourteenth century appeared the bascinet, a helmet fitted with a mesail and a pointed visor most likely designed to deflect enemy steel. Plate-iron armour also offered good protection against the devastating impact of missiles, whether arrows shot from a bow or bolts fired from a crossbow. It was at this time that Lombard workshops, which exported their products throughout Europe, achieved their greatest renown. And as late as the sixteenth century, Cervantes compared Milan with Vulcan's forge. Following the Lombard initiative, other workshops gained prominence, notably in Germanic lands and in Spain. All these centres produced what were known as "white harnesses," armour with brilliant, polished surfaces that has been compared to metal sculpture. This period also saw the introduction of gunpowder artillery, whose technology soon revolutionized the defence and attack of strongholds, but was not applied to individual, handheld weapons until the end of the fifteenth century.

Offensive weapons included the lance and sword, chiefly used by knights, who dominated the battlefield until the fourteenth century. Above all other medieval weapons, it was the sword, whose design had evolved from that of its cruciform Viking predecessor, that crystallized the religious symbolism of chivalry. Foot soldiers used knives, daggers and shafted weapons—axe, pike, vouge, and many other variants or ramifications of the great family of the halberd. Combatants engaged in projectile warfare used different kinds of bows and crossbows, such as the stirrup crossbow or crossbows fitted with pulleys and bent by a moulinet.

With tournaments and jousts, the use of weaponry spread from the theatre of war to the field of play. As early as the fourteenth century, specific arms or armour, notably the frog-mouthed helm, were designed to meet the particular challenges of these martial exercises. The astonishing pomp that surrounded them was captured in the mid-fifteenth century (1460-1465) in King René of Anjou's book of tournaments, the *Traité de la forme et devis d'un tournoy* [Treatise on the form and parts of a tournament].

Emphasis should also be placed on the art of hunting, the aristocratic pastime par excellence and the attribute of the nobiliary lifestyle, which called for the handling of both defensive and offensive weapons. ■

JEAN-PIERRE REVERSEAU
Chief Curator
Musée de l'Armée, Paris

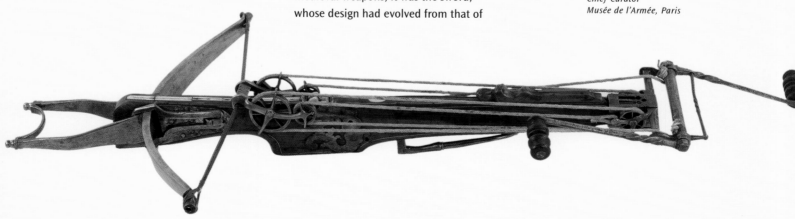

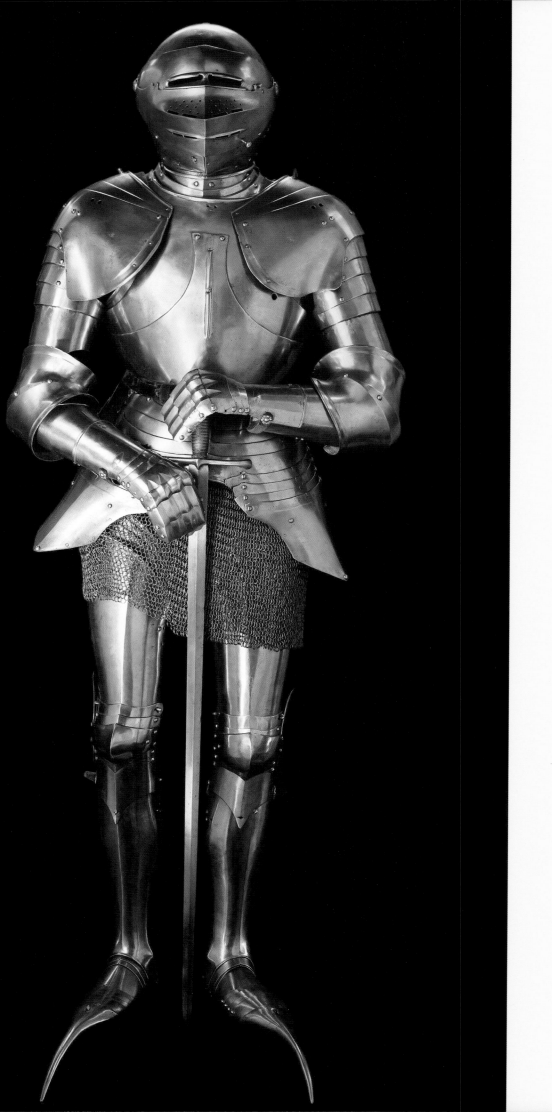

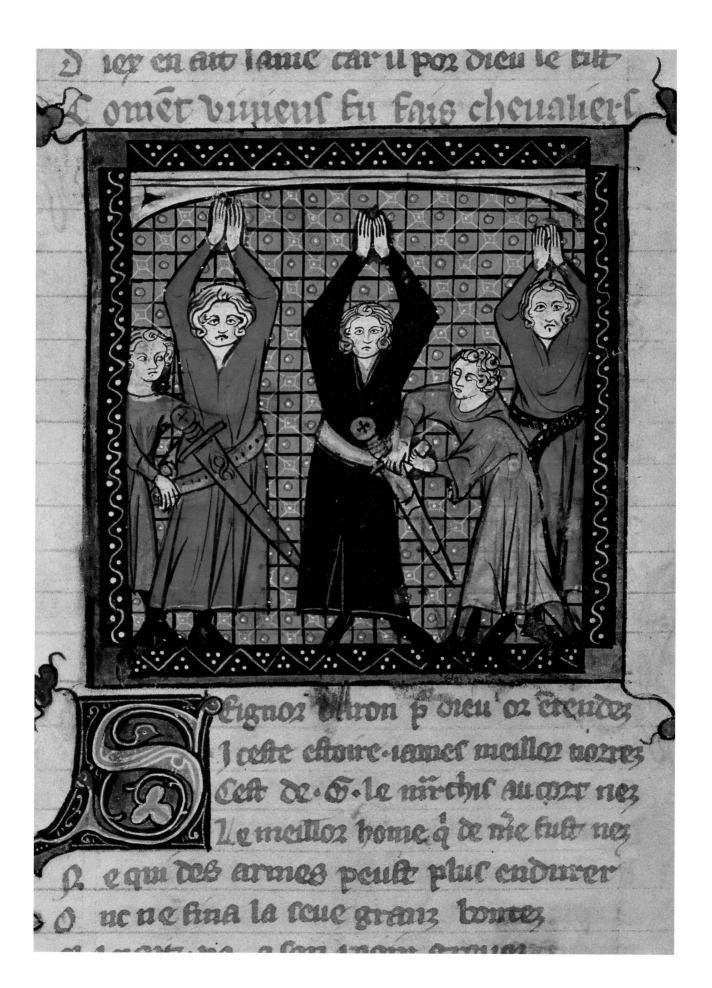

A Rite of Knighthood: Dubbing

Like other medieval social groups, knights structured their class as a spiritual family. Dubbing, by which a young squire became a knight, compared with baptism. Indeed, the ritual owed much to its religious model. On the eve of the ceremony, the aspiring knight would take a bath as a symbol of purification, followed by a prolonged fast and a vigil of prayer. In the morning, the young man attended mass and received Holy Communion. The dubbing ceremony began with the bestowing of defensive and offensive weapons. This was followed by the buffet or *collée,* a violent blow dealt with the flat of the hand to the nape of the youth's neck. This symbolic decapitation was meant both to test the young man and to show off his toughness. He then had to demonstrate his skill and strength by tilting at the quintain: the idea was to topple or decapitate a straw manikin, or to bring down a shield, in either case with a single thrust of the lance. Finally, the youth took an oath on the Bible, pledging allegiance to his lord and protection of the poor. The ceremony usually ended with a lively banquet and a tournament.

Once dubbed, young knights were ready for combat but, like their elders, they must guard against vainglory and pointless battle. Their calling was to engage in just war, including of course holy war should the Church be threatened. Rather than destruction, their weapons symbolized the seven Christian virtues. The three theological virtues were represented by the helm (hope), the shield (faith) and the lance (charity). The coat of mail, the gloves, the sword and the spurs stood for prudence, justice, fortitude and temperance – the four cardinal virtues. Swords were blessed before a dubbing and before battle.

Tournaments

Tournaments were in a sense a concentrate of all the rituals and ideals of chivalry. Ceremonial events, they were more than training sessions for idle knights. They were proof, highly visible proof, that knights had formed a class apart and were determined to exert their influence on society. The speed with which tournaments spread underlined their significance. The first ones took place in France and England around 1100; fifty years later they were held throughout Europe.

There was a deeply subversive aspect to tournaments. Decisions as to their site and date were made at the last possible moment, although, in view of the pace of medieval transportation, a few weeks' notice was given to allow for travelling time. Tournaments usually took place on days that did not coincide with the feasts of the Church calendar, and were never held inside towns. As far as possible, they were played on vast, open fields that lay between two towns or villages. The intention was clear: to escape the traditional frameworks of space and time.

In order to attract as many spectators as possible, the convening lord had the event announced for hundreds of kilometres around. On the appointed day, participants were grouped into regional or family teams known as *mesnies,* each of which came under the leadership of a captain. Combat was collective and often violent, the object being to unhorse opponents so as to ransom them later.

FACING PAGE

Dubbing ceremony
Chanson de Geste du Cycle de Guillaume d'Orange,
[Chanson de geste from the cycle of William of Orange]
Thomas de Quent, early 14th century.
(© British Library, MS Roy 20 d. XI, fol. 134v°)

BELOW

Head from a recumbent figure of a knight
Saint-André Cathedral, Bordeaux, late 13th–early 14th century. (Limestone, 27 × 19 × 17 cm; Musée d'Aquitaine, Bordeaux, 11743; © DEC, photo: J. Gilson)

The knight whose prowess was the most impressive was designated winner and received a falcon, a belt or a shield adorned with gems.

The Church looked unfavourably upon these festive meetings convened outside the frameworks it sought to impose. It criticized such useless expenditure of energy as diverting knights from their true mission, which was to defend the Church, and even brandished the threat of refusing Christian burial to knights who died during tournaments. But in vain: its prohibitions went unheeded and tournaments continued ever more numerous. Kings too balked at tournaments for fear of losing fighting men, but to little avail.

Myths of Chivalry: The Grail and The Round Table

The constitution of the knightly ideal owed much to the emergence of a new literary form that spread to various parts of Europe from the twelfth century on. It was written in the vernacular, in those languages that had long been reserved for speech and that clerics termed vulgar in opposition to scholarly Latin. Yet as early as the waning of Antiquity, Latin had begun to lose ground in spoken exchanges and had gradually given birth to a number of idioms,

The knightly dream
(© Bibliothèque nationale de France,
Ms FR. 24364, fol. 40r°)

Although battles and tournaments were not as bloody as is often imagined, their representation in literature, which echoed the knightly ideal, was sometimes extremely violent.

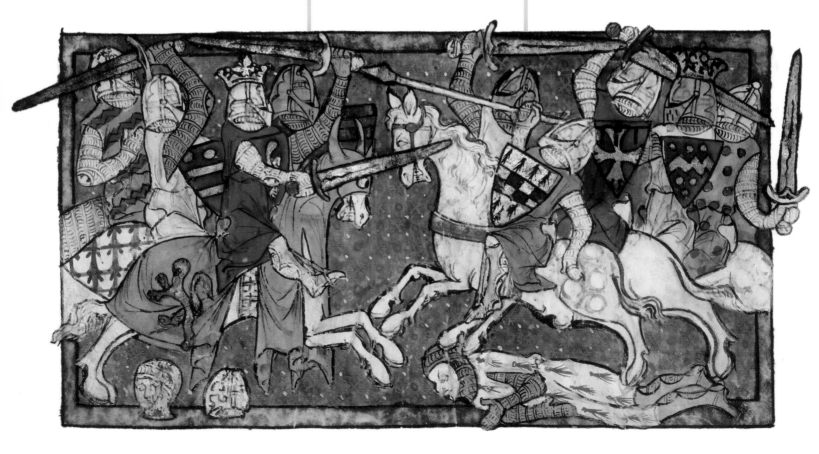

designated collectively as "romance languages." Since knights wrote in these languages, their works were called romances.

By starting to write in vernacular tongues, knights were appropriating a privilege, that of public utterance, which had previously been reserved for clerics engaged in the oral or written transmission of the word of God. These new authors had far-reaching ambitions. The tales of knights vying in prowess to win the heart of a lady who, by definition, could never be theirs, their accounts of battling monsters in the depths of the forest, all can be read as a veritable mythography of the knightly class. When publicly recited by troubadours and jongleurs, such stories conveyed the knightly ideology and voiced the ambition of an entire counterculture: emancipation from the matrix of the Church.

Amongst the most subversive themes was that of the Grail, which in effect made chivalry into the true Church, whose origins went back to Joseph of Arimathea, a contemporary of Christ who removed his body from the Cross. The ultimate objective of knights was to find the Grail, the cup in which Joseph was said to have caught the last drops of Christ's blood. The myth of the Grail inspired one of the most prolific literary cycles of the twelfth and thirteenth centuries. Its main characters, Lancelot, Percival and Gawain, created by Chrétien de Troyes around 1160, were later treated in depth in the cycles of the *Queste del saint Graal* or of the *Lancelot-Graal*.

The knights involved in the quest for the Grail were twelve in number, like the apostles. The regular gatherings at King Arthur's Round Table were their equivalent of the Last Supper. The myth of King Arthur had historical roots. As a military chieftain in England, he federated the Britons in an attempt to repel a sixth-century Saxon invasion. Later, he became a legendary figure who embodied both the qualities of God-as-sovereign and the values of twelfth-century chivalry.

Courtly Love

King Arthur's wife, Guinevere, was coveted by Lancelot. Their idyll illustrated another ideal of chivalry, courtly love.

Medieval authors of romances did not use such an expression. Chrétien de Troyes and his successors celebrated *fin'amors*, pure and true love. Nineteenth-century literary historians advocated the term "courtly love" to show that such love suited those who frequented the courts of kings.

*M*ade from copper, bronze and, less commonly, iron, harness pendants were ornamental accessories fastened to equestrian equipment. Most often used during parades or ceremonial entrances of kings, they took various shapes (square, star, polygon, lobe, etc.) and bore either the knight's armorial bearings or decorative motifs. Maxims were often added to the pictorial work.

Harness pendant
Spain, 15th century. (Enamelled copper, 7.2 × 5.9 cm; Museo Arqueológico Nacional de Madrid, 59116, © Archivo fotográfico. Museo Archeológico Nacional de Madrid)

In the twelfth century, *fin'amors* was enacted between lovers, not spouses. The lady, invariably married, was of higher rank than her invariably unmarried suitor; in most instances, she was also wife to the suitor's lord. By his virtues, his acts of prowess, his self-control and his total devotion to the service of his lady, the young lover sought to gain her favour. Sexuality, if not impossible, was perilous to the relationship. *Fin'amors* culminated in desire for the beloved and in hope of a first kiss – which often would be the only one. Furthermore, if the young lover was unmasked, he risked losing everything, most notably the protection of his lord. Nonetheless, *fin'amors* was a deeply eroticized relation, and therefore highly subversive. Not only did it establish love in the realm of adultery, it associated it with carnal union. By developing such a theme, the authors of romances attempted to resolve a major contradiction: the great difficulty of reconciling love and marriage in a society where husbands were commonly imposed on women for basically strategic reasons. And by extolling adultery, the same writers undermined one of the foundations of the Church, Christian matrimony, at the very time it was becoming a sacrament.

Far from being strictly literary, the theme of *fin'amors* influenced the lay aristocracy's ideology, and was thus part of a movement that saw the latter in competition with the Church. The same motif inspired knights with an ideal inseparable from the very definition of their class, in much the same way as hunting, tournaments or chess came to embody their lifestyles. As for the people, the common folk, they were by definition beyond the pale of *fin'amors*.

Man giving a flower to a woman
Secular emblem or clip, first half of the
15th century, ancienne collection Gay.
(Lead-tin alloy, 4.4 × 4.6 cm; Paris, Musée national
du Moyen Âge – Thermes de Cluny, Inv. Cl. 18084;
© Photo RMN-Gérard Blot)

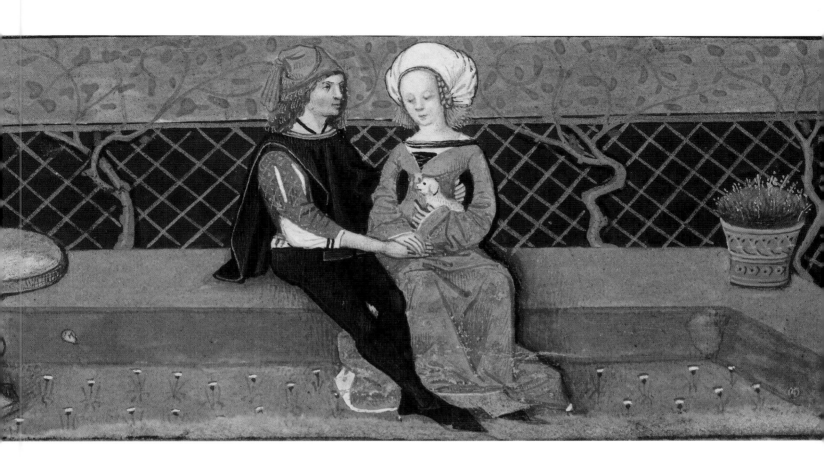

The Medieval Kiss

In the Middle Ages, a kiss on the mouth was a gesture of Christian love that expressed the bonds of charity between two people. For that reason, the "model" kiss was that which Christ had reportedly given a leper. As signs of unity and of equality, these kisses were exchanged between members of the same spiritual family, whether they were knights, overlords and vassals, members of a confraternity, parishioners or priests. Thus, whether it was a matter of knighting a young squire, ordaining a priest, swearing homage or settling seigniorial disputes, many ceremonies predictably ended with a kiss on the mouth. Parishioners also exchanged such greetings at the end of mass as a sign of peace.

Though these kisses had to be relatively prolonged, woe be to those who would open their mouths on such occasions, for they thereby sunk into lechery. Understandably, men and women shunned any public exchange of kisses or, at the very least, set strict limits on such displays. Kisses between men were looked on more favourably since, theoretically at least, they were not carnal. Between persons of opposite sex, such behaviour was the preserve of filial, conjugal or adulterous relations. While in courtly love, the kiss was the culmination of an arduous quest, throughout romances and epics, knights embraced and kissed each other frenetically, sometimes even before removing their helms...

ABOVE
Lovers in the garden
Calendar from the Hours of Charles d'Angoulême, month of April, 15th century. (© Bibliothèque nationale de France, Ms Lat. 1173, fol. 2v°)

By the end of the thirteenth century, the kiss of peace was replaced during mass by a kiss made on an "instrument of peace" – a reliquary or paten circulated among the faithful. With the advent of the Renaissance, kisses disappeared from all the rituals of which they had become an essential element and lived on solely as expressions of emotion. Only in some Eastern European countries has the diplomatic kiss on the mouth survived to this day, as a mark of hospitality towards a guest considered an equal.

By abandoning the kiss on the mouth, Renaissance men deprived themselves of a gesture essential to the maintenance of a harmonious society, ideally united by peace, faith and charity. They lost much more as well. Knights, born with feudal society, slowly died out with it. As early as the fourteenth century, with the triumphant rise of artillery, they lost their military usefulness. The rituals and myths of chivalry grew insipid and, as time went by, the knightly class became merely the old nobility. ✤

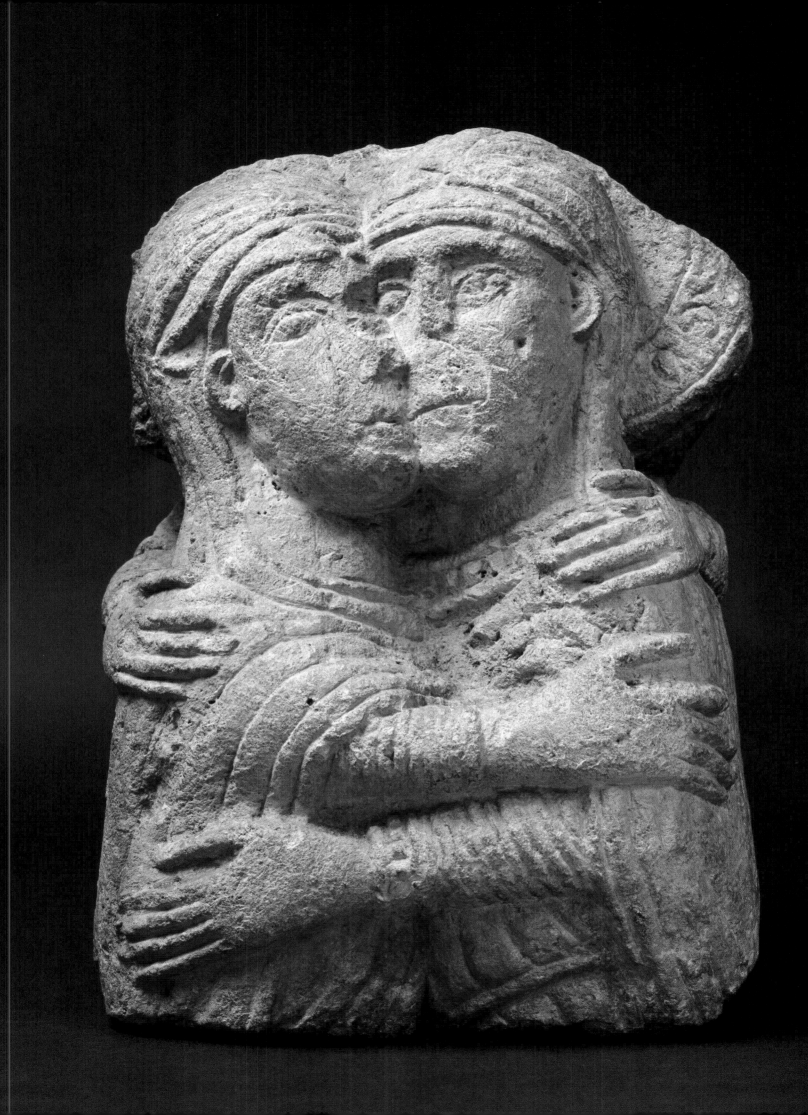

Knowledge and Communication

MEDIEVAL CIVILIZATION began at a time when little use was made of written instruments; it ended with the invention of printing. During that period, writing underwent changes in its forms, materials and uses. Schools migrated from monasteries to towns. As universities were founded, their masters unsettled the world of knowledge. Jewish and Arab sciences crossed the Mediterranean. Architects achieved extraordinary feats, continually lightening the walls of churches and raising their vaults to the very limits of stability. Images flooded into manuscripts and houses of worship, and filtered into the homes of the bourgeoisie, where books were now less rare. Most significant, the clerics were beginning to lose their monopoly on public speech.

Reading, studying, speaking, writing, singing and preaching had long been the preserve of influential figures. Between the eighth and fifteenth centuries, these defining attributes were gradually removed from clerical monopoly and became available to laymen.

Charlemagne's Schools

The formal framework of schools provided a stable structure for the transmission of knowledge. That Charlemagne played an essential role in establishing them is a well-known fact, which should nonetheless be qualified. First, schools can hardly be portrayed as a medieval invention, given that educational institutions had existed in Antiquity and that the Church, since the sixth century, had ceaselessly promoted the creation of Christian schools. Charlemagne merely speeded up this process, as a good Christian king eager to be of service to the Church. Second, Charlemagne's schools differed greatly from modern-day secular institutions. They were established around cathedrals and inside monasteries to educate clerics and to provide a modicum of instruction to a few elite laymen. The first academic subject was Latin, which was essential for the education of clerics, the men of letters of the Middle Ages. It is significant that the word "cleric" came to designate both an educated person and a member of the clergy: in most instances, they were one and the same. So pronounced was this pattern that, before the year 1000, few laymen even knew how to read or write. Thus clerics secured the position of mediators with regard to both the transmission of knowledge and access to the divine.

FACING PAGE

St. Matthew writing with a calamus
Bible, New Testament, Rheims, France, 9th century. (© Bibliothèque nationale de France, Ms Lat. 265, fol. 11v°)

Episcopal and monastic schools were the repositories of culture up to the twelfth century. Institutions in Fulda, Reims, Chartres, Cologne, Winchester, Salamanca and Liège acquired particular prestige. Teaching began with the seven liberal arts. These included the three disciplines of the *trivium*: grammar, dialectics and rhetoric, three ways of becoming skilful in the use of Latin and in the framing of arguments in discourse. The *trivium* was followed by the four arts of the *quadrivium*: arithmetic, geometry, astronomy and music, which provided instruction on how to decipher the world and its harmonic structures.

Under the direction of a schoolmaster, clerics studied the Greek and Latin authors, both pagan and Christian. They were quite aware that the learned men of Antiquity were at a disadvantage, for having lived before the Revelation of Christ. "Dwarfs perched upon the shoulders of giants:" thus did the schoolmaster of Chartres describe his clerics, with due reverence to the giants of Antiquity, but equally stressing, behind an apparent humility, that Christian dwarfs could see further.

Universities: Corporations of Masters and Students

The clerical approach to teaching was to use reason as a means of comprehending Revelation and the mysteries of Creation, while being fully aware that human understanding, by definition, would never achieve the knowledge of God. This approach changed gradually from the twelfth century on. In about 1140, a Parisian master, Peter Abelard, voiced for the first time the difficulty of reconciling with reason the revelation contained in the Scriptures. He dared to weigh the pros and cons of the matter, the *sic et non* (yes and no). This new mode of thought, at first unambiguously condemned, would eventually influence scholars throughout the network of universities.

In medieval times, the term *universitas* referred simply to a corporation, an association; thus confraternities, communes and crafts were all universities. The meaning we assign to this word today applied then only to one *universitas* among others: the "university of masters and students." The first such corporations were formed in Bologna, Oxford and Paris over the course of the twelfth century. The model then spread to Italy (Salerno, Reggio, Vicenza, Arezzo, Padua, Naples), to France (Toulouse, Orléans, Angers, Montpellier), to England (Cambridge), to Spain and Portugal (Palencia, Salamanca, Seville, Lisbon) and finally reached the Germanic empire (Prague, Vienna, Heidelberg), Poland (Cracow) and Hungary (Pécs, Buda) in the fourteenth century.

Kings and princes played an important role in the founding of new universities, for they realized that these institutions could serve their interests, notably by providing recruitment pools for their chancelleries. Even though the universities were powerful, they were therefore not independent.

Teaching began with the liberal arts. The Bachelor of Arts degree opened the door to the higher Faculties of Theology, Law and Medicine. These offered two diplomas: the license, giving its recipient the right to teach, and the doctorate, crowning the deepening of knowledge of a specific subject.

Universities were closed corporations, jealously bent on protecting their privileges. In the mid-thirteenth century, the accession of Franciscans and Dominicans to professorships caused some controversy, because

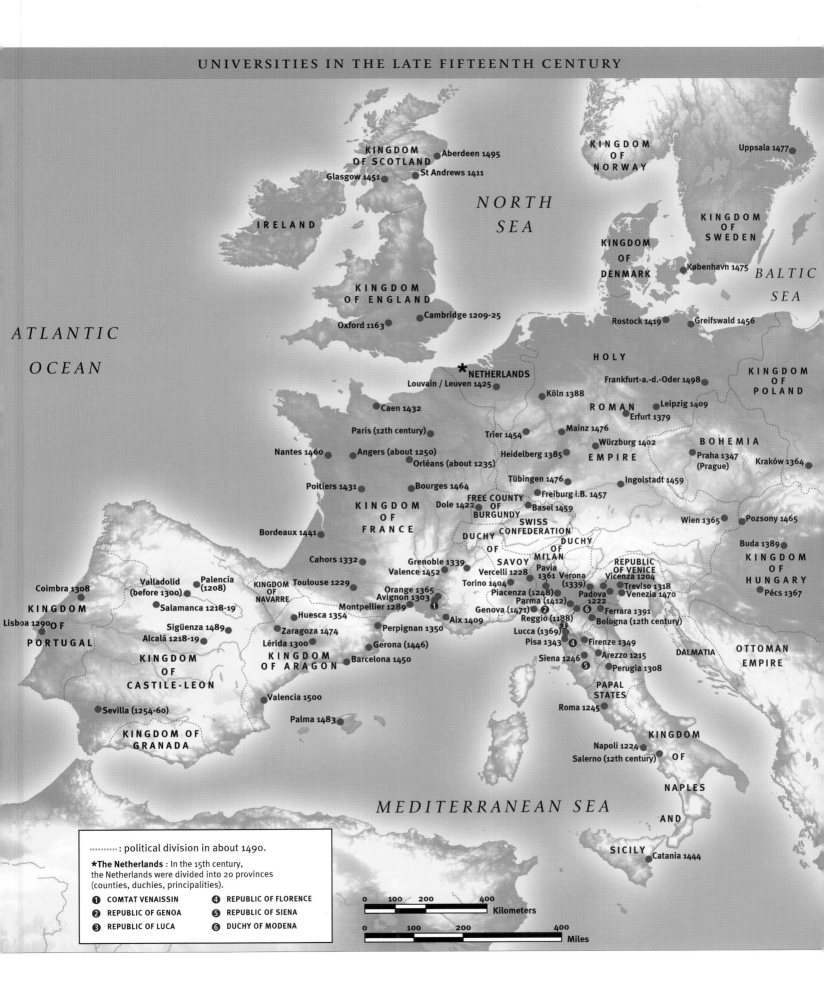

KINGDOM OF SCOTLAND

Aberdeen 1495

Glasgow 1451

St Andrews 1411

KINGDOM OF NORWAY

Uppsala 1477

NORTH SEA

IRELAND

KINGDOM OF SWEDEN

KINGDOM OF DENMARK

København 1475

BALTIC SEA

ATLANTIC OCEAN

KINGDOM OF ENGLAND

Cambridge 1209-25

Oxford 1163

Rostock 1419

Greifswald 1456

HOLY

ROMAN

EMPIRE

Frankfurt-a.-d.-Oder 1498

KINGDOM OF POLAND

*NETHERLANDS

Louvain / Leuven 1425

Köln 1388

Leipzig 1409

Erfurt 1379

Caen 1432

Mainz 1476

Würzburg 1402

BOHEMIA

Paris (12th century)

Trier 1454

Heidelberg 1385

Praha 1347 (Prague)

Kraków 1364

Nantes 1460

Angers (about 1250)

Orléans (about 1235)

Tübingen 1476

Ingolstadt 1459

Poitiers 1431

Bourges 1464

Freiburg i.B. 1457

Dole 1422

FREE COUNTY OF BURGUNDY

Basel 1459

Wien 1365

Pozsony 1465

KINGDOM OF FRANCE

Bordeaux 1441

SWISS CONFEDERATION

DUCHY OF SAVOY

DUCHY OF MILAN

Buda 1389

KINGDOM OF HUNGARY

Cahors 1332

Grenoble 1339

Valence 1452

Vercelli 1228

Pavia

Verona (1339)

REPUBLIC OF VENICE

Vicenza 1204

Treviso 1318

Pécs 1367

Coimbra 1308

Valladolid (before 1300)

Palencia (1208)

KINGDOM OF NAVARRE

Toulouse 1229

Orange 1365

Avignon 1303

Montpellier 1289

Torino 1404

Pavia 1361

Piacenza (1248)

Parma (1412)

Genova (1471)

Padova 1222

Venezia 1470

Ferrara 1391

KINGDOM

Salamanca 1218-19

Sigüenza 1489

Huesca 1354

Aix 1409

Reggio (1188)

Bologna (12th century)

Lisboa 1290 OF

Alcalá 1218-19

Zaragoza 1474

Lucca (1369)

PORTUGAL

Lérida 1300

Perpignan 1350

Pisa 1343

Firenze 1349

Arezzo 1215

DALMATIA

OTTOMAN EMPIRE

KINGDOM OF CASTILE-LEON

Gerona (1446)

Barcelona 1450

KINGDOM OF ARAGON

Siena 1246

Perugia 1308

Valencia 1500

PAPAL STATES

Sevilla (1254-60)

Roma 1245

Palma 1483

KINGDOM OF GRANADA

KINGDOM

OF

NAPLES

Napoli 1224

Salerno (12th century)

MEDITERRANEAN SEA

AND

SICILY

Catania 1444

........... : political division in about 1490.

*The Netherlands : In the 15th century, the Netherlands were divided into 20 provinces (counties, duchies, principalities).

❶ COMTAT VENAISSIN

❹ REPUBLIC OF FLORENCE

❷ REPUBLIC OF GENOA

❺ REPUBLIC OF SIENA

❸ REPUBLIC OF LUCA

❻ DUCHY OF MODENA

0 100 200 400
Kilometers

0 100 200 400
Miles

Legenda lrãlis Alberti magni

*T*he writings of Albertus Magnus brought him great fame and undisputed authority. He was numbered among the blessed, but despite his disciples' efforts, he would not be canonized until 1931. When his relics were enshrined in 1483, an account of his life was written by Peter and Rudolph. When it appeared in print, it was prefaced with a picture commemorating Magnus's profound influence on the thought of Thomas Aquinas, the other Grand Master of the University of Paris in the 13th century.

Legenda Alberti Magni [The life of Albertus Magnus]
Rudolphus de Novimagio (†1480), Cologne, Germany, Johann Koelhoff, printer, 1490. (Paper, 14.5 × 12 × 1 cm; Musée de la civilisation, dépôt du Séminaire de Québec, Inc. 22)

these friars, bound more to their orders than to university structures, were reluctant to become integrated into the new corporations. They nonetheless brought a new open-mindedness to teaching, since they were more receptive to non-Christian philosophical currents, whether derived from Antiquity (Aristotle), from Judaism (Maimonides) or from Islam (Avicenna, Averroës). The most renowned scholars eventually rose from within the ranks of these monastic "innovators," including Albertus Magnus, Thomas Aquinas, Roger Bacon and Bonaventure. And the universities, pure products of medieval society, were destined to transform the very values and mentalities they had been founded on.

A Book is Born

The innovations introduced by universities would have amounted to little had there not been a revolution in the way that writing was transmitted. The period between the fifth and the fifteenth centuries witnessed the slow death of the fragile and non-reproducible papyrus scroll, and the emergence of incunabula, printed on paper in several hundreds of copies.

The first revolution was the invention of the book. Antiquity had bequeathed to the West the technique of making papyrus scrolls. Separate leaves were formed from stalks of Egyptian reed, cut into thin strips, flattened and stuck together in alternating horizontal and vertical bands. These leaves were then joined end to end to form long rolls. This was the only way papyrus could be effectively preserved, but such a format did not lend itself easily to regular perusal. This was particularly awkward for monks, who were bound by their calling to assiduously reread and meditate on identical passages of the Scriptures, of their rule or of the Church Fathers' writings. A new medium, suited to monastic needs, had to be developed – and so the book was born.

The principle was simple: instead of being joined end to end, papyrus leaves were stacked and sewn in the middle. The result was called a *codex*. As papyrus was too fragile for such an operation, a stronger material was sought and found: parchment. Until the seventh century, papyrus continued to be used for short documents such as royal charters and diplomas; after that, it was entirely superseded by parchment.

BELOW AND PAGES 166-167

Hours, prayers and texts of the Passion
The Last Judgement and the battle for souls, Flanders, Ghent or Antwerp (?), Belgium, miniature attributed to Lieven van Lathem, ca. 1475. (Parchment, 11.5 × 7.7 cm; © Museum Catharijneconvent, Utrecht, BMH h66; photo: Ruben de Heer)

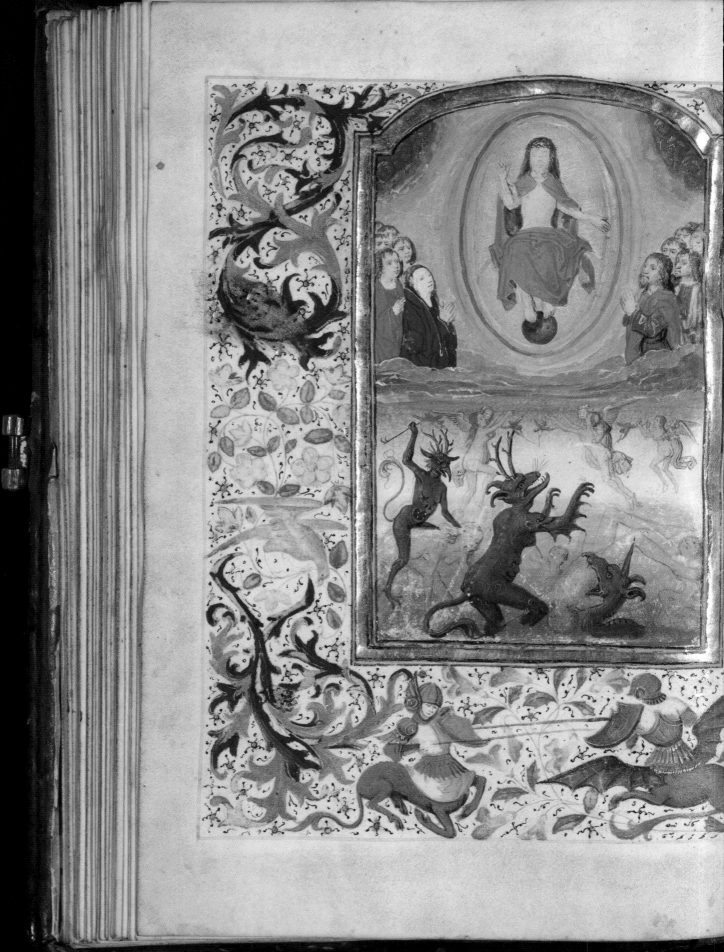

Bonnes gens qui vi[u]es deues
quon dit son temps bien dit
car la mort homme ne d[...]
[...]moing maistre jehan de la
[...]minateur par le
on chastellet et [...] de[...]
Jean des eschevins en sa
de paris sans dutruy en
[...] quiben terre en
[...] come le mort [...]
et laissa ce monde hy
mil cccc quarante
en novembre neufiesme
si pries dieu que sans le
de les pechez pardon luy
et le puisse veoir en
la sus en son glorieur
ou il domme vit et
et quil nous vueille si bien
[...] la fin nous y puisse con
Amen

pense
vous
roy

dinat
dyu
Jour
fare
Rome
duire

Memento mei

This material was produced by tanning the skin of young animals, usually sheep and goats. The finest kind, vellum, was made from the hide of young calves, and the finest vellum, from the skin of stillborn calves. Converting hide into parchment was meticulous work performed by highly specialized craftsmen. The skins had to be sheared, depilated and scraped so as to remove the slightest particle of flesh. They were washed several times and cleansed in baths of lime, then covered with a thin layer of chalk for waterproofing.

Well-prepared parchment was a durable but expensive material. The skin of one animal would yield four to eight sheets, depending on the size of the manuscript; parchment production therefore required a substantial supply of livestock. The smallest trimmings would be saved for drafting a short charter. Poorer quality pieces, either cut near the legs of the animal or marred by holes, would yield manuscripts for everyday purposes, while the finest ones would be reserved for illuminated manuscripts.

Writing, however, was not necessarily intended to last, so that it might be done on clay or on a piece of slate, wood or bark. Remember that the word "library" is derived from the Latin *liber* (meaning book, work, treatise), which initially referred to the thin layer between wood and bark that had been used for writing in ancient times, before the discovery of papyrus.

Among the various writing materials available for short-term purposes, medieval man favoured wax. This is understandable, given his esteem for bees and their labour. Wax was applied to the hollowed-out inner surface of two small wooden tablets, which were then tied together so that they could close like a book. Notes and drafts were incised in the soft wax with a stylus of metal or bone. They were erased simply by smoothing out the wax. When it hardened or was damaged, a new layer would be applied.

FACING PAGE

Epitaph of Jean de la Porte
Paris (?), ca. 1442. (Limestone (?), 65.7 × 4 cm; Paris, Musée national du Moyen Âge–Thermes de Cluny, Inv. Cl. 12772; © Photo RMN)

At other times, hard materials such as stone were used. On stone were engraved commemorative inscriptions intended for future generations. This type of writing was seen in particular on the facades and inner walls of churches, where it commemorated their date of consecration, gifts received towards their construction or the name of a sculptor. Funerary monuments bore epitaphs or inscriptions recalling the status or the good deeds of the deceased. In such instances, writing was associated with eternity.

The Scribe at Work

Until the twelfth century, the scribe was first and foremost a monk and, accordingly, his writing was carefully regulated, as were all his activities. Morning was the best time to copy manuscripts in the scriptorium, with the clearest light of day pouring in through the windows.

First, the sheet had to be prepared. The parchment was cut to the in-
tended size, then folded in two to form four pages. With a point made of
metal – lead, silver or tin – the scribe traced margins and horizontal lines
as a guide for even writing.

He would then choose one of a variety of instruments: a calamus, shaped
from a reed, or a quill plucked from a goose or, failing that, from a swan,
a duck or even a crow. Ink was kept in cow or goat horns, rarely in metal
inkpots. The body of the text was written with brown or black ink. Red
ink was reserved for titles, which were therefore called rubrics, from the
Latin *rubrica,* red.

The scribe sat in front of a desk on which he placed the text to be
copied. In his right hand, he held a calamus or a quill, in his left, a knife or
a scraper to sharpen his pen, erase his mistakes and hold the sheet steady. For
he wrote free-hand, his hand never touching the parchment, to avoid smudg-
ing the still-fresh ink.

The Downstrokes and Upstrokes of the Middle Ages

The way the quill or calamus was cut was determined by the style the
scribe wanted to achieve. A slit in the middle of the pen ensured a smoother
script, better adapted to ligatures. Pointing or bevelling, towards the right or
left, made possible a number of variations in the downstrokes and upstrokes.

IN PRIN CIP IO ERAT VERBŪ

ET UERBUM ERAT APUD DM̄ · ET
DS ERAT UERBUM ; HOC ERAT
IN PRINCIPIO APUD DM̄ ; OMNIA
PER IPSUM FACTA SUNT · ET SINE
ipso factū ē nihil ; Qd factum · ē · in ipso uita erat ;
et uita erat lux hominū · et lux in tenebris lucet ·
et tenebrae eam non conprehenderunt ; ꝑ ꝑ ꝑ

FUIT homo missus a dō ; cui nomen erat Iohannes ;
Hic uenit in testimonium · ut testimoniū ꝑhiberet
de lumine · ut omnes crederent ꝑ illū ; Non erat
ille lux · sed ut testimonium ꝑhiberet de lumine ;

ERAT lux uera · quae illuminat omnē hominē ueni

N illo tempore. Re
cumbentibus
undecim discipulis
apparuit illis ihus
et exprobrauit incredulita
tem illorum et duriciam
cordis quia his qui uiderat
cum resurrexisse a mortuis
non crediderant. Et dixit eas.
Euntes in mundum uniui
sum predicate euuangeliū
omni creature. Qui credide
rit et baptizatus fuerit sal
uus erit. Qui uero non cre
diderit condempnabitur
Signa autem eos qui credide
rint hec sequentur. In eois

...rico demonia eicient. ſigui-
loquentur nouis. Serpantes
tollent. Et ſi mortiferū quid
biberint non eis nocebit. Et
ſuper egros manus imponent
et bene habebunt. Et dominus
quidem ihus poſtquam locutus
eſt eis aſſumptus eſt in celū
et ſedet a dextris dei. Illi autē
profecti predicauerunt ubiqꝫ
domino cooperante et ſermo-
nem confirmante ſequenti-
bus ſignis. Deo gratias. oro

bſecro te dña
ſancta maria
mater dei pieta
te pleniſſima

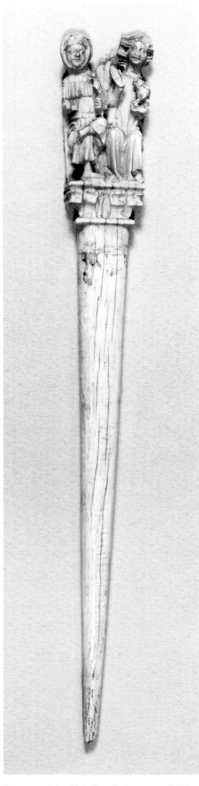

Graver or stylus
Paris, 14th century. (Ivory; Paris, Musée national du Moyen Âge, Thermes de Cluny, Inv. LOA 7281; © Photo RMN)

Graver or stylus
Italy, 14th century, ancienne collection Sauvageot. (Ivory, 21.6 × 2 cm; Paris, Musée national du Moyen Age, Thermes de Cluny, Inv. LOA 157; © Photo RMN)

Graver or stylus (detail on facing page, right)
France, 14th century. (Ivory, 20 × 2 cm; fonds Du Sommerard, Paris, Musée national du Moyen Âge, Thermes de Cluny, Inv. Cl. 376; © Photo RMN)

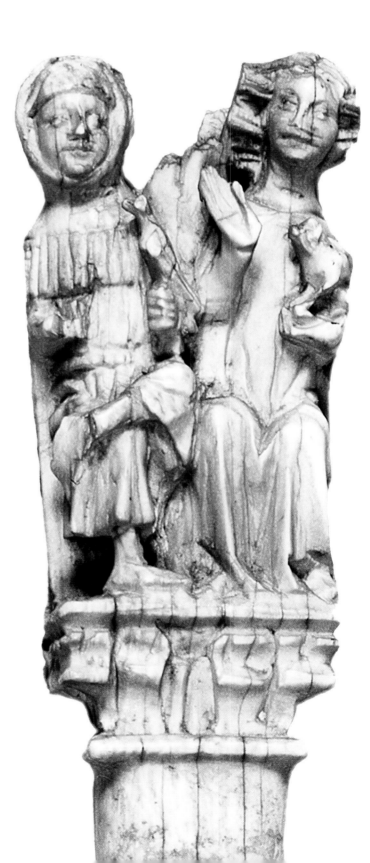

Pen
France, 15th century (?), ancienne collection
Victor Gay. (Bronze, 12.6 cm; Paris,
Musée national du Moyen Âge, Thermes
de Cluny, Inv. Cl. 18160; © Photo RMN)

Handwriting styles were also determined by what might be called the fashion of the time. The "r," the "e" and the "c," the capital and lower-case letters were not penned in the same way in the time of Hugh Capet as in that of Christopher Columbus. As each century had its particular penmanship, more or less similar in the various regions of Western Europe, paleographers are able to tabulate this evolution. Roughly speaking, handwriting would become increasingly more cursive and rapid as administrative or commercial writing became more prevalent in medieval society.

At the end of the eighth century, Charlemagne's clerical advisers decided to standardize handwriting so that all clerics in the kingdom would be able to read and understand each other's work. Thus was born a script based on lower-case letters known as the Carolingian minuscule, which took its name from the king himself (Carolus). Its letters were short and separated from each other. Abbreviations were standardized and kept to a minimum so as not to hinder comprehension.

Until the end of the eleventh century, many documents were written in Carolingian minuscule, and ligatures were added between letters. At the end of the twelfth century, the letters' forms became more angular. This marked the birth of Gothic script, which took its name from the architectural style flourishing at the time.

Luxury manuscripts and official documents were still drafted very slowly, but notaries, merchants and burghers, who made daily use of written documents, adopted a cursive and rapid style of writing, which reached summits of illegibility in the script of fifteenth-century notaries.

A Paper Revolution

The twelfth century witnessed a revolution in the medium and use of writing. As Italian and Flemish cities acquired administrative powers, they began to establish archives. Notaries became recognized as professionals in Mediterranean regions, and as their ranks swelled, an ever greater number of contracts were submitted to them for recording. The Holy See rapidly developed its chancery, an example

Carolingian script
Feliciter [joyfully]

Gothic script
Vestimentorum [clothes]

15th-century script
Assignaverunt [have assigned]

[Calligraphy: Anne Beauchemin]

At the end of incunabula, typographers often printed an emblem that had been carved into wood. It might be as simple as a circle with a cross, a fairly common combination laden with Christian symbolism, or as sophisticated and expensive as the device used by Koelhoff.

Printer's device
Legenda Alberti Magni [The life of Albertus Magnus], Rudolphus de Novimagio, Cologne, Germany, Johann Koelhoff, printer, 1490. (Paper; Musée de la civilisation, dépôt du Séminaire de Québec, Inc. 22)

soon followed by the kings. Since parchment was too expensive for such extensive use, it was essential for another material to be found. This led to the development of a technique long known to the Chinese and Arabs: the manufacture of rag paper.

The sheets were made from scraps of hemp and cotton (the rags), which were washed, crushed, boiled and pressed several times, then dried. The resulting paper was often coarse and uneven, similar to cardboard, but fairly strong. As demand grew, so did product quality. Towards the end of the Middle Ages, the widespread use of underclothes led to an increase in the amount of raw material available for recycling. Paper mills appeared widely on the river banks. Heavy hammers, driven by hydraulic power, crushed vegetable waste into pulp for paper.

A Movable Revolution

In the fifteenth century, printing revolutionized the work of scribes. Johannes Gensfleisch, also known as Gutenberg, is credited with its invention, probably in 1437 or 1438. Gutenberg left Mainz, his birthplace, over some fiscal matters, then established himself in Strasbourg as a goldsmith. He first specialized in cutting gems, then in the production of mirrors sold to pilgrims bound for Aachen. This kind of mass production may have led him to consider large-scale production of letters and books. The idea was in the air at the time. All over Europe, people were searching for a way to meet the growing demand for books created by the bourgeoisie, the universities and the nascent humanist movement.

Printing had actually been practised long before Gutenberg, but only from fixed engravings on wood. Gutenberg hit upon the idea of creating movable metal type representing the 25 letters of the Latin alphabet as well as standard punctuation marks. He would first carve fixed type in raised relief. This in turn would be used to make a type mould, the matrix, in which the type appeared to be hollowed out. Pouring metal into the matrix, he would obtain movable type in raised relief, with which he could create any number of combinations of letters with no need for further carving.

By the mid-fifteenth century, this kind of printing had developed significantly. Gutenberg worked in partnership with other goldsmiths and was able to sell his type. His technique spread to towns known for the skill of their goldsmiths. Missals, treatises on morals, romances and works from Antiquity appeared in print. The most popular went through several editions within a few years, but the greatest success of medieval printing was the Bible, printed first in 42 and then in 36 lines.

Books printed before 1500 are called incunabula. They retained some characteristics of manuscripts, such as rubrics and initials ornamented with red or green tracery or with gold leaf applied by hand. After printing, illuminations were added by specialized artists, who sometimes had to leave their work unfinished because the book was put on sale. Not until the sixteenth century did the practise of numbering folios become widespread. Before that time, printers provided customers with a table referring to the first word of each section, the latter being identified by a letter followed by a number: a1, a2, b1, and so on. This system, originally devised to assist bookbinders, also proved useful to readers.

Liber penitentialis ad instar libr. Canonū penitentialiū ex diuersis scō rum doctoruz Augustini Hieronimi Gregorii ꞇ ceteroꝝ dictis edit9 ostē dens ꞇ docēs que penitētia cuiꝗ pec cato sit iniungenda. ac interrogatio nes confitentib9 necessarias. Ab alme uniuersitatis Coloniē Rectore ap probatus ꞇ admissus. sacerdotibus summe necessari9ꞇ utilis. presertim cu ram animarum habentibus.

Incipit prologus in librum penitētialem

Vm miserationes domini sint super omnia opera eius misericordiam ta men suā super ho mines ampli9 ex tendit. Nam quia homo benignitate creatoris dignissi ma creaturarum est. eum in uisceribus misericordie sue magis respexit. ꞇ nō solum magnā misericordiā sed etiam abundantem ꞇ superabundantē ei ex hibuit. Magna em fuit misericordia cp ad restaurationē ruine angelice ho minem creare uoluit. ut ipsum partici pem sue beatitudinis efficeret. Vnde ꞇ Boetius. Quem non externe pepu lerunt fingere cause. Materie fluitan tis op9 uerū insita summi forma bo ni liuore carens. Idem etiā ait Aug9. Si non potuit domin9 hominē face re ad gloriā suaꝫ participandaꝫ ipo tens fuit si potuit ꞇ noluit inuidie re darguendus erat. sed quia nec impo tens nec inuid9 fuit. homini regnū su um cōmunicare uoluit. Abundans

autem gratia fuit quādo homini pꝗ peccatum remediū cōtulit. ut quē dā nare potuit per iustitiā repararet per gratiam. sed qui ante aduentū suū in carne quedam sem plena remedia cō tulit. in aduētu suo plenitudinē reme dii contulit. Circūcisio ꞇ sacrificia ꝗ ante aduentum suum p puulis exhi bebātur. reatū ꞇ maculā originalꝰ pec cati delebant. sed gratiam non confe rebant nec ianuā paradisi aperiebant Vnde omnes strauerunt lectuꝫ suū in tenebris in infernū descēdētes. sꝫ cum per passionē suā aquas sanctificassꝫ ꞇ uim regeneratiuā eis cōtulisset. p re media baptismi reat9 originalis pec cati delebatur. ꞇ ex uirtute baptisma tis grā cōferebatur. ꞇ amota rūphea introitus celestis renatis patebat.

Superabundās āt gratia fuit cum homo fracto federe baptismatis ite rum mortē meruit. ꞇ domin9 tn reme dium remedio superaddēs per cōfes sionem ꞇ penitentiā homini resurgere concessit. ut fracta naui naufragās p penitētiam quasi per secūdam tabulā post naufragiū enataret. Et bn tabu le inter fluct9 maris concusse peniten tia comparat. quia qui uere penitet inter procellas satisfactōis cōcussus laborat. Et uere hec est superabūdās misericordia. Non em eadē est cā que induxit dominū ad hominē creādum ꞇ que induxit eum ad remissionē per penitētiam cōcedendā. Non em inut die posset redargui si hominē non re parasset per misericordiā quem dam nare potuit per solā iusticiā. Erāt tn quidā heretici quasi caput xpiane re ligionis amputātes qui dicerēt p ca ritarem semel amissam nullū esse locū

The Power of the Word

Impressive as they were, advances in the field of writing should not obscure the fact that oral expression remained the predominant medium of medieval communication. The stakes involved in such communication were similar to those that had led to the transformation of writing practices.

The Bible taught that the written text and the spoken word had been closely connected from time immemorial. The word was first and foremost the Word – the word of God, conveyed to men by the patriarchs and their descendants. On rare occasions, the Word was set down in writing, usually on durable materials such as the Tables of the Law. Most often, though, it was the prophets and angels who handed down God's message from generation to generation. This pattern did not really change with the advent of Christianity. Christ wrote nothing, save on the rare occasions when he traced a few ephemeral signs in the sand. The apostles spread his words and clerics soon took over from them.

During the Middle Ages then, public speech devolved in the first instance on the mediators of God, and particularly on bishops. They schooled themselves by assiduous reading, most often repeated again and again, and thus came to centre their discourse on interpretation and teaching. Their favoured means of communication was the reproduction of existing works, the composition of new treatises that sought to decipher the universe, and preaching.

The Virtues of Preaching

The practice of preaching changed significantly over the course of the Middle Ages. In early Christian times, the gospel was proclaimed in public, in places where it would reach as many people as possible. Once Christianity became established as the dominant religion, preaching moved into churches, and became a prominent feature of Sunday mass, usually claiming its place before consecration.

In the eleventh century, it once again reached beyond places of worship. For it was the Church's duty to bring all men, even those in remote areas, under its wing. New media had to be found for the Good News. Monks were the first to make the leap. Many ascetics took to the forest, where they lived as hermits and preached the need to reconcile body and soul in anticipation of the Last Judgement. By the year 1100, some forests in Burgundy or Anjou had become veritable hives, where the most austere of monks were sought out by motley crowds; some of these disciples were searching for a new voice, others were looking for a place they could not find in ordinary society.

At the turn of the thirteenth century, preaching moved from forests to the towns, which had become the driving force of society. It was therefore all the more imperative to press the good example upon all those burghers, merchants and usurers whose social legitimacy had yet to be established. Clerics left the cloister to preach in front of church portals and in town squares. In 1225, the order of the Friars Preachers was established by Pope Innocent III.

Rivalries soon sprang up because, in theory, bishops retained the exclusive privilege of preaching. They were most often resolved through a partition of urban space into carefully delimited preaching zones shared among

FACING PAGE

The catechism of fear
Les douze périls d'enfer
[The twelve perils of hell], translated by Pierre de Caillemesnil, ca. 1490. (© Bibliothèque nationale de France, Ms FR. 449, fol. 3 v°)

Cy commance le primer peril denfer.
Pericula inferni invenerunt me. Ceste
sentence proferee par la bouche du pro
phete doit tresfort espouenter et entie
rement retirer derreur de pechie en la
voye de vertu lecourraige des hommes buians en volupte
embrasez du feu daiuaiue. esprins dambicion donneur et
de gloire mondaine endurcie en obstinacion de malice en

Heresy: Subversive Speech

A RIGHTEOUS SOUL had every reason to be alarmed about the growing number of men who, throughout medieval Europe, were claiming the right to speak in the public arena. For the devil would surely not waste such an opportunity to spread false doctrines, most likely by whispering them into the ear of one of his minions, temporarily disguised as a preacher. Moreover, the Church might lose one of its most valuable instruments of social control should it allow just anyone to start expounding his view of the world in public. Obviously, this was not a matter to be taken lightly. And it would be settled in a straightforward way, by defining one truth and condemning all opinions deemed irreconcilable with it. This was a path that medieval society as a whole would follow, inspired by the Church, which in the fourth century clearly distinguished orthodoxy (correct belief, in Greek) from heresy.

And yet the word "heresy" initially carried no negative connotations, as least not etymologically speaking, as it was derived from the Greek *hairesis*, choice. But with the Council of Nicaea in 325, the Church defined its dogma, and choices differing from it became dissent.

From the fourth to the eighth century, doctrinal disputes focussed on the Trinity, the double nature of Christ (divine and human) and the relation between grace, free will and salvation. In the eleventh century, different controversies came to the fore, this time related to the baptism of children, the role of priests in administering the sacraments, the wealth of the Church and the symbolic use of the cross. These debates had little to do with revolutionary projects; most often they reflected attempts to restructure religious experience. The knightly and merchant classes proved particularly receptive to new doctrines. Those of the Waldensians in the Lyon area, the Albigensians in southwestern France and the Cathars in Germany echoed the ambitions and frustrations of these groups which, in many respects, remained poorly integrated into medieval society.

The Church's response to dissent evolved over time. Preaching was the gentlest approach, even though its message might be scathingly worded. Cistercian monks were initially entrusted with this task but, as they made little headway, they were replaced by the Friars Preachers, the Dominicans. In the late twelfth and thirteenth centuries, the papacy added its voice to that of the Dominicans by issuing repeated condemnations. In 1199, Pope Innocent III equated heresy with divine lese-majesty and, ten years later, preached a crusade against the Albigensians.

But it was with the establishment of the Inquisition in 1231 that the Church truly perfected its control over dissidence. Henceforth, heretics would be judged by a permanent ecclesiastical court, a special tribunal that dispensed with such formalities as indictments, and brought accusations on the basis of denunciations or rumour. The court owed much of its devastating efficiency to its partnership with civil authorities, who carried out its verdicts. Sentences ranged from excommunication, which could be lifted after various periods of penance, to confiscation of all personal possessions. In theory, death at the stake awaited only relapsed heretics and those who recanted their confessions. These were sometimes extracted under torture, which was sanctioned by the Pope in 1254 as a means of interrogation. ■

Le xxviie chappitre parle des baron
des prelats qui furent alobit du roy
si come par miracle n

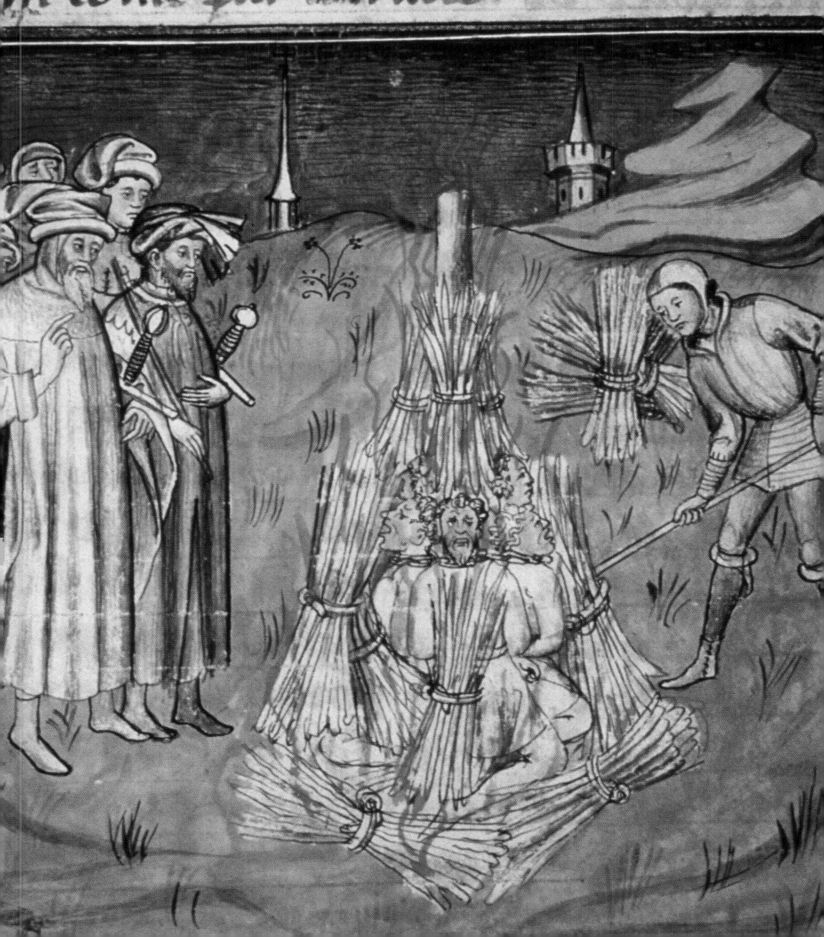

**Tropes, proses and neumes
for the Nativity of St. John the Baptist**
Troper and proser, England (probably Winchester),
late 11th century. (© British Library,
Cotton MS Caligula A XIV, fol. 20v-21r°)

bishops, Dominicans, university clerics and Franciscans. New techniques were developed to hold the attention of the congregation. Preachers included in their sermons moralizing tales called *exempla*, featuring burghers, monks, knights and kings presented in a favourable or an unflattering light. Thus the impenitent usurer would be carried off by the devil, along with the adulterous wife, the lascivious nun or the simoniac bishop. Such sermons offered an extraordinary opportunity for making known the concept of purgatory.

The Layman Speaks

That the speech of clerics should become so forceful was due in part to the increased competition from laymen that it faced. The appointment of a town crier played an important part in shaping any urban community. In town squares and at crossroads, these men spread the news of the town and kingdom. They detailed recent judgements and broadcast the names of guilty parties, in much the same way as clerics threatened delinquent Christians with the torments of hell. In seigniorial castles, troubadours too began to take the floor. From court to court, they sang of *fin'amors* and extolled the prowess of knights in search of the Grail. On every street corner and in every tavern, gossips and beggars spread the public rumour that can make or ruin reputations, so that this kind of behaviour came to justify arrests for crimes of lese-majesty. Even the written word was conveyed orally, since texts were read out loud both in private and in public. Similarly, confession of guilt to a priest or judge, the near ritual repetition of the same formulae in the ordination of priests, the dubbing of knights and the granting of absolution, all were oral.

The Musical Order of the World

At the confines of written and spoken words was song, and the music that accompanied it. In the Middle Ages, music was included in the seven liberal arts taught in schools and universities. Along with astronomy, geometry and arithmetic, *ars musica* was one of the disciplines of the *quadrivium*, those four paths of knowledge aimed at understanding the universe. It was believed that the world was structured according to mathematical and astronomical laws that together revealed a musical order. As the Church had the mission of leading men to the heavenly city, it integrated music into its liturgy. Music and singing themselves became a liturgy through which man could communicate with the heavenly, invisible powers.

To emphasize the unity of Creation and that of the Church, voices would form a single choir. This chorus of many voices merging into one was called plainsong, plainchant or Gregorian chant. Gregory the Great, Pope from 590 to 604, was credited with its invention, but this is merely one of the legends that seem to suround the Church Fathers. Promoted with particular insistence by Carolingian kings and by Popes, plainsong spread between the ninth and eleventh centuries.

It was sometimes accompanied by instruments, such as the organ or the tintinnabula, but most often the voices rang out alone under the vaults of churches, which were shaped so as to favour resonance. The chant was not rhythmic nor was the melody conceived in isolation. Indeed, the essential

stinauit. Et posuit. ALII

DE utero genitricis mee me uocauit deus meus

meo nomine. De uentre. Ad inuiorum capita

triumphaliter abscidenda. Vocauit. Ne hosti

lis inmanitas superaret me. Et posuit. Valen

tiorem faciem meam omniu uultibus potenti

um reddens. Sub tegumito. Bonu est. ITĒ

QVE prophete predixere agni fore precurso

rem. De uentre. Honestauit uerbū suum ore

meo. Et posuit. Construens me sup gentes

atque regna. Posuit me. Gloria. ALII

VAĪU firma fides regis baptista iohannes. ex

utero sterili. narrant preconia xpi. De uentre.

Post longū senium inspirato germine foete.

Vocauit. Qui quondam moysi dixit te excno

element of this vocal music was the words, which were seen as the word of God. Most often sung were the psalms, those 150 poems to the glory of God that were attributed to King David, the musician king of the Old Testament.

Medieval music was initially memorized, learned and retained by ear. To prevent any possible alteration of songs and to facilitate learning them, scribes took to transcribing them through systems of musical notation, which first appeared in the ninth century. In the earliest musical manuscripts, fashioned above all to assist memory, small symbols knows as neumes were jotted above words. Notational letters, still used in English-speaking countries (A, B, C, D, E) were introduced in the eleventh century, at the same time as the inflecting sign that stands for a lower semitone (a flat). The stave was developed in the twelfth century, limited at first to one line and developing gradually to settle at four lines. Notation of rhythm, initiated shortly before 1200, became more elaborate during the thirteenth century.

The great musical innovation of the end of the Middle Ages was polyphony. Reserved for great occasions, it inspired compositions sung at masses during major feasts, added musical pomp to coronations, and accompanied both the ceremonial entrances and no less splendid burials of pre-eminent dignitaries. As a choir of many voices, each carrying its own melody, polyphony was the musical symbol of a society at once plural and united beneath the vaults of the church.

FACING PAGE

Five-line staves for polyphonic song
Music and songs for Holy Week, Meaux or Windsor Abbey, 1430–1444.
(© British Library, Egerton MS 3307, fol. 20r°)

BELOW

Four-line staves and three part arrangement
Circumcision Office and Play of Daniel, Beauvais, 1227-1234. (© British Library, Egerton MS 2615, fol. 43v-44r°)

Jongleurs, Minstrels and Troubadours

Music soon moved from the church to the castle. As if inspired by those choirs of clerics devoted to singing in praise of the Lord, secular lords hired itinerant musicians to sing their own praises. Such players first appeared on the scene during the twelfth century, in Languedoc and at the court of Champagne, and would eventually appear, under different designations, in many regions of Europe. They went from castle to castle, singing of *fin'amors* and giving voice to the values of a knightly class that was then at its heyday.

Some musicians were the authors of their texts and, because they "found" *(trobar, trouver)* their words and melodies, they were called troubadours in the southern lands where old Provençal was spoken and trouvères in the northern regions of France. The performer who played productions of others was a *joglar* or *joculator*, a jongleur. To his performance he often added displays of exotic animals or acrobatic tumbles. Certain families had their own hired jongleurs, called minstrels since they ministered dutifully to their lord's pleasures.

Troubadours most often sang their compositions *a capella*, as monks did their plainsong. From the thirteenth century on, trouvères started to compose songs for dancing, which were accompanied by a number of instruments. String instruments: harp, vielle, lute, psaltery, rebec; wind in-

ABOVE

Gradual of the Chapter of Andenne
Late 12th century. (Parchment, 29.5 × 19 cm;
© Musée diocésain de Namur, 515; photo: Guy Focant)

FACING PAGE

A musician and a jongleur
Troper-proser, 11th century.
(© Bibliothèque nationale de France,
Ms Lat. 1118, fol. 107r°)

struments: flute, horn, organ, bagpipe; percussion: drum, bells, cymbals, tintinnabula; and many others lost to memory: symphony, rota, krumhorn, shawm, buzine.

Urban and Popular Music

There was also music in the streets. At the end of the Middle Ages, a town was nothing if it did not have several "waits and trumpets" or "gleemen and jestours" – storytellers of sorts. And no community would want to lack the services of professional minstrels, members of a menestrandise or jongleurs who accompanied their songs on the vielle. These men would sound the watch, announce the news and enliven solemn feasts.

Pictorial representations of ceramic whistles and birdcalls, and of hunting and calling horns indicate that instruments were also used in the hunt. Jew's harps and small bone flutes, found in archaeological digs, testify to a widespread use of music for personal entertainment. Such instruments may have been played in taverns or during friendly evening gatherings.

And then there was dancing. Village communities missed no opportunity for revelry during fairs, religious feasts or confraternity banquets. Fetes always ended with feasting, drunkenness and music. Church authorities took a dim view of such collective merrymaking, especially as revellers gladly broke into drinking songs or anticlerical couplets. Whether frowned on or not, collective dances strengthened bonds of solidarity to such an extent that Italian painters of the fifteenth century portrayed them as normal attributes of a proud and prosperous town.

Imagery and Communication

Written text and spoken word would remain dry if they were not accompanied by images, whether pictorial or mental, images such as the parables and analogies with which preachers peppered their sermons. To designate these realities, medieval Latin used a word with a variety of connotations: *imago*. Thus language reflected the fact that the Middle Ages were a civilization focussed on the image.

In the sixth century, Gregory the Great defined the four functions of the *imago*. It should call to mind the events of Creation and of Bible history. It should render visible that which is invisible, in order to elevate the mind towards spiritual realities. It should also appeal to the emotions and to that end should be executed with care. Finally, the *imago* should teach the fundamental truths, as did writing and speech.

FACING PAGE

Love and music: the knight and poet Frauenlob
Manesse Codex, Schenk von Limburg, 1315.
(© Universitätsbibliothek, Heidelberg, Cod. pal. Germ. 848, fol. 82v°)

On the basis of this definition, the pictorial image would become one of the most powerful media used by the medieval Church. As early as the seventh century, manuscripts were crowded with paintings. In the scriptorium, copyists left pages blank on which illuminators might paint images to complement the text. At the beginning of chapters, dropped capitals were drowned in interlaced tracery that transformed writing into image. During the Carolingian period, images entered places of worship and progressively covered every surface. On the walls and vaults of the nave, frescoes or mosaics echoed the subjects of paintings in the choir or on the inside of the facade. On altars and in chapels, reliquaries gleaming with gems depicted the saint whose bones they contained. Portals bore sculptures that called to mind biblical episodes or key moments of the patron saint's life.

All images were powerful, but those erected as statues were particularly influential. They represented the saint; more, they were the saint, acting, healing, sometimes aggrieved if his devotees seemed to stray from the path. This was an image people could pray to, could see and touch; this was the figure they sought out and begged to intercede with God on their behalf. Even the deepest of communions was attained through the ingestion of an image, the taking of the host. For did not the consecrated host bear the image of the body of Christ sacrificed on the Cross?

A White Robe of Churches

The place of worship was itself an image, a metaphor, as witness the evolution of the vocabulary designating it. To the many terms used since the dawn of Christianity (*basilica, capella, locus, oratorium*), the faithful increasingly preferred the word *ecclesia* because, figuratively, it represented the Church: *Ecclesia,* in Latin.

The construction of churches took on a sociological dimension. It was Christian society as a whole that rebuilt itself when its *ecclesia* was built anew. The Burgundian monk Raoul Glaber, who wrote a chronicle of his time in about 1030, was well aware of this. "When came the third year after 1000," he wrote, "over almost the entire earth, above all in Italy and Gaul, people started rebuilding the churches… and it was as if the world itself, shaking off the tatters of its old age, vested itself on all sides with a white robe of churches."

Almost the entire earth? Raoul, it seems, allowed himself to get somewhat carried away. Yet he erred not so much through ignorance as through excess enthusiasm, since the limits of the earth, for a monk in the eleventh

Foliated Romanesque capital
Saint-André Cathedral, Bordeaux, 12th century.
(Limestone, 21 × 21 × 21 cm; Musée d'Aquitaine,
Bordeaux, 12308; © M. A., photo: J. Gilson)

Romanesque capital with palmette motif
Saint-André Cathedral, Bordeaux, 12th century.
(Limestone, 20 × 19 × 18 cm; Musée d'Aquitaine,
Bordeaux, 12010; © M. A., photo: J. Gilson)

Romanesque capital with plant motif: crosiers
Saint-André Cathedral, Bordeaux, 12th century.
(Limestone, 21 × 20 × 19 cm; Musée d'Aquitaine,
Bordeaux, 11710; © M. A., photo: J. Gilson)

Romanesque capital with fruit motif
Saint-André Cathedral, Bordeaux, 12th century.
(Limestone, 21 × 22 × 20 cm; Musée d'Aquitaine,
Bordeaux, 11953; © M. A., photo: J. Gilson)

Romanesque capital with stylized sawtooth motif
Saint-André Cathedral, Bordeaux, 12th century.
(Limestone, 21 × 20 × 19 cm; Musée d'Aquitaine,
Bordeaux, 11715; © M. A., photo: J. Gilson)

Romanesque capital with floral motif: fleur-de-lis
Saint-André Cathedral, Bordeaux, 12th century.
(Limestone, 21 × 20 × 20 cm; Musée d'Aquitaine,
Bordeaux, 11713; © M. A., photo: J. Gilson)

Romanesque capital with animal motif: griffins
Saint-André Cathedral, Bordeaux, 12th century.
(Limestone, 21 × 20 × 19 cm; Musée d'Aquitaine,
Bordeaux, 11772; © M. A., photo: J. Gilson)

Capital with animal motif: facing figures
Saint-André Cathedral, Bordeaux, 12th century.
(Limestone, 20 × 19 × 21 cm; Musée d'Aquitaine,
Bordeaux, 11697; © M. A., photo: J. Gilson)

**Historiated Romanesque capital:
Holy Women at the Tomb**
Saint-André Cathedral, Bordeaux, 12th century.
(Limestone, 21 × 20 × 19 cm; Musée d'Aquitaine,
Bordeaux, 11701; © M. A., photo: J. Gilson)

194

Capital with animal motif: eagles
Saint-André Cathedral, Bordeaux, 12th century.
(Limestone, 21 × 20 × 20 cm; Musée d'Aquitaine,
Bordeaux, 11711; © M.A., photo: J. Gilson)

Romanesque capital with animal motif: dragon
Saint-André Cathedral, Bordeaux, 12th century.
(Limestone, 21 × 20 × 20 cm; Musée d'Aquitaine,
Bordeaux, 83.7.2; © M. A., photo: J. Gilson)

**Historiated Romanesque capital:
horseman and lady**
Saint-André Cathedral, Bordeaux, 12th century.
(Limestone, 21 × 20 × 20 cm; Musée d'Aquitaine,
Bordeaux, 11699; © M. A., photo: J. Gilson)

**Foliated Romanesque capital
with monster figures**
Saint-André Cathedral, Bordeaux, 12th century.
(Limestone, 22 × 22 × 20 cm; Musée d'Aquitaine,
Bordeaux, 11952; © M. A., photo: J. Gilson)

century, were those of Europe. Between 950 and 1150 approximately, and in some regions until 1200, Romanesque forms prevailed from Catalonia to England, from the Atlantic shores to the Danube and to Sicily. 950-1150: this was the time of the great renewal; and Romanesque churches reflected this revival.

It was characterized in part by stone construction, which expressed the stability and solidity of the Church. If possible, the entire building was vaulted, because stone vaults symbolized the vault of heaven. Care was taken to provide a space in which relics might be venerated – the crypt – and to make abundant use of imagery, since churches were places of representation and apprenticeship.

Religious communities usually initiated church constructions, and relied on their own resources as well as donations to secure their financing. Construction was entrusted to master builders, who, as much as possible, gave form to ecclesiastical ambitions. To this end, they provided for a mul-

A masterpiece of Romanesque architecture
The abbey-church of Conques, France, 11th–12th century. (© Photo: Didier Méhu)

tiplicity of chapels and ample space for the reception and circulation of pilgrims, and opted for an austere style of architecture. Most Romanesque architects, sculptors and painters have remained anonymous, for they could not compare with God, the true architect, the "builder" of the universe and the original image maker, who had created man in his image. Yet these master builders commanded, albeit on second-hand authority, an army of quarrymen, masons, stone dressers, sculptors, carpenters and smiths.

Gothic Innovations

This prolific cycle of building continued into the twelfth and thirteenth centuries. Centres in England, Normandy and Ile-de-France witnessed an exceptional profusion of new construction, because the power of the Church encountered there the newly triumphant might of dukes and kings.

Since houses of worship were intended to lead the faithful to heaven, particular emphasis was put on vertical lines and on opening up church walls with as many apertures as possible. So great was the task that it required wonders of ingenuity. Walls were lightened and the thrust of arches was brought to fall on fasciculate pillars. Vaults were supported by intersecting ribs and then, by combining the rib with the flying buttress, the thrust of the vaults and the weight of the framework were transferred to the outside of the building. Inner surfaces became veritable walls of light. Immense stained-glass windows were created so that light, the word of God, should meet image and flood the structure with its message.

The Church was meant to gather into one family the disparate flock of the faithful. Gothic style reflected that spirit, and its vast structures sheltered unified spaces, in contrast with the partitioned spaces of Romanesque churches.

Old Testament queen (top of the head)
Notre Dame Cathedral, Paris, ca. 1150,
(Limestone, 24 × 26 × 14 cm; Paris, Musée national
du Moyen Âge, Thermes de Cluny, Inv. Cl. 22893;
© Photo RMN-Franck Raux)

Construction aimed to impress by its height or by any other number of architectural feats. Thus each patron of a new church would ask his architects to build it higher than the neighbouring one. And so the contest began: 28 metres, 30 metres, 35, 38, 43, up to the 48 metres of the vault of Beauvais, which collapsed in the middle of the thirteenth century because the limits of available techniques had been exceeded. But contemporaries were undaunted. From then on, rivalry focussed on the height of spires and belfries, which reached close to 100 metres towards 1480.

Gothic and Secular Images

Romanesque imagery had been reluctant to attempt any literal figuration of reality and of humanity. Gothic imagery did venture to do so, for the Church was now so involved in society that such images no longer offended. Having managed to assimilate the medieval universe in its entirety, the Church ceased perceiving the representation of nature as a threat to its ascendancy. Thus the Virgin assumed the demeanour of a woman, Christ became a child on the knees of his mother or a man suffering on the Cross. Laymen found their way into these triumphant churches through the

Gothic portal
The facade of the Cathedral of Saint-Étienne,
Bourges, France, 13th century.
(© Photo: Didier Méhu)

Fragment of a canopy
Notre Dame Cathedral, Paris, ca. 1250,
(Limestone, 31 × 38 × 32 cm; Paris,
Musée national du Moyen Âge, Thermes de Cluny,
Inv. Cl. 23147; © Photo RMN)

works they financed: confraternities were portrayed in stained-glass windows and donors in paintings. Peasants, craftsmen and merchants were pictured in scenes of daily life.

Churches became flamboyant during the fourteenth century. Architecture itself became imagery. Ribbing proliferated in windows and under vaults, initially for the sake of stability, then as a display of ingenuity. Walls were adorned with veritable lace in stone. Altars were crowned with great painted retables, which were opened or closed in keeping with the liturgical cycle.

<div align="center">❖ ❖ ❖</div>

Imagery eventually spread from churches to secular society, where it met the needs of emerging powers, who recognized the strategic importance of building up their own image. By the colours of their garments and armorial bearings, knights came to resemble itinerant images. Princes and kings had themselves depicted as being crowned by God and vested themselves with insignia marking their might. Some particularly well, managed towns saw themselves as ideal communities and commissioned paintings that reflected this exemplary state. The painters and sculptors who worked for the laity gradually became aware of their creative function. By 1500, this fruit had ripened and fallen. Dürer, the German painter, signed and dated his pictures, and modelled a portrait of Christ on his own features. The artist had got even with God. He had become the new creator, and the image had become art.✤

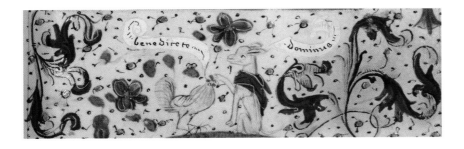

IN 1437 OR 1438, GUTENBERG invented printing from movable type. In 1453, the fall of Bordeaux marked the end of hostilities in the Hundred Years' War, the last feudal war, which was legally concluded by the Treaty of Picquigny in August 1475. Also in 1453, the Turks took Constantinople and brought about the collapse of the Byzantine Empire, which had endured for 900 years. In 1492, Christopher Columbus set foot in Cuba, and the town of Granada, the last Muslim bastion in Spain, fell into the hands of Ferdinand and Isabella. In 1500, Dürer painted Christ in his own image.

The thread of events seems significant: the fifteenth century was a turning point, which saw the West open itself up to Atlantic passages and to international trade.

Parting Ways With the Middle Ages

The humanists who coined the phrase "*Middle* Ages" saw themselves as living in a new society, a "modern" one, as they put it. But was that really the case?

While reform was certainly an abiding concern of their time, it had no pronounced impact on the structure of society. In both Europe and the New World, the sixteenth and seventeenth centuries were thoroughly permeated by Christian doctrine. Kings were kings by divine right, and religion and the Church remained the focal points of major conflicts. Thousands of men and women were judged and burned under accusations of sorcery in the name of the fight against Satan, though the stake was also a way to consolidate the structure of the modern state, pure and absolute.

The most important breaks with medieval patterns came during the second half of the seventeenth century, when the liberal arts became sciences, when the state relegated the Church to a secondary rank, and philosophers conceived new theories of existence based on consciousness, not Creation. The stage was set for all manner of deconstruction. Some men were so bold as to cease worshipping God, others went so far as to deny his existence. Some would dare bring down monarchies and proclaim the sovereignty of the people, while others would lay down the rules of commerce as the new standards of social life.

The pace of change was slower in the countryside, where parishes and villages continued to structure life until the massive rural exodus that followed the Second World War.

FACING PAGE

Corpus
Spain, 15th century. (Polychrome wood, 68.4 × 44 × 22 cm; © Musée d'art de Joliette, Canada, 1978.113, donated by the Right Honourable Jules Léger; photo: Ginette Clément)

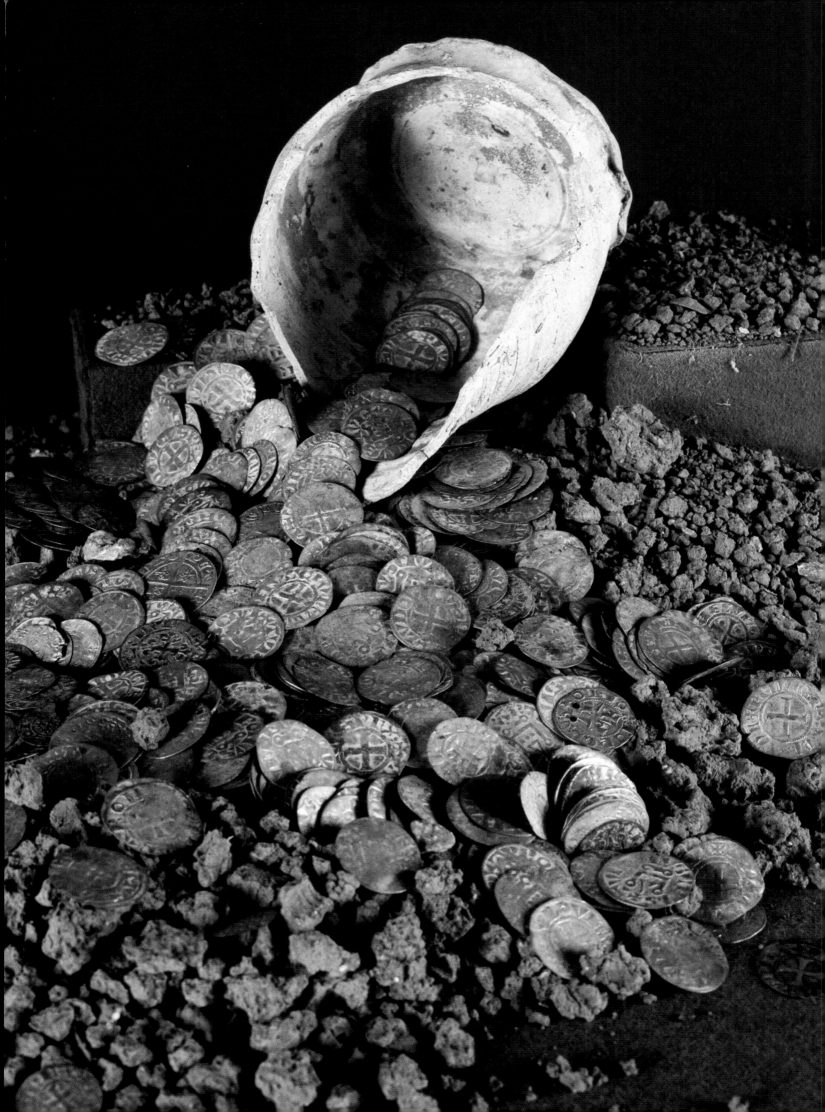

Neo- and Pseudo-Middle Ages

The great upheavals of the eighteenth and nineteenth centuries contributed to the emergence of neo-Middle Ages. The further the observer is from a civilization, the more pressing is his urge to recreate it, usually in his own image.

Such was the trend between the 1820s and 1850s in Germany and in France: the Middle Ages were romanticized. Painters, poets and novelists projected into imagined Middle Ages the dreams they could not fulfil in their own society. For them, the Middle Ages embodied a perfect union of passionate living and spiritual quest, and seemed the antithesis of the rigorous classicism of the period that came just before. At the very time when capitalism and the industrial revolution were seeping into all aspects of daily life, artistic fantasies crystallized around chivalry and the Church. The escapist focus of these neo-Middle Ages gave rise to a new regard for medieval architecture, which until recent times had been left in utter neglect, if not destroyed because it symbolized feudal tyranny. Commissions were set up left and right to restore Romanesque and Gothic churches, soon designated as historical monuments. This movement reached its peak in the France of the July Monarchy and of the Second Empire. Victor Hugo wrote *Notre-Dame-de-Paris*. Prosper Mérimée toured France to identify buildings that had to be preserved. Viollet-le-Duc undertook the first of his works of restoration, which he carried out in the fiery spirit of his time, having no qualms about reconstructing what had never existed, imagining towers and steeples where none had ever been, all because the final result yielded the image of the Middle Ages that so many wanted to believe in.

At the end of the nineteenth century, historians monopolized the debate. In Germany, their discussions agonized over the place of law and community in the medieval structure. In contrast with contemporary society, which promoted individualism, the Middle Ages were seen as the golden age of "Gemeinschaft," a kind of ideal community structured by the Church and by common interests. In France, controversies over the place of the Church in society found a promising echo in the field of historical study. A blessed era of faith for some, an age of obscurantism for others, the Middle Ages were part of all debates. Advocates of the centralized Republic often seemed unable to interpret feudal society in any other terms than those of anarchy. As for Marxists, they founded their concept of feudalism on what had been, in their view, the major interests at stake in the medieval period.

Golden Age or Middling Age?

We are not yet at the end of it. Whether in universities or museums, in theses or in novels, the Middle Ages are reconstructed in the first instance by whoever is writing on the subject. Caught between the neo-Middle Ages of the nineteenth century, whose debates have left so many traces, and the pseudo-Middle Ages of modern reconstructions, historians face a real challenge.

The debates are far from over and never will be; so it is hoped, if only for the sake of intellectual development. Again and again, current approaches have regilded the image of the Middle Ages solely as a means of exploring contemporary preoccupations in times past. Thus the Middle Ages as the prehistory of feminism, as the golden age of the workers' condition or of

FACING PAGE

The treasure of Courpiac: silver deniers in a broken earthenware pot, 14th century. (Silver and alloy; Musée d'Aquitaine, Bordeaux, D.83.2.1; © DEC, photo: J. Gilson)

homosexuality, as the crucible of capitalism, as the theoretical foundation of the American constitution and no doubt as many other matters we shall presently be reading about.

Golden age for some, middling age for others: what can be made of it? Nothing, I am inclined to write. Indeed, this is not the concern of the historian, whose task is to understand, and not to judge distant civilizations – for there is no point in judging a past that can be neither changed nor recreated.

Why the Middle Ages?

Medieval civilization was tremendously creative. To note just some of its "inventions:" the iron needle, distillation of alcohol, the crossbow, the flying buttress, fire arms, three-yearly crop rotation, the portable compass, the button (for clothes), the wheelbarrow, the cannon, the caravel, the geographical map, the coffin, champagne, the wheeled plough with a coulter and skewed share, the chimney, bells, the coat of mail, the spiral staircase, the stirrup, the nailed horseshoe, the jointed flail, cast iron, the fork, the blast furnace, the harrow, the mechanical clock, printing from movable type, the head yoke, underclothes, spectacles with converging lenses, the glass mirror, the watch, the fulling-mill, the windmill, musical notation, parchment, the suction-and-force pump, the spinning wheel, the hydraulic saw, the sharpening lathe, stained glass, the ribbed vault.

Many of the words, concepts and realities mentioned in this book or otherwise rooted in medieval civilization have taken on various modern meanings: judicial confession, banks, the Christian calendar, ecclesiastical celibacy, cemeteries, communes, counties and Länder, secret auricular confession, corporations or fraternities, election by majority vote, munici-

Spur with escarbuncle-like rowel
England, mid-14th century. (Gold-plated bronze, 9 × 13.7 cm; © York Museums Trust (Yorkshire Museum), YORYM 2001.10756; photo: Charlie Nickols)

pal taxation, hospices, town halls, mayors, Christian matrimony, monasticism, crafts and trades, notaries, parishes, godparents, portrait painting, romances, villages, universities, and so forth.

We may well be the direct heirs of the women and men of the Middle Ages, but present-day villages, communes, judicial confessions or notaries bear only the slightest resemblance to their counterparts of the twelfth or fifteenth century. The world has changed. Words may endure but, as centuries go by, the legacy, and with it the legibility of the past is transformed. In this perspective, historical inquiries should not be guided by haste. The Middle Ages can never be understood if they are seen only as one step on the way to contemporary civilization. The men and women of the tenth century are no closer to us than those of black African or of Australian aboriginal tribes. We should stop appropriating them, stop constantly reshaping them to give historical form to our own wishes. They structured their world in a distinctive way, and if we were able to fully grasp that fact, we would be in a better position to deal with the issue of otherness in our own time.

Neither in space nor in time is today's world monolithic. And that is perhaps the most valuable form of enlightenment that could mark a medieval journey's end. ✛

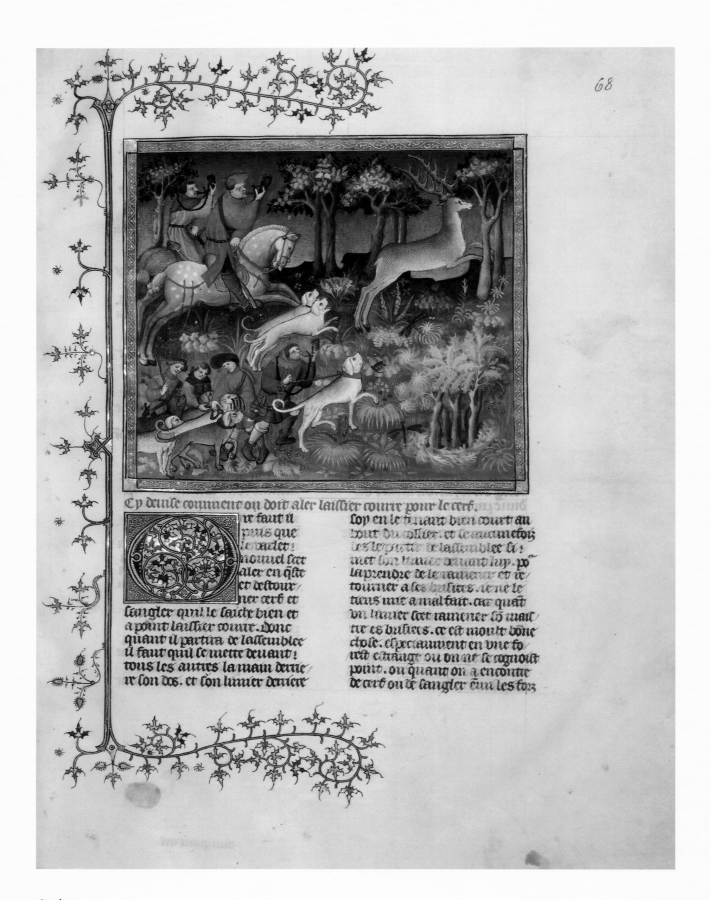

Stag hunt
Gaston Febus, *Livre de la chasse*
[Hunting book], ca. 1400,
(© Bibliothèque nationale de France,
Ms FR. 616, fol. 68rº)

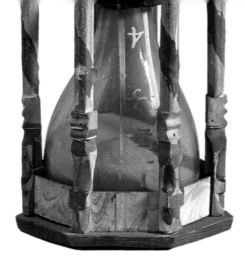

Western Europe

ca. 300–350
The first monks settle in the Egyptian desert

ca. 380–420
The Vulgate, St. Jerome's Latin translation of the Bible

410
Rome captured by Alaric's Visigoths

412–426
St. Augustine, *The City of God*

432
St. Patrick evangelizes Ireland

451–453
Attila's Huns invade the West

476
End of the Western Roman Empire
The Visigoths settle in Spain

481–751
Merovingian dynasty in the Frankish kingdom

ca. 496–498
Baptism of Clovis I, king of the Franks

533–535
Emperor Justinian I reconquers Italy

ca. 535
Rule of St. Benedict

568–575
The Lombards invade Italy

ca. 580–660
The Lombards convert to Christianity

ca. 590
Rule of St. Columban

590–604
Pontificate of Gregory I the Great

596–605
Evangelization of England

677
For the first time, parchment is used instead of papyrus to record royal acts (France)

ca. 690–739
St. Willibrord evangelizes Friesland

Rest of the World

312
Constantine converts to Christianity

324
Constantine chooses Byzantium as capital:
Byzantium renamed Constantinople

325
Council of Nicaea

380
Edict of Emperor Theodosius establishes Christianity as state religion

381
Council of Constantinople

429–439
Theodosian Code (Roman law)

451
Council of Chalcedon

527–565
Justinian I, Byzantine emperor

529
Justinian Code (Roman law)

ca. 570–632
Life of Mohammed

622
The Hegira: Mohammed flees from Mecca to Medina

638–651
Tai-tsung, emperor of China, conquers Central Asia

647
Arabs begin to settle in the Maghreb

687–691
Mosque of Omar in Jerusalem

Western Europe

711–714
Fall of the Visigothic kingdoms;
Muslim conquest of Spain

732
Muslim defeat at Poitiers

ca. 740–755
St. Boniface evangelizes Germany

751–768
Pepin III the Short, king of the Franks

751–987
Carolingian dynasty

756
Establishment of the Papal States

756
Umayyad emirate founded in Spain

768–814
Charlemagne, king of the Franks

ca. 780
Development of the Carolingian minuscule

781
Charlemagne's mints produce the silver penny

ca. 785–800
Tithing becomes widespread

800
Charlemagne crowned emperor

810–840
Viking raids on England begin

816–817
Council of Aachen: religious unification
of the Carolingian Empire

827–902
Arabs conquer Sicily

ca. 840
Beginning of Viking raids in France and Germany
and of Saracenic raids in France and Italy

842
Strasbourg Oaths, first known text written
in a romance language and in High German

ca. 850
Invention of neumes

ca. 900
First Hungarian raids in Bavaria

909–910
Abbey of Cluny founded

919–1024
Saxon dynasty in Germany

929–1031
Umayyad caliphate of Córdoba

Rest of the World

710–713
Muslim penetration of India

726–843
Iconoclastic controversy in the Byzantine Empire

ca. 750
Mayan civilization at its peak

773
Introduction of the Arab numbering system

787
The Second Council of Nicaea legitimates the cult of images

870
First book printed in China

874
The Danes occupy Iceland

908
End of the T'ang dynasty and break-up of China

909–973
Fatimid caliphate in North Africa

920
The Toltecs settle in Mexico

Western Europe

936–973
Otto I, king of Germany

ca. 950
Forests begin to be extensively cleared for cultivation
The wheeled plough is used north of the Loire River

955
Otto I defeats the Hungarians at Lechfeld

962
Otto I crowned emperor

966
Harald Bluetooth, king of the Danes, converts to Christianity

967
Baptism of the Polish duke Miezko

ca. 970
Introduction of Arab numerals and invention of the weight-driven clock, both credited to Gerbert of Aurillac

ca. 980–1100
Christianization of Denmark, Norway and Sweden

985
Baptism of the Hungarian prince Vajk (the later King Stephen I)

987–1328
Capetian dynasty in the Frankish kingdom

989
Beginning of the "Peace of God" movement

999–1003
Gerbert of Aurillac, Pope (Sylvester II)

992–1000
Catholic kingdom of Poland organized by Boleslaus I

997–1038
The Hungarians convert to Christianity

1000
Stephen I, first Christian king of Hungary

1017–1035
Canute the Great, king of England, Denmark and Norway (1028)

1020
Lintel of Saint-Genis-des-Fontaines, the first dated Romanesque sculpture

ca. 1020
Guido of Arezzo invents musical solmization (six notes, staves)

1027
Beginning of the "Truce of God"

ca. 1030
Family names introduced in the aristocracy

1031–1110
Taifa kingdoms in Muslim Spain

Rest of the World

960–1127
Sung dynasty in Northern China

969
The Fatimids found Cairo

973–1171
Fatimid caliphate of Egypt

ca. 980
The Danes in Greenland

980–1037
Life of the Arab philosopher and physician Avicenna

987
Beginning of the new Mayan Empire in Mexico

992
First commercial treaty between Byzantium and Venice

Early 11th century
Vikings in Newfoundland

1009
Caliph al-Hakim destroys Christian sanctuaries in Jerusalem

Western Europe

1043
Norman conquest of southern Italy

1049–1054
Pontificate of Leo IX. Beginning of the Gregorian reform

ca. 1065–1100
The Song of Roland

1066
Battle of Hastings: William, Duke of Normandy, conquers England

1070–1080
Beginning of the communal movement in Italy, France and Germany

1073–1085
Pontificate of Gregory VII

1075–1122
Investiture controversy between the Pope and the Emperor

1085
Toledo falls into the hands of Alfonso VI of Castile: beginning of the Christian *Reconquista* of Spain

1086
First mention of a fulling-mill in Normandy

1088–1132
Construction of the third abbey-church of Cluny, the biggest Romanesque church in the West

1093
Construction of the Durham cathedral begins: first use of the ribbed vault

1095
Pope Urban II preaches the First Crusade

1098
Foundation of the abbey of Cîteaux

Late 11th century
First troubadours and trouvères

Late 11th century
Notaries become established as professionals in Italy

1119
Order of the Templars founded

1120–1150
First craft statutes in the West

1122
Abelard, *Sic et non*

1123
First Lateran Council

1125–1153
Archbishop Raymond of Toledo has Arabic texts translated into Latin

1127
Flemish towns obtain charters of franchise

Rest of the World

ca. 1050
Invention of movable type in China

1054
Eastern Schism: foundation of the Orthodox Church

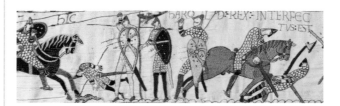

1076
The Seljuk Turks take Jerusalem

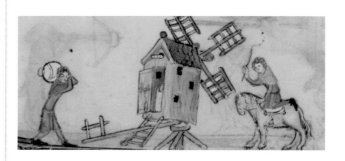

1096–1099
First Crusade

1098–1144
County of Edessa, founded by the Crusaders

1098–1268
Christian Principality of Antioch

1099
Led by Godfrey of Bouillon, the Crusaders capture Jerusalem

Late 11th century
The compass used in China

ca. 1100
Forming of the Incan Empire

1100–1291
Latin Kingdom of Jerusalem

1109–1289
County of Tripoli

1124–1215
Kin dynasty in northern China

1126–1198
Life of the Arab philosopher Averroës

Western Europe

1137–1266
Hohenstaufen dynasty in Germany

1138
Beginning of rivalries between Guelphs and Ghibellines in Italy

1139
Kingdom of Portugal established

1139
Second Lateran Council

ca. 1139
The pilgrim's guide to Santiago de Compostela

1140
Abelard's teachings condemned by the Council of Sens

1140
Gratian's *Decretum*, the foundation of canon law

1144
Consecration of the new abbey-church of Saint-Denis
Gothic art begins in France

1150–1155
First organization of the universities of Paris and Bologna

1152
Peter Lombard, *Sentences*

1152–1190
Frederick I Barbarossa, emperor

1154–1250
Conflict between *Sacerdotium* and *Imperium*

1154–1485
Plantagenet dynasty in England

1167
Foundation of the Lombard league (federation of towns resisting the authority of Emperor Frederick Barbarossa)

1168–1183
Works of Chrétien de Troyes

1170
Thomas Becket murdered

1173
Beginning of the Waldensian movement in Lyon

1179
Third Lateran Council

ca. 1180
Windmills built in Normandy and England

ca. 1180–1280
The Fairs of Champagne at their peak

1184
Establishment of the Episcopal Inquisition

1190
Foundation of the Teutonic Knights

1198–1216
Pontificate of Innocent III

Late 12th century
The compass used in the West

Rest of the World

1128–1269
Almohad Empire

1135–1204
Life of the Jewish philosopher Maimonides

1145–1160
The Almohads conquer the Maghreb

1147
Teutonic crusade against the pagan Slavs

1147–1149
Second Crusade

1168
The Aztecs settle in Mexico

1171
The Byzantines grant commercial privileges to Genoa and Pisa

1171–1250
Ayyubid sultanate of Egypt and Syria

1180
Independence of Serbia

1185
Re-forming of a Bulgarian kingdom

1187
Battle of Hattin; Saladin recaptures Jerusalem

1189–1192
Third Crusade

1192
The Shogunate established in Japan

1197
Incan Empire founded

1197–1227
Genghis Khan, "supreme king" *(Khagan)* of the Mongols

Western Europe

1206
St. Dominic begins to preach

1208
Conversion of Francis of Assisi

1209
Beginning of the Albigensian Crusade

1212
Victory of the Spanish Christians at Las Navas de Tolosa

1215
Fourth Lateran Council. Foundation of the orders
of the Preachers (the Dominicans)
and the Minors (the Franciscans)

1215
The English barons obtain the Magna Carta

ca. 1220
Album of architectural drawings and depictions
of machines by Villard of Honnecourt

1220–1245/1250
Frederick II, emperor

1226–1270
Louis IX, king of France (St. Louis)

1230
Averroës's commentaries on Aristotle studied in the West

1231
The Dominicans are put in charge of
the Inquisition's tribunal

ca. 1240
Bills of exchange introduced

1243–1254
Pontificate of Innocent IV

1245
Council of Lyon: Frederick II excommunicated

1245–1248
Albertus Magnus teaches in Paris

ca. 1245–1275
Collective enfranchisement of peasants in northern France

1250–1273
Long interregnum in Germany

1252
Gold coins struck in Florence and Genoa

1252–1259
Thomas Aquinas teaches at the University of Paris

1254
Innocent IV allows members of the Inquisition
to use torture as a means of interrogation

1255
Jacobus da Varagine, *The Golden Legend*

1265
Thomas Aquinas, *Summa Theologica*

Rest of the World

ca. 1200
Collapse of Mayan civilization

1202–1204
Fourth Crusade

1204
The Genoese establish trade colonies on
the Black Sea in Kaffa and Tana

1204
The Crusaders sack Constantinople

1204–1261
Trebizond Empire

1205–1348
Despotate of Epirus

1206–1526
Delhi Sultanate in India

1218–1221
Crusade to Egypt (fifth crusade)

1219
Autocephalous Church of Serbia founded

1228–1229
Crusade led by Frederick II in Syria (sixth crusade)

1229–1574
Hafsid kingdom of Tunisia

1230–1231
The Mongols conquer Iran

1231–1234
The Mongols destroy the Kin Empire

1234–1279
The Mongols conquer Sung-ruled China

1235
Empire of Mali founded

1236
Mongol-ruled China issues paper money

1244
The Turks capture Jerusalem

1248–1254
Louis IX leads a crusade to Egypt and Syria (seventh crusade)

1250
The troops of Louis IX defeated in El Mansura

1250–1798
Mameluke regime in Egypt

Western Europe

1266
The gold *écu* struck in France

ca. 1275–1310
Italian banking companies at the height of their power

1284
The gold ducat struck in Venice

1285–1314
Philippe IV the Fair, king of France

1291
Establishment of the Swiss Confederation

1294–1303
Pontificate of Boniface VIII

1296
King Edward I of England conquers Scotland

1296–1304
Giotto paints the *Life of St. Francis* frescoes in Assisi

Late 13th century
Introduction of the spinning wheel

1300
First Jubilee of Rome

1300
First definite mention of spectacles

1303
Boniface VIII outraged at Anagni

1307–1314
Trial of the Templars

1307–1321
Dante, *The Divine Comedy*

1309–1377
The papacy in Avignon

1328–1589
Valois dynasty in France

1337–1453
Hundred Years' War between France and England

1346
Battle of Crécy. First use of the cannon

1348–1349
The Black Death

1358
Peasant revolts and urban uprisings in northern France

1378
Revolt of the Ciompi in Florence

1378–1417
Great Schism between the Popes of Rome and Avignon

1381
Peasant revolt in England

1395
Establishment of the duchy of Milan

1399–1461/1471
Lancaster dynasty in England

Rest of the World

1270
Eighth Crusade. Louis IX dies in Tunis

1271–1295
Marco Polo's travels in India, China and other countries of the Orient

1279–1368
Mongol Yuan dynasty in China

1283
The Teutonic Knights conquer Prussia

1291
The Mamelukes seize Acre, the last bastion of the Latin Kingdom of Jerusalem

1299–1326
Osman I, first Ottoman sultan

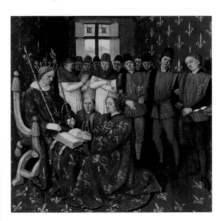

1333–1582
Muromachi period in Japan

1352–1358
Chinese revolt against the Mongols

1354
First Ottoman settlements north of the Bosphorus

1368–1644
Ming dynasty in China

1382
The Mongols sack Moscow

1386
Union of Poland and Lithuania

1389
The Turks defeat the Serbs at Kosovo Polje. End of Serbian independence

Western Europe

1409
Council of Pisa, the Church has three Popes

1409–1435
War between the Armagnacs and Burgundians

1414–1418
Council of Constance, end of the Great Schism

1415
English victory at Agincourt

1415
Jan Hus sentenced to death, burned at the stake in Constance

1418
The Burgundians occupy Paris

1420
Franco-English Treaty of Troyes

1420–1434
Revolt of the Hussites and Taborites in Bohemia

1429–1430
Victories of Joan of Arc

ca. 1430–1440
First witch hunts in the Vaud canton

1431
Joan of Arc sentenced to death, burned
at the stake in Rouen

1431–1449
Councils of Basel, Ferrara, Florence

1437–1438
Gutenberg "invents" movable type

1439
Abortive attempt to unite the Church
of Rome with the Orthodox Church

1440–1918
Hapsburg imperial dynasty

1447–1450
Republic of Milan

1453
English defeat at Castillon, last battle
of the Hundred Years' War

1455–1485
The Wars of the Roses in England

1469
Marriage of Ferdinand II the Catholic to Isabella
of Castile: the Catholic Kings

1475
Treaty of Picquigny between France and England

1483–1546
Life of Martin Luther

1492
Granada captured by the Catholic Kings: fall
of the Muslim states of Spain

1492–1496
Forced conversion of Spanish Jews and Moors to Christianity

Rest of the World

1405–1435
Chinese maritime expeditions in the Indian Ocean

1409
Peking, Ming capital

1415
The Portuguese conquer Ceuta

1418–1419
The Portuguese in Madeira

Warlocks' and witches' Sabbath
Johannes Tinctoris, *Invectives contre la secte de Vauderie* [Invectives against the sect of the Waldensian way], Arras, France, ca. 1470. (© Bibliothèque nationale de France, Paris, Ms FR. 961, fol. 1)

1432–1453
The Portuguese discover the Azores

1444
Colony of Lagos founded
First conquests of the Incas

1453
Mehmet II, Ottoman sultan, takes Constantinople:
end of the Byzantine Empire

1456
Cadamosto discovers the Cape Verde Islands

1461
The Turks seize Trebizond

1480
The Turks land in the Strait of Otranto

1487
Bartolomeu Diaz rounds the Cape of Good Hope

1492
Christopher Columbus discovers America

1493
The Pope divides the New World between Spain and Portugal

1498
Vasco da Gama reaches the Indian city of Calicut

Western Europe

1500
Self-portrait of Dürer as Christ

1508
Michelangelo paints the Sistine Chapel

1509–1564
Life of John Calvin

1516
Machiavelli, *The Prince*. Thomas More, *Utopia*

1517
Luther publishes 95 theses against indulgences

1521
Luther excommunicated

1530
Charles the Fifth crowned emperor

1536
Calvin, *Institutio religionis christianæ*

1543
Copernic, *De revolutionibus*

1545–1563
Council of Trente

ca. 1580–1640
Large-scale witch hunt in the north of the Continent

1582
Gregory XIII reforms the calendar

1610
Galileo invents the telescope

1637
Descartes, *Discourse on Method*

1675
Leibniz invents infinitesimal calculus

1679
Habeas Corpus Act introduced in England

1682
Newton, law of gravitation

1688
Glorious Revolution in England

1689
Declaration of Rights in England

1694
Establishment of the Bank of England

Rest of the World

1500
Portuguese explorers: Corte Real in Labrador, Cabral in Brazil, Diego Dias in Madagascar

1519–1522
Magellan attempts to sail around the world; after Magellan's death, Sebastián del Cano successfully completes the voyage

1520–1566
Suleiman the Magnificent, Ottoman sultan

1534–1535
Jacques Cartier explores the St. Lawrence River

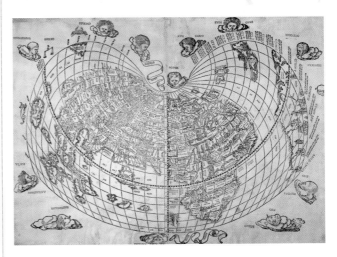

Map of the world
Made by Bernardo Sylvano, Venice, 1511.
(Coloured wood engraving, 56.5 × 41.5 cm;
© Musée Steward, Fort de l'Île Sainte-Hélène,
Montreal, Canada, 1980.497)

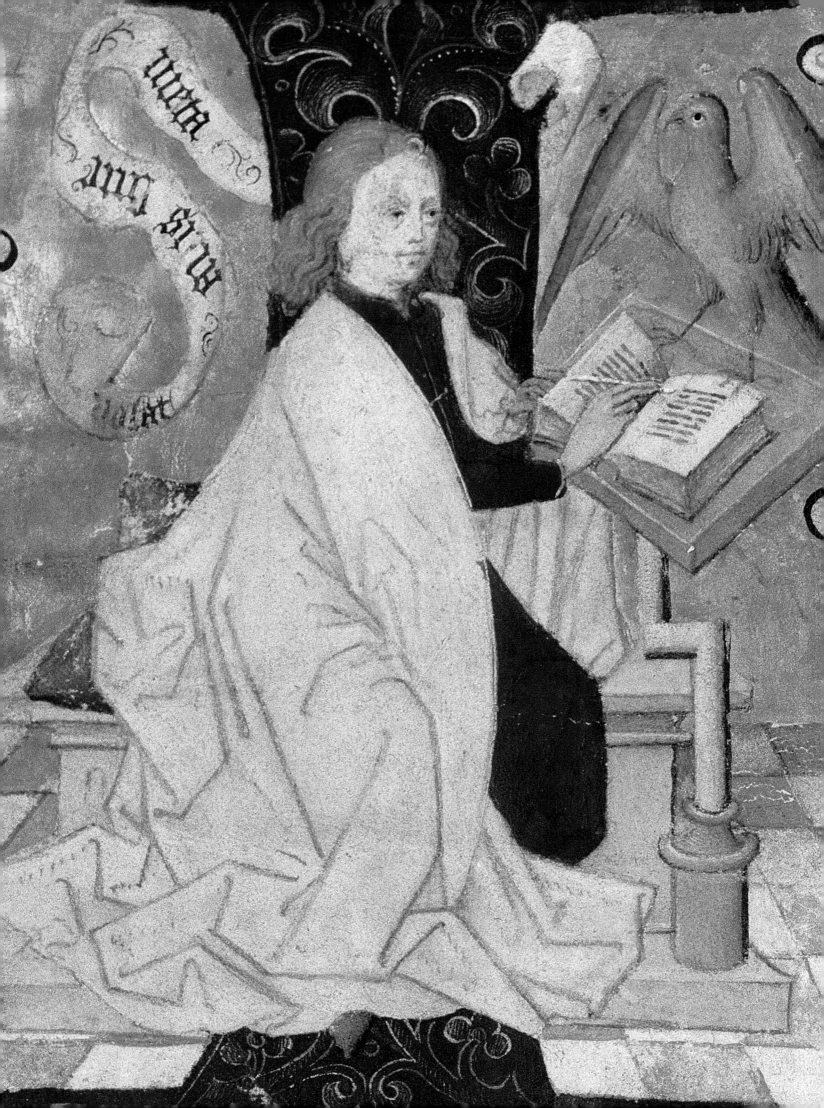

BIBLIOGRAPHY

CHAPTER 1: SPACE AND TIME

BASCHET, Jérôme. *Les justices de l'au-delà: les représentations de l'enfer en France et en Italie (XIIᵉ-XVᵉ siècle)*. Rome: École française de Rome, 1993, 700 p.

—. *Le sein du père. Abraham et la paternité dans l'Occident médiéval*. Paris: Gallimard, 2000, 416 p.

Death and Dying in the Middle Ages. Edited by Edelgard E. DuBruck and Barbara I. Gusick. New York: Peter Lang, 1999, 515 p.

EDSON, Evelyn. *Mapping Time and Space. How Medieval Mapmakers viewed their World*, London: The British Library, 1997, 210 p.

LE GOFF, Jacques. *The Birth of Purgatory*. Translated by Arthur Goldhammer. Chicago: University of Chicago Press, 1984. 430 p.

—. *Medieval civilization 400-1500*. Translated by Julia Barrow. Oxford ; New York: B. Blackwell, 1988, 393 p.

—. *The Medieval Imagination*. Translated by Arthur Goldhammer. Chicago: University of Chicago Press, 1988, 293 p.

Medieval Practices of Space. Ed. Barbara A. HANAWALT, Michal KOBIALKA, Minneapolis: University of Minnesota Press, 2000, 269 p.

RILEY-SMITH, Jonathan. *The Atlas of the Crusades*. London: Times Books, 1991, 191 p.

SCHMITT, Jean-Claude. *Ghosts in the Middle Ages. The Living and the Dead in Medieval Society*. Translated by Teresa Lavender Fagan. Chicago: University of Chicago Press, 1998, 290 p.

CHAPTER 2: LAND AND PEASANTS

Animals in the Middle Ages. A Book of Essays. Edited by Nona C. FLORES. New York: Garland Pub., 1996. 206 p.

BECHMANN, Roland. *Trees and Man. The Forest in the Middle Ages*. Translated by Katharyn Dunham. New York: Paragon House, 1990, 326 p.

CHAPELOT, Jean, and Robert FOSSIER. *The Village and the House in the Middle Ages*. Translated by Henry Cleere. Berkeley: University of California Press, 1985, 352 p.

DUBY, Georges. *Rural Economy and Country Life in the Medieval West*. Translated by Cynthia Postan. Philadelphia: University of Pennsylvania Press, 1998, 600 p.

—. *The Early Growth of the European Economy. Warriors and Peasants from the Seventh to the Twelfth Century*. Translated by Howard B. Clarke. Ithaca: Cornell University Press, 1974, 292 p.

FOSSIER, Robert. *Peasant Life in the Medieval West*. Translated by Juliet Vale. New York: B. Blackwell, 1988, 215 p.

GIMPEL, Jean. *The Medieval Machine. The Industrial Revolution of the Middle Ages*. Aldershot: Wildwood House, 1988, 294 p.

POSTAN, Michael M. *Essays on Medieval Agriculture and General Problems of the Medieval Economy*. Cambridge [Eng.] University Press, 1973, 302 p.

POSTAN, Michael M. *The Medieval Economy and Society. An Economic History of Britain in the Middle Ages*. Harmondsworth [Eng.]: Penguin, 1975, 296 p.

CHAPTER 3: TOWNS AND MERCHANTS

BOISSONNADE, Pierre. *Life and Work in Medieval Europe. The Evolution of the Medieval Economy from the Fifth to the Fifteenth Century*. Translated by Eileen Power. Westport: Greenwood Press, 1982, 394 p.

EMERY, Anthony. *Greater Medieval Houses of England and Wales, 1300-1500*. 2 vols., Cambridge; New York: Cambridge University Press, 1996.

FAVIER, Jean. *Gold and Spices. The Rise of Commerce in the Middle Ages*. Translated by Caroline Higgitt. New York: Holmes and Meier, 1998, 390 p.

LE GOFF, Jacques. *Your Money or Your Life. Economy and Religion in the Middle Ages*. Translated by Patricia Ranum. New York: Zone Books, 1988, 116 p.

LILLEY, Keith D. *Urban Life in the Middle Ages, 1000-1450*. Hampshire: Palgrave, 2002, 295 p.

POSTAN, Michael M. *Medieval Trade and Finance*. Cambridge [Eng.] University Press, 1973, 382 p.

REYNOLDS, Susan. *Kingdoms and Communities in Western Europe, 900-1300*, Oxford: Clarendon Press, 1997, 387 p.

Shaping Urban Identity in Late Medieval Europe. Edited by Marc Boone and Peter Stabel. Leuven: Garant, 2000, 269 p.

SPUFFORD, Peter. *Power and Profit. The Merchant in Medieval Europe*. London: Thames and Hudson, 2002, 432 p.

TOUATI, François-Olivier. *Maladie et société au Moyen Âge. La lèpre, les lépreux et les léproseries dans la province ecclésiastique de Sens jusqu'au milieu du XIVᵉ siècle*. Bruxelles: De Boeck Université, 1998, 866 p.

CHAPTER 4: AUTHORITY

BLOCH, Marc. *Feudal Society*. Translated by L.A. Manyon. 2 vols. Chicago: University of Chicago Press, 1965.

—. *The Royal Touch. Sacred Monarchy and Scrofula in England and France*. Translated by J. E. Anderson. London: Routledge and K. Paul; Montreal: McGill-Queen's, 1973, 441 p.

BROWN, Peter. *The Cult of the Saints. Its Rise and Function in Latin Christianity*. Chicago: University of Chicago Press, 1981, 187 p.

CAMILLE, Michael. *The Medieval Art of Love. Objects and Subjects of Desire*. London: Laurence King, 1998, 176 p.

CONGAR, Yves. *L'Église de saint Augustin à l'époque moderne*. Paris: Cerf, 1970, 483 p.

CONTAMINE, Philippe. *War in the Middle Ages*. Translated by Michael Jones. New York: B. Blackwell, 1984, 387 p.

De Lubac, Henri. *Corpus mysticum. L'Église et l'eucharistie au Moyen Âge*. Paris: Aubier, Éditions Montaigne, 1949, 373 p.

Duby, Georges. *The Knight, the Lady, and the Priest. The Making of Modern Marriage in Medieval France*. Translated by Barbara Bray. Chicago: University of Chicago Press, 1993, 311 p.

—. *Love and Marriage in the Middle Ages*. Translated by Jane Dunnett. Cambridge: Polity Press, 1994, 231 p.

Iogna-Prat, Dominique, Éric Palazzo, and Daniel Russo, eds. *Marie. Le culte de la Vierge dans la société médiévale*. Paris: Beauchesne, 1996, 623 p.

Keck, David, *Angels and Angelology in the Middle Ages*. New York: Oxford University Press, 1998. 260 p.

Lobrichon, Guy, and Pierre Riché, eds. *Le Moyen Âge et la Bible*. Paris: Beauchesne, 1984, 639 p.

Paravicini Bagliani, Agostino, and Baudoin Van Den Abeele, eds. *La chasse au Moyen Âge. Société, traités, symboles*. Florence: Sismel – Edizioni del Galluzzo, 2000, 266 p.

Petkov, Kiril. *The Kiss of Peace. Ritual, Self, and Society in the High and Late Medieval West*. Leiden; Boston: Brill, 2003, 355 p.

Reynolds, Susan. *Fiefs and Vassals. The Medieval Evidence Reinterpreted*. Oxford [Eng.]: Oxford University Press, 1994, 544 p.

Southern, Richard W. *Western Society and the Church in the Middle ages*. Harmondsworth: Penguin, 1970, 376 p.

CHAPTER 5: KNOWLEDGE AND COMMUNICATION

Bischoff, Bernhard. *Latin Palaeography: Antiquity and the Middle Ages*. Translated by Dáibhí ó Cróinin and David Ganz. Cambridge [Eng.]: Cambridge University Press, 1990, 291 p.

Camille, Michael. *Gothic Art: Glorious Visions*. Upper Saddle River: Prentice Hall; New York: Harry N. Abrams, 1996, 192 p.

Camille, Michael. *Image on the Edge. The Margins of Medieval Art*. London: Reaktion Books, 1992, 176 p.

de Ridder-Symoens, Hilde, ed. *A History of the University in Europe*. Vol. 1, *Universities in the Middle Ages*. Cambridge: Harvard University Press, 1992, 505 p.

Hoppin, Richard H. *Medieval Music*. New York: W. W. Norton, 1978, 566 p.

Pastoureau, Michel. *The Devil's Cloth. A History of Stripes and Striped Fabric*. Translated by Jody Gladding. New York: Columbia University Press, 2001, 128 p.

Pastoureau, Michel. *Blue. The History of a Color*. Princeton: Princeton University Press, 2001, 216 p.

Medieval Sermons and Society: Cloister, City, University. Proceedings of the International Symposia at Kalamazoo and New York. Edited by Jacqueline Holmes. Louvain-la-Neuve: Fédération internationale des instituts d'études médiévales, 1998, 414 p.

Moore, Robert Ian. *The Origins of European Dissent*. Toronto: University of Toronto Press, 1994, 322 p.

Paterson, Linda M. *The World of the Troubadours. Medieval Occitan Society, c. 1100-c. 1300*. Cambridge ; New York: Cambridge University Press, 1993. 367 p.

Recht, Roland. *Le croire et le voir: l'art des cathédrales XIIᵉ-XVᵉ siècle*. Paris: Gallimard, 1999, 446 p.

Riché, Pierre. *Écoles et éducation dans le Haut Moyen Âge*. Paris: Picard, 1989 (1st ed. 1979), 471 p.

Romanesque: Architecture, Sculpture, Painting. Edited by Rolf Toman ; translation from the German by Fiona Hulse, Ian Macmillan. Köln: Könemann, 1997. 481 p.

Schmitt, Jean-Claude. *Le corps des images. Essai sur la culture visuelle au Moyen Âge*. Paris: Gallimard, 2002, 409 p.

General Works

Angermann, Norbert, et al., eds. *Lexikon des Mittelalters*. 9 vols. München: Artemis; Zürich: LexMA, 1977-1999.

Brunner, Otto, Werner Gonze, and Reinhard Koselleck, eds. *Geschichtliche Grundbegriffe. Historisches Lexicon zur politisch-sozialen Sprache in Deutschland*. 8 pts in 9 vols. Stuttgart: Klett-Cotta, 1972-1997.

The Cambridge Illustrated History of the Middle Ages. Edited by Robert Fossier ; translated by Sarah Hanbury-Tenison. 3 vols., Cambridge ; New York: Cambridge University Press, 1987-1997.

Debating the Middle Ages: Issues and Readings. Edited and introduced by Lester K. Little and Barbara H. Rosenwein. Malden, Mass.: Blackwell Publishers, 1998, 396 p.

Dictionary of the Middle Ages, ed. Joseph R. Strayer, 13 vol., New York: Charles Scribner's sons, 1982-1989.

Encyclopedia of the Middle Ages. Edited by André Vauchez ; English translation by Adrian Walford. 2 vols., Chicago: Fitzroy Dearborn Publishers ; Paris: Editions du Cerf ; Rome: Città Nuova, 2000.

Fossier, Robert. *Enfance de l'Europe. Xᵉ-XIIᵉ siècles. Aspects économiques et sociaux*. 2 vols. Paris: Presses universitaires de France, 1982, 1125 p.

Guerreau, Alain. *Le féodalisme. Un horizon théorique*. Paris: Le Sycomore, 1980, 229 p.

—. *L'avenir d'un passé incertain. Quelle histoire du Moyen Âge au XXIᵉ siècle ?* Paris: Seuil, 2001, 348 p.

Le Goff, Jacques. *Un Moyen Âge en images*. Paris: Hazan, 2000, 199 p.

Moore, Robert Ian. *The First European Revolution, c. 970-1215*. Oxford ; Malden: Blackwell Publishers, 2000, 237 p.

The New Cambridge Medieval History. Edited by David Abulafia et al. 7 vols., Cambridge ; New York: Cambridge University Press, 7 vol., 1995-2003.

Southern, Richard W. *The Making of the Middle Ages*. London: Cresset Library, 1967, 263 p.

Works Used for the Captions

Block, Christian. *Le gisant du chevalier au lion couronné*. Bordeaux: Éditions Sud Ouest, 32 p.

Brandl, Rainer. *Imagination Des Unsichtbaren*. Ausstellung des Westfälischchen Landesmuseums für Kunst und Kulturgeschichte, Münster, Landschaftsverband Westfalen-Lippe and Westfälisches Landesmuseum, Münster, 1993, 314 p.

Bruna, Denis. *Enseignes de pèlerinage et enseignes profanes*. Catalogue du Musée national du Moyen Âge, Thermes de Cluny. Paris: Réunion des musées nationaux, 1996, 383 p.

Defoer, H. L. M., and W. C. M. Wüstefeld. *L'art en Hollande au temps de David et Philippe de Bourgogne*. Zwolle, Wanders Éditeurs – Institut Néerlandais, Paris – Musée des Beaux-Arts, Dijon, 144 p.

Erlande-Brandenburg, Alain, in collaboration with Dominique Thibaudat. *Les sculptures de Notre-Dame de Paris au Musée de Cluny*. Paris: Ministère de la culture, Éditions de la Réunion des musées nationaux, 1982, 133 p.

Erlande-Brandenburg, Alain, Jean-Pierre Caillet, Fabienne Joubert, and Élizabeth Tburet-Delahaye. *Musée de Cluny, Guide*. Paris: Ministère de la Culture et de la Communication, Éditions des Musées nationaux, 1986, 138 p.

Erlande-Brandenburg, Alain, Pierre-Yves Le Pogam, and Dany Sandron. *Musée national du Moyen Âge, Thermes de Cluny, Guide des collections*. Paris: Réunion des musées nationaux, 1993, 191 p.

Hoffman, Conrad. *The Year 1200. A Centennial Exhibition at the Metropolitan Museum of Art*. New York: The Metropolitan Museum of Art, 1970, 354 p.

Jaszai, Gésa. *Werke des frühen und hohen Mittelalters*. Münster, Bildhefte des Westfälisches Landesmuseum, Landesmuseums für

Kunst und Kulturgeschichte, Münster, Landschaftsverband West-falen-Lippe and Westfälisches Landesmuseum, 1989, 95 p.

JEANMART, Jacques, ed. *Œuvres restaurées au Musée diocésain de Namur*. Namur: Musée diocésain de Namur, 2001, 44 p.

JENNINGS, Sarah. *Medieval Pottery in the Yorkshire Museum*. York: The Yorkshire Museum and Museum Gardens, 1992, 57 p.

KOERS, Niels. *Museum Catharijneconvent, A Selection of the Finest Works*. Gent-Amsterdam: Ludion, 2000, 87 p.

L'Europe des Anjou. Aventure des princes angevins du XIIIᵉ au XVᵉ siècle. Collective work. Paris: Somogy éditions d'art, 2001, 394 p.

LEMOINE, Pierre, ed. *Le Musée d'Aquitaine à Bordeaux*. Bordeaux, Musées et monuments de France – Ville de Bordeaux, Albin Michel, 1992, 127 p.

Liège. La cité des Princes-Évêques. Du Musée Curtius au Trésor de la Cathé-drale. Collective work, Folios no. 54-60, Les Feuillets de la Cathé-drale de Liège ser., Liège, Trésor de la Cathédrale de Liège, 2001, 56 p.

Musée d'Aquitaine. *Sculpture médiévale de Bordeaux et du Bordelais*. Bordeaux: Musée d'Aquitaine, 1976, 347 p.

Musée des Traditions namuroises. *Piété populaire en Namurois*. Namur: Crédit Communal, 1989.

Musée national du Moyen Âge, Thermes and Hôtel de Cluny. *Le Jardin médiéval, du rêve à la réalité*. Paris: Musée national du Moyen Âge, Thermes and Hôtel de Cluny, 2000, 21 p.

Museo arqueológico nacional. *Boletín del Museo arqueológico Nacional*, tome 4, no. 2, 1986, 219 p.

NOTIN, Véronique, and Bernadette BARRIÈRE (collab.). *Cuivres d'or-fèvres, Catalogue des œuvres médiévales en cuivre non émaillé des col-lections publiques du Limousin*. Limoges: Musée de l'Évêché and Musée de l'Émail, 1996, 127 p.

NOTIN, Véronique, Sandrine GAUDRON, Geneviève FRANÇOIS et al. *De l'influence des princes Plantagenêt dans l'Œuvre de Limoges*. Limoges: Musée municipal de l'Évêché and Musée de l'Émail, 1999, 139 p.

"Présence du Moyen Âge au Québec." Thematic issue of *Cap-aux-Diamants*, La revue d'histoire du Québec, no. 42, (summer 1995).

PRIGENT, Christine. *Les sculptures anglaises d'albâtre au Musée national du Moyen Âge*. Thermes de Cluny, Paris, Réunion des musées na-tionaux, 1998, 104 p.

Société archéologique de Namur. *Annales de la Société archéologique de Namur*, tome 1, Namur, La Société, 1849.

STUMPF, Gerd, Silvia CODREANU-WINDAUER, and Heinrich WAN-DERWITZ. *Der Goldschatz vom Neupfarrplatz. Ein spätmittelalter-licher Münzfund in Regensburg*. Regensburg, Museen der Stadt Re-gensburg, Historisches Museum, 1997, 56 p.

The Trustees of the Armouries. *Royal Armouries Museum*. Leeds, England, The Trustees, 2000, 32 p.

TRAPP, Eugen, Andreas BOOS, and Peter GERMANN-BAUER. *Regens-burg im Mittelalter*, Katalog der Abteilung Mittelalter im Museum der Stadt Regensburg. Regensburg: Universitätsverlag Regensburg, 1995, 266 p.

VAN BUEREN, Truus, and W. C. M. WÜSTEFELD (collab.). *Museum Catharijneconvent Leven na de dood Gedenken in de late Mid-dleleeuwen*. Turnhout: Brepols, 1999, 280 p.

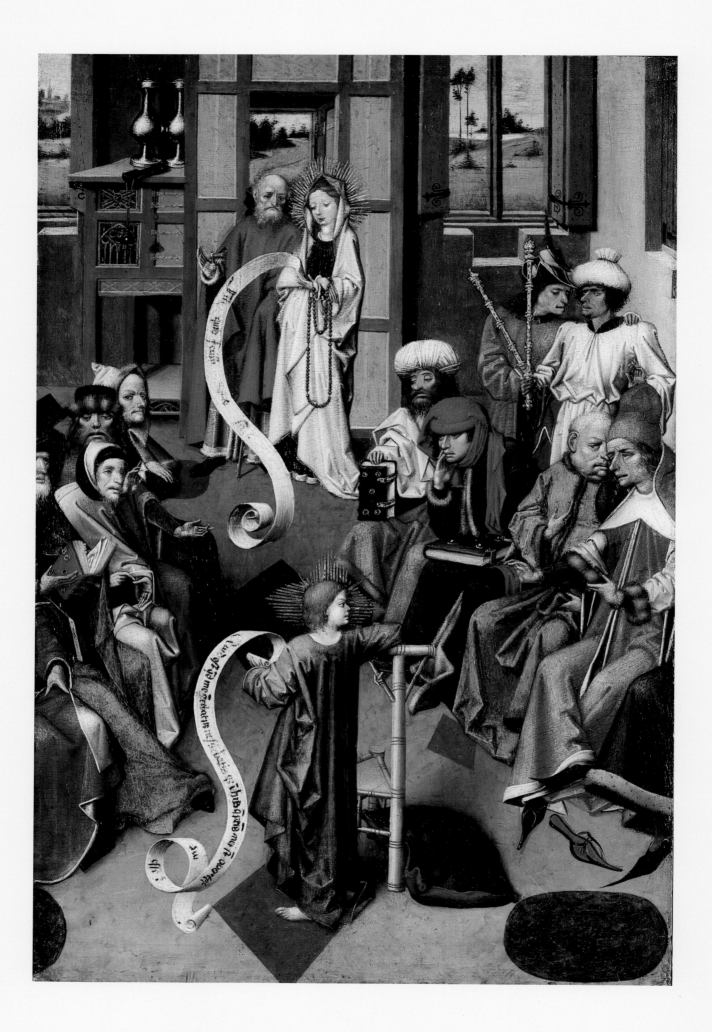

FACING PAGE

Jesus in the Temple at age twelve
High altar of Iserloh, Westphalia, Germany,
ca. 1450–1460. (Tempera painting on oak
panel; Westfälisches Landesmuseum für
Kunst und Kulturgeschichte, Münster, 2041
LM; photo: Sabine Ahlbrand-Dornseif and
Rudolf Wakonigg)